the *Annie Sloan*
collection

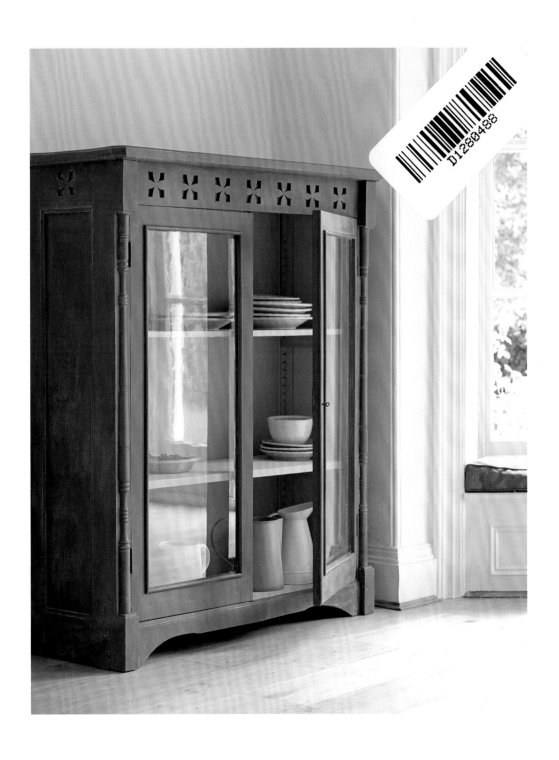

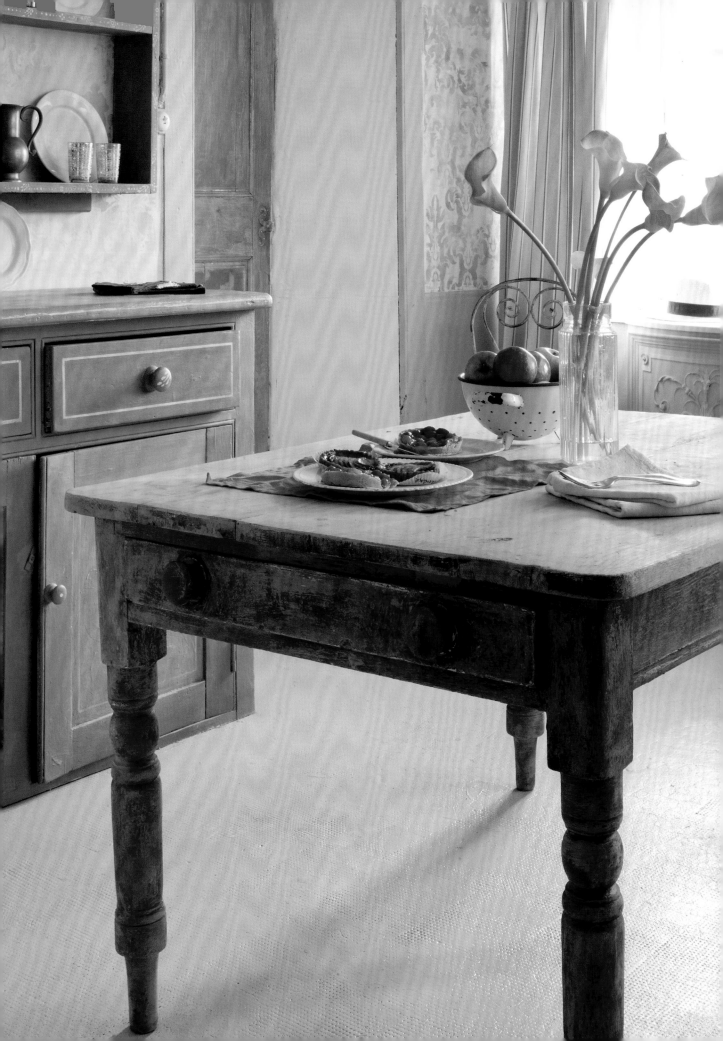

the *Annie Sloan*
collection

75 step-by-step paint projects and
ideas to transform your home

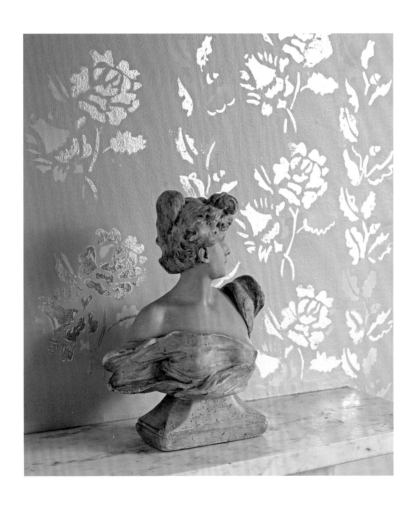

CICO BOOKS

LONDON NEW YORK

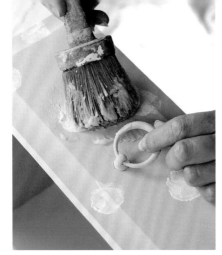

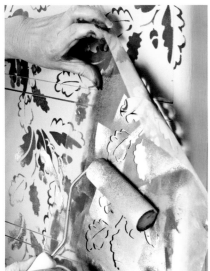

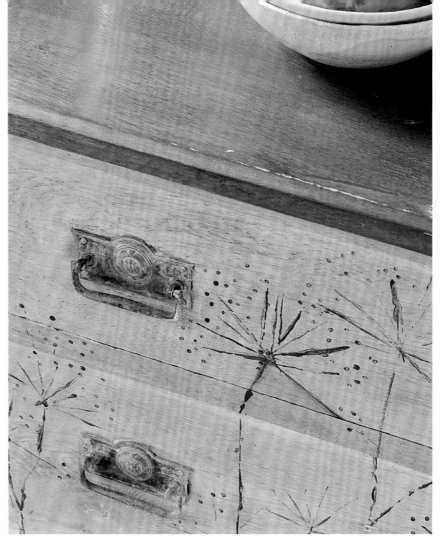

Published in 2021 by CICO Books
An imprint of Ryland Peters & Small Ltd
20–21 Jockey's Fields 341 E 116th St
London WC1R 4BW New York, NY 10029

www.rylandpeters.com

10 9 8 7 6 5 4 3 2 1

Text © Annie Sloan 2021
Design and photography © CICO Books 2021

Projects in this book previously appeared in *Annie Sloan Paints Everything*, *Color Recipes for Painted Furniture and More*, and *Quick and Easy Paint Transformations*

A CIP catalog record for this book is available from the Library of Congress and the British Library.

ISBN: 978 1 80065 029 9

Printed in China

Photographer: Christopher Drake

Editor: Martha Gavin
Art director: Sally Powell
Production manager: Gordana Simakovic
Head of production: Patricia Harrington
Publishing manager: Penny Craig
Publisher: Cindy Richards

MIX
Paper from
responsible sources
FSC® C008047
FSC
www.fsc.org

contents

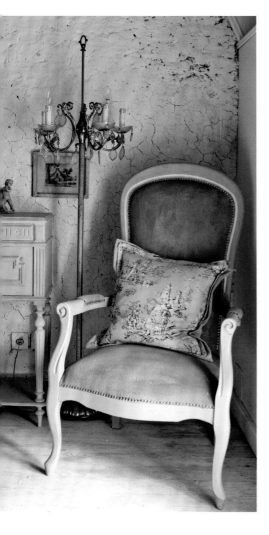

introduction

After developing and writing about my quick and easy paint transformations, color recipes for furniture, and basically painting everything I could, here is a collection of my favorite projects! This is a celebration of thirty years since the invention of my unique range of Chalk Paint, showcasing my greatest hits of projects using this paint.

Let this book be your ultimate painted library. It is part of a greater story about interior decorating, involving fabrics, walls, and floor treatments, where paint can be used to transform your home in a natural and stylish way. I want to excite and inspire you to paint everything and anything you can get your hands on.

The projects that have been selected truly epitomize my art and interior design style, and you could even describe this book as my "Best of" album. My versatile Chalk Paint range, which I developed in 1990, has continued to evolve and develop with new techniques and treatments, and can be used on anything! The possibilities are endless: as well as using it on wood, the paint works on fabrics, concrete, plastics, glass, leather, marble, and metal.

Start off by working with the base. It is very important to understand the piece of furniture and it's not necessary to have a plan that you follow rigidly. It is quite acceptable to change your mind, because as you paint, the furniture starts to tell you what it wants and needs. The age, texture, and color of the wood, plus the shape and style of the furniture, are all determining

factors in how you will paint it. As the first coat goes on, characteristics start appearing and you will begin to have ideas that might differ a little from the original plan. Part of the fun is working with new inspiration and it is this that will make the piece unique.

Color combinations are probably the most important thing to get right. Hard contrasts, lots of colors without an anchor, too many hot colors, or too many same-toned colors are all things I try to avoid when working. If you are not confident with color, a good rule is to try using just two colors, or three at the most. This book is a huge shout-out for the power of color and how colors can be combined. If anything gets my juices going, then it's how color and texture work together.

Don't underestimate the power of simple techniques to create salient and striking designs, from potato-printing on drawers to gilding and using metal leaf, or painting, tying, dyeing, and dipping fabrics. I have printed, stenciled, and reverse-stenciled on fabrics, walls, and furniture. I have also painted in a painterly, freehand way and in a controlled way. All these skills are valid.

Finally, trust your creative artistry and instincts. I have been inspired by art and artists, fashion, and design, and I've thought inside the box and outside the box, being conventional and unconventional. I have designed lots of easy projects and a few projects that will need a little more skill. Please enjoy the collection, be inspired, and, above all, paint everything!

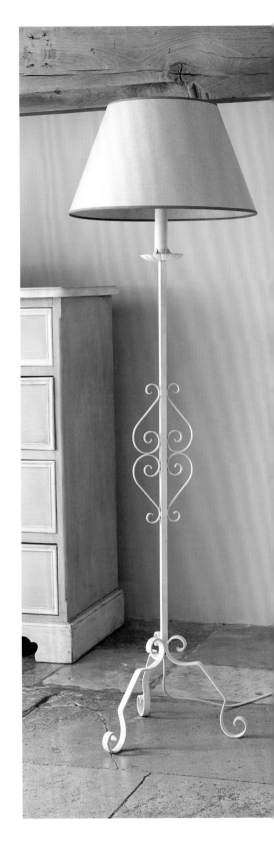

tools and materials

As you flick through the projects in this book, you'll see that none of them calls for specialist equipment. Have a few pots of paint in your chosen colors, some brushes, and clean rags to hand and you are all set to get started.

paint

The starting point is to choose the right paint for the job. This will make painting your furniture an enjoyable experience because the paint will be responsive and you will be able to work in a practical, flexible way. There are many paints on the market, but I have designed the projects in this book with my purpose-made Chalk Paint in mind (see page 224 for stockists). The paint can be applied to most surfaces or used as a dye for fabrics (see www.anniesloan.com for information on unsuitable surfaces). It has a very matte texture and absorbs wax easily, and has been specially created to be used in a huge variety of ways—for example, as a wash, with or without texture, applied thickly, on fabric, or as a dye—which is why it lends itself so well to painting everything.

One of the great bonuses of using this particular paint is that there is no need to prepare furniture first by priming or rubbing down, which means you can start painting easily and quickly while you have the urge. The paint, despite being water-based, even mixes easily with the solvent-based wax too, so you can color the final finish to get the exact color you want. As a general guide, you will need 1-quart (1-liter) cans of paint for large projects and small project pots for painting and decorating smaller areas. For the most part, you only need to apply one coat of Chalk Paint, but where two coats are necessary, apply the first one with a big brush.

One of the most exciting and interesting ways to use the paint is on fabric. I used to do this many years ago, but have recently rediscovered this technique. One method is to use it as a dye by washing fabric in heavily diluted paint and the effect is wonderful—

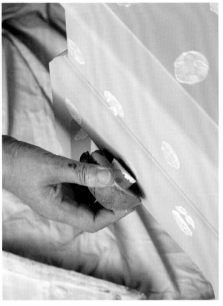

I have rewashed one dyed linen sheet several times now and the color has remained the same. The other method is to paint and then wax upholstered chairs with my paint, which creates a stunning effect.

color

Working with a good palette of colors is important, as is being able to mix them. I use a palette of ready-mixed neutrals with stronger colors, working on the premise that you can lighten strong colors but can't make a light color strong. My already-aged colors, such as Duck Egg Blue, can be lightened with Old White, but for colors like Provence, which is rather clean, it might be better to add Country Grey to dull it and give it a little complexity. Of course, waxes can change the color too, so take this into consideration when you are applying your chosen paint.

My paints are made so that they can be mixed together, which means you can also create your own colors. To do this, begin by mixing different paints together on paper, in a paint roller tray, or on an Annie Sloan MixMat™. Use your fingers or small brushes to work out the proportions of each color. Once you have determined the ratio of colors, you can go on to make larger quantities, using this as your guide. Start with the greater quantity and then add the second and third colors, testing all the time to see where you are in the mix.

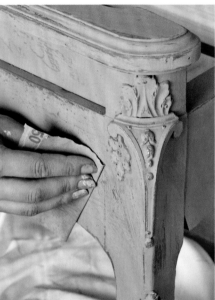

Color is extraordinary because it changes so much according to the context within which it is used—a color that looks great in one room could look like dirty pondwater in another because of light (either artificial or natural) and the surroundings. Don't worry if your initial choices do not give the effect that you hoped for—with the methods in this book you can change the tone and color of a piece using washes and colored waxes.

brushes

Your brush does not have to be expensive, but it does need to have certain qualities because working with bad brushes can be very frustrating. I find that using a brush that is a mix of synthetic and bristle is the best. The hairs should be fairly long and flexible with a little bounce to allow you to be expressive in your work.

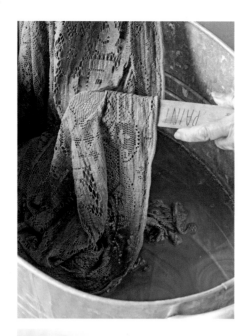

Have a collection of brushes to hand, such as a large one at least 3–4in (8–10cm) wide for painting onto the furniture with speed and a smaller 1–2in (2.5–5cm) brush to work paint into the intricate parts, such as moldings and corners. I tend to work with a 2in (5cm) and 1in (2.5cm) brush. In some projects I recommend which brush to use, but it's more important to pick a size that feels comfortable for you to use and suits the size of the piece of furniture or wall/floor being worked on.

Don't choose brushes that are too short since the paint will not flow well, and don't use a brush with hard and inflexible bristles, because the paint will look scratchy. Don't have a floppy brush, because you will have to work too hard to make the paint spread.

I often mention artists' brushes—by this, I mean soft-haired ones from an artists' supplier. Cheap craft brushes will only result in frustration, as they are not responsive and the hairs quickly become floppy or fall out. The most expensive artists' brushes are made from sable hair, which are very good, although squirrel hair and high-quality synthetic brushes don't cost as much and work extremely well, offering the right amount of strength and spring. I use a range of artists' brushes: two flat-ended brushes, known as "one strokes," ¼in (6mm) and ½in (12mm) in size and made from high-quality synthetic hair; and two pointed brushes in a size 4 and a size 6, both made from sable hair.

wax, sandpaper, and varnish

I wax more or less everything I paint to get the right finish for my furniture and walls. I find it makes my projects strong and practical and gives them a beautiful, workable finish. I recommend that you choose a soft wax that can be applied easily with a brush. I often use a 1in (2.5cm) brush to apply wax, but you can use a large brush to get it done quickly if it feels more comfortable. After adding a layer of clear wax to a piece, you can then start applying dark wax or coloring the clear wax with some of my paint to alter the finish.

For the distressed look, or for achieving a very fine finish, you need to be able to sand the waxed surface to reveal the wood or another coat of paint—so have a range of fine-, medium-, and coarse-grade sandpapers at hand for this purpose. I produce an Annie Sloan range of Sanding Pads in all three grades. I find that using just the fine and medium grades is usually enough, but sometimes move on to the coarser paper if I really want to distress the furniture.

The only time I use varnish is on floors, when doing decoupage and transfer work, and when I use the crackle varnish set. I prefer to apply wax to my work at the end because it has such a soft finish, can be colored and changed as you work, and stops the work chipping.

cloths

Finally, have a good supply of clean, dry, lint-free cloths to hand so you can wipe brushes, polish wax, apply and wipe off paint, and generally use them to clean. I often buy old sheets from thrift stores and charity shops and find these are ideal.

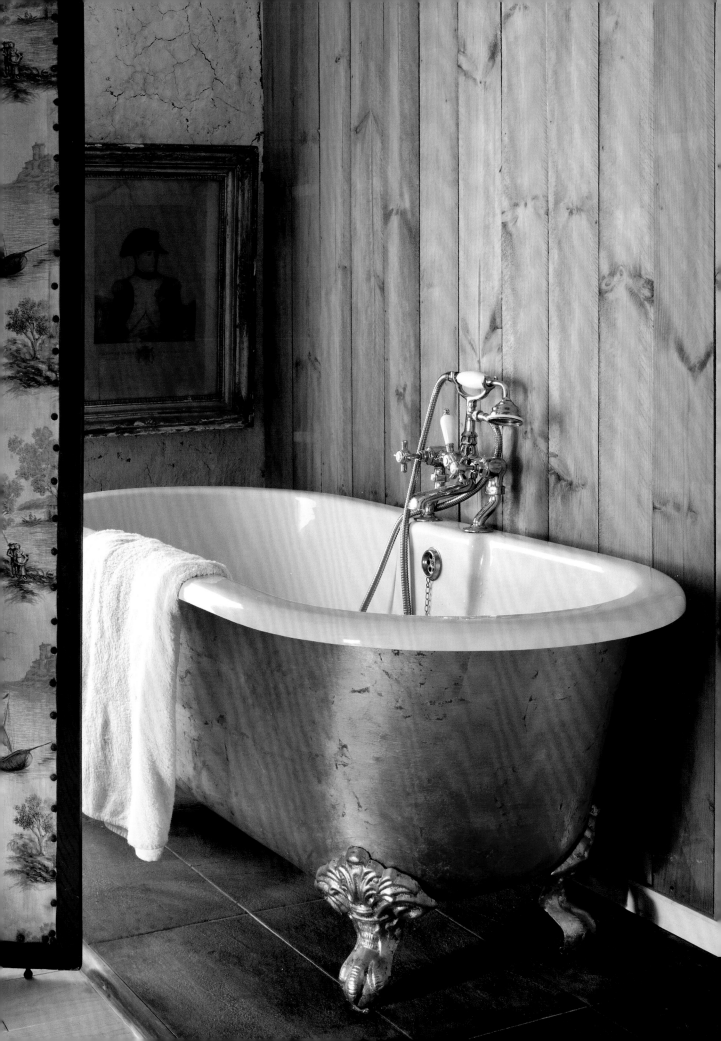

PART 1

painted floors, walls, ceilings, furniture, and more

Paris Grey parquet floor

Parquet is a very old form of flooring that uses small, usually rectangular, blocks of wood, which are pieced together like a mosaic to form a simple pattern. It became very popular in the 1950s and '60s, and is now returning to popularity. Finding evenly colored parquet flooring in perfect condition is not easy, as I discovered with this particular parquet, but I was able to even out the differences with a wash of one color. Each floor will be different, so do a test patch before you begin. I chose to do a wash of Paris Grey over the wood before lacquering it. Other paint-wash colors that would work well over the wood are Graphite, one of the whites, or Duck Egg Blue.

you will need

- Chalk Paint in Paris Grey
- Pail (bucket)
- Large sponge
- Large flat brush
- Clean, dry, lint-free cloths
- Lacquer
- Large sponge roller

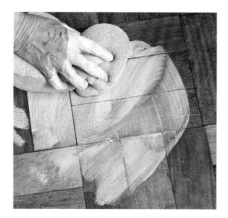

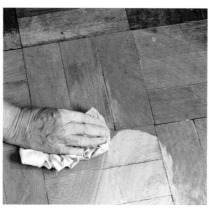

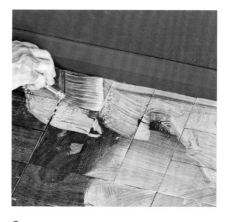

1 Test the color of the Paris Grey wash with the lacquer over it on a small piece of spare wood. When you are happy with the mix of paint and water, make a pail (bucket) of the mix and apply with the sponge, wiping and rubbing it all over the floor. When applying the paint mix, you need to be quick and decisive, and work on the floor in sections.

2 After using the sponge to apply the paint, you may find that you need to spread the paint so that it is even. This will depend on the absorbency of the wood.

3 Use the flat brush to get into the edges and corners of the room.

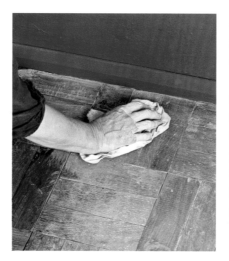

4 To get an even effect on the floor, rub off any excess with a clean, dry cloth.

5 Stir the lacquer well before using a large sponge roller to apply it all over the floor. Using a sponge roller ensures you have a thin coat. Use a flat brush to reach the edges, again applying only a thin coat. Once dry, apply a second coat of lacquer in the same way.

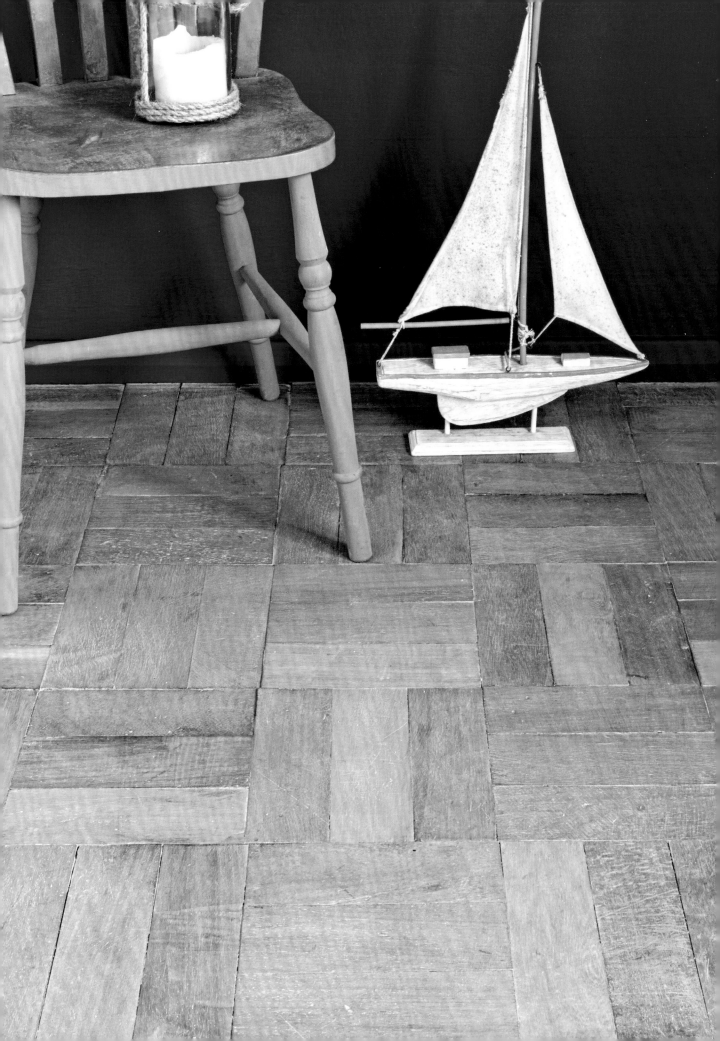

painted floor

The original paint on my kitchen floor was starting to wear away and the concrete underneath began to show through. Rather than simply apply one color I wanted to try something new to give the floor a more interesting look. I decided to go for a rustic approach, selecting gray as my base coat and then applying squares of buttery Cream and Old White quickly and simply with a square sponge.

you will need

• Paint tray and roller

• Masking tape and string

• Chalk Paint in Paris Grey, Old White, and Cream

• Square sponge

• 2in (5cm) paintbrush

• Clear, extra strong varnish

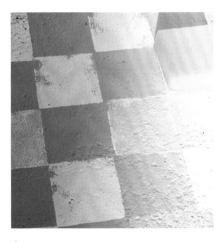

1 Use a roller to cover the floor with the base gray color. Make sure you have vacuumed the floor before you start to avoid any unwanted detritus when you apply the paint.

2 Starting in the center of the room, tape a piece of string to the floor from one side of the room to the other. Spread the Old White evenly in the paint tray. Dip the square sponge into the tray, making sure it is wholly covered, and press onto the floor at regular intervals, using the string as a guide. Repeat on the other side of the string. When you have done two lines of squares, move the string for the next two lines and continue until the whole room is done.

3 Go over some of the squares you have already made with a third color. Print some next to each other and leave gaps in other areas. The sponge will cover the squares unevenly so some of the white will show, but it is this randomness that looks so appealing.

4 Give the floor two coats of extra strong varnish, using a brush at the edges and a roller over the rest.

painted rug

Floors are easy to paint, whether they are concrete or wood—simply use a sponge roller, with a brush for the edges. Depending on the type of floor and the color you choose, you will need either one or two coats of paint, plus a final coat of floor lacquer as a sealant.

Painting a rug is a bit of extra fun and a cheeky solution when you despair of finding a real rug in the right size, color, and design for your newly painted floor. After painting this floor with two coats of Old Ochre, I felt it needed a little something to give it focus but instead of holding out in my search for the perfect rug, I decided to paint one. Drawing around a blanket meant that I could get a very natural shape, so that the "rug" looks real.

you will need

- Chalk Paint in Old White and French Linen
- Blanket, to use as a template
- Pencil
- Large, flat-ended brush
- 1in (2.5cm) brush
- Clean, dry, lint-free cloth
- Floor lacquer
- Lacquer brush

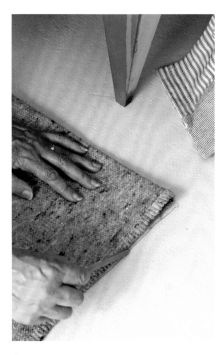

1 Take a blanket and fold it to the size you want for your painted rug. Lay it in position on the floor.

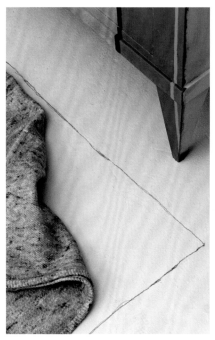

2 Draw around the blanket lightly in pencil, following its slightly uneven outline—the pencil line will be covered by the paint.

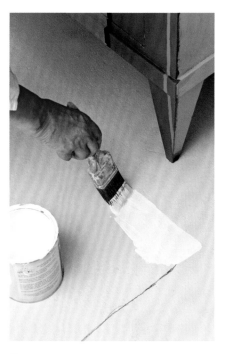

3 Holding the flat-ended brush at right angles to the floor, paint on Old White, following the pencil line but covering it, and allowing the odd wobble or curve, so that it is like the outline of a fabric rug. Paint the outside of the rectangle first, then fill it in. Let it dry.

This is such an easy way to trick the eye! From afar, the rug looks like the real thing. Only closer inspection reveals that it is, in fact, painted! And if in time the paint becomes too scuffed, it's very easy to paint a new rug.

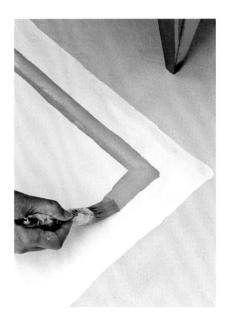

4 Dilute the French Linen with a little water. With the 1in (2.5cm) brush, paint a narrow band that loosely follows the edges of the rug, about 2in (5cm) in. (If you don't feel confident about doing this, draw a pencil line first as a guide, covering it as you paint.) Pull the brush along slowly and deliberately, dabbing off any excess paint with a clean, dry cloth, so that the band has added interest and is not completely flat. When the paint becomes too opaque, add a little more water. Let the paint dry, then cover the entire rug with a coat of floor lacquer, to seal it.

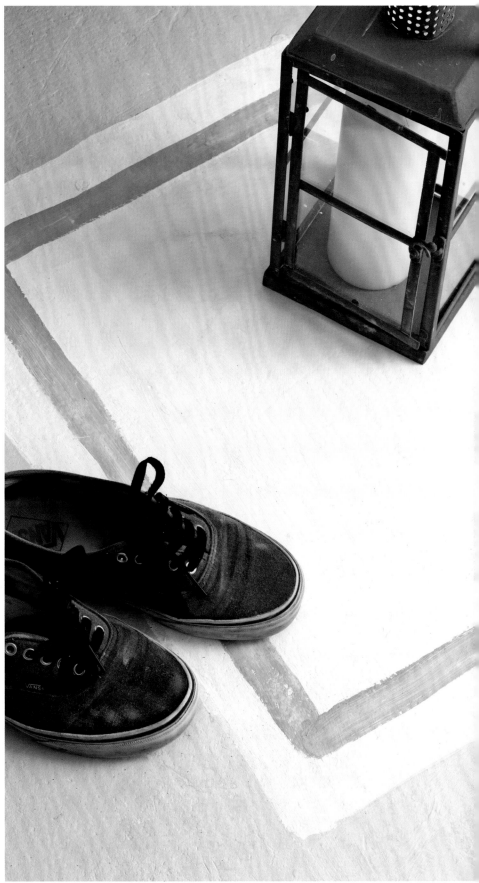

staircase

Painting a whole staircase is a quick, practical, and economical solution to camouflaging a new step added to an existing staircase, and also allows you to add some extra color to the area. Adding a coat of paint to the stairs opens up many possibilities—from highlighting the edging, as I have done, to applying vertical stripes, painting the steps a different color to the risers, or simply using one bold color.

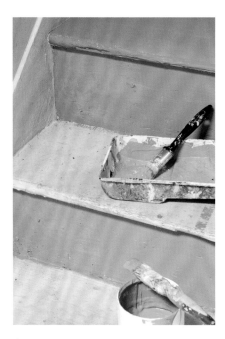

you will need

- Chalk Paint in Château Grey and Scandinavian Pink
- 2in (5cm) paintbrushes for applying paint
- Paint trays
- Extra-strong semi-matte lacquer
- 4in (10cm) brush for lacquer

1 I have chosen two colors that work well together, Scandinavian Pink for the edging and Château Grey for the rest. Simply paint the whole staircase first with the gray, then once it is dry paint the edging in the pink.

2 When all the paint is dry, varnish the staircase with a strong lacquer. I have used a water-based semi-matte product.

tip If your floorboards are in good enough condition you could apply the paint thinly as a wash, painting it on and wiping it off if you want a slightly more opaque effect. The same application of lacquer would follow.

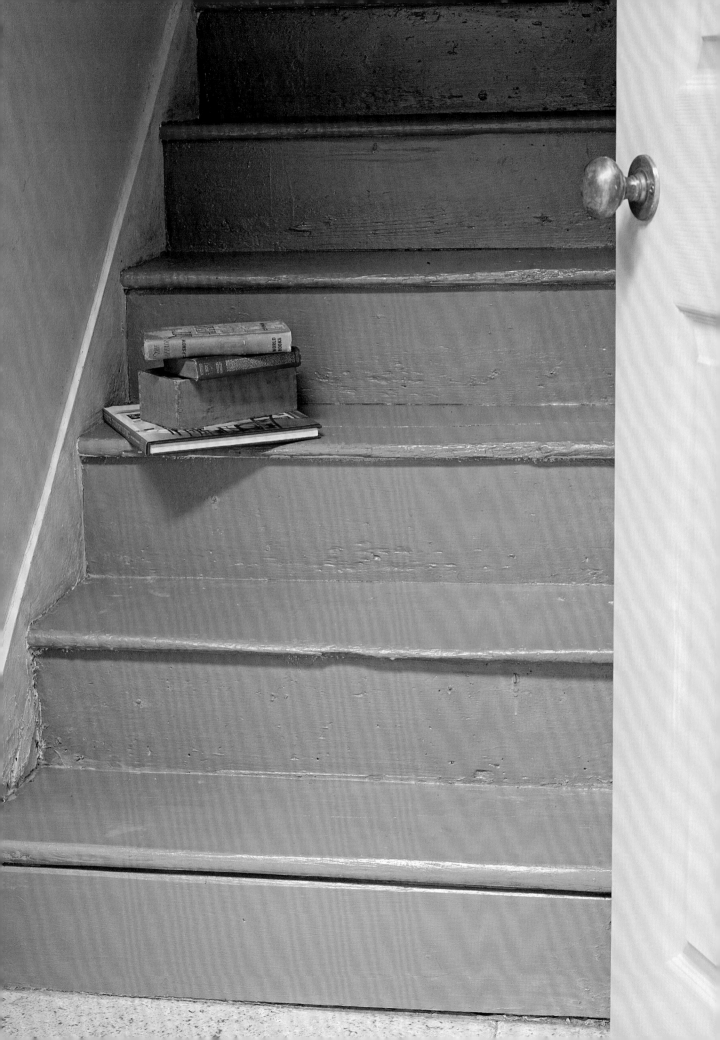

striped stairs

This is a modern staircase comprising 14 stairs, which was fairly unremarkable, rather dark, and generally needed cheering up. It was inspired by a staircase which caught my eye on the Pinterest website because of its wobbly, uneven nature. Although all that was needed here was a series of horizontal lines, it was a difficult undertaking. Making certain that the rhythm of loud, quiet, deep, and high colors works well requires time and planning.

Remember that the cool colors—blues, greens, and quiet Old Violet—are used more frequently than the few lines of the hot, bright colors. There are only about nine or ten stripes of these hot colors, yet they dominate over the cooler stripes.

you will need

• A good selection of Chalk Paint (see below for guidance on color choices)

• 2in (5cm) flat synthetic brush

1 Each stripe of paint is not only a little wobbly but is also of a different width and some are on the step and the riser too, so blurring the definition of the stairs giving it an interesting twist.

2 This detail of newel post shows a different technique—lime washing on oak (see page 55), which makes a great contrast to the colorful stripes.

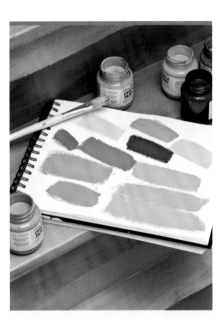

Choosing the colors that work together should be done in advance, before you are tempted to begin painting. Aim for a group of some dark and light neutrals, many cool colors, and just a few warm colors. I repeated each color several times, especially the neutrals and cool colors. I started with a smaller group of colors, but found I added a few more as I went. Sample pots are a good way to use a lot of colors economically.

tip Use a flat synthetic brush which can easily get into edges and corners. Don't overload the brush to avoid paint pooling and making raised edges.

painting and waxing a wall

I wanted to give this wall a really smart polished look, but with a little texture in the paint so that it didn't look too flat. Graphite paint looks very good with the white plaster statue against it and certainly makes a great statement. In contrast, Old White with clear wax also looks very appealing as a polished wall. A stronger color with clear and dark wax could also look good.

you will need

• Chalk Paint in Graphite
• Sponge roller and paint tray
• Tin of clear wax
• Cloth or 2in (5cm) paintbrush for applying wax
• Cloth for polishing

tip If you have a really large area to paint and wax you might find the polishing is best done with an electric buffer.

1 Apply two coats of Graphite paint using a sponge roller. Have some solid areas of paint but don't try to make the whole wall completely opaque. Avoid creating a pattern or texture as this can become too busy. Remember that when you apply the clear wax any pattern will become much more apparent.

2 Using a cloth or a large brush apply lots of clear wax to the wall. Spread the wax all over the surface to create a thin layer—there shouldn't be any excess because it will be worked over the whole wall. Don't leave any thick areas of wax as this might dry white. Polish the next day—this is easier on the second day—for a really good sheen.

polished plaster

I wanted to give this wall color, depth, and interest. The finished result has little flecks of white from the base color, as well as touches of Arles and Old Ochre, but still looks and feels very smooth. There are many color options for this technique, such as Burgundy under Arles, with small patches of deep red coming through.

you will need

- Chalk Paint in Arles and Old Ochre
- Woolen roller and paint tray
- Water
- 4in (10cm) paintbrush
- Cloths for removing excess paint and wax
- Tin of clear wax
- 2in (5cm) paintbrush for applying wax
- Fine- or medium-grade sandpaper

1 Apply the Arles using a woolen roller so that the paint is rough and textured. Don't roll out too far because this can make the paint too smooth.

2 Once the first coat is dry, apply a wash using Old Ochre diluted 50/50 with water. Take a large brush in one hand and paint the wall with the Old Ochre mix. With the other hand, use a cloth to spread the paint thinly and mute the Arles underneath. Allow the paint to dry for half an hour or so—a few damp spots can make interesting marks.

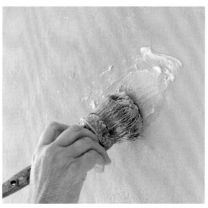

3 Paint a layer of clear wax on the wall using a brush and then wipe off any excess with a cloth.

tip If you want to create this finish on a very large area then you might find an electric sander cuts down the work. Wait until the wax is completely dry before sanding as it can clog up the sandpaper very quickly when still soft.

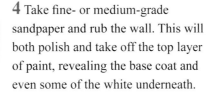

4 Take fine- or medium-grade sandpaper and rub the wall. This will both polish and take off the top layer of paint, revealing the base coat and even some of the white underneath.

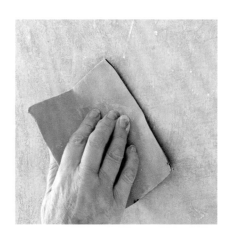

washed wood wall

I first came across the idea for this richly textured finish when I made a table out of two wooden pallets, one on top of the other. I use the table in the design rooms at the warehouse where we all work in Oxford, England. Unfinished pallet wood is just too raw and plain for us "sophisticated" people in design! Plus, of course, it also has a texture that is rather too rough for comfort. So I came up with a finish which is a little different to my normal method. Usually, I apply paint and then wax it afterward, but this time I reversed the process! The result is rich and textural, yet smooth and characterful.

Since then I've used this method on various walls, notably in my rustic bathroom in my house in France. There I used a ragtag of old used boards, both planed and unplaned, and even scaffolding boards too. I was able to unite them all with the rich, textural finish of dark wax and Old White paint. If you wanted a little more color on the wood, the colors and their combinations could easily be varied, so try using black wax, instead of the dark wax, and overlaying it with Duck Egg Blue or Paris Grey, for instance.

you will need
- Chalk Paint in Old White
- Dark wax
- 2 large wax brushes
- Large oval bristle brush
- Clear wax
- Clean, dry, lint-free cloths

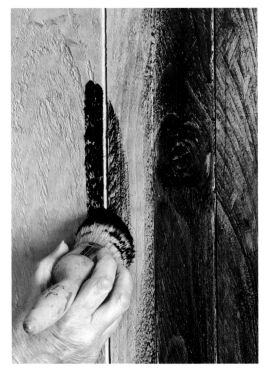

1 Use one of the wax brushes to apply dark wax generously into and over the area of wood, making certain you cover it all. The wood may absorb a lot of the wax, depending on the type of wood you are waxing, so ensure the dark wax remains sticky and isn't all absorbed into the wood. It's essential to apply the wax in strips, so that the wax stays wet/fresh for the next step.

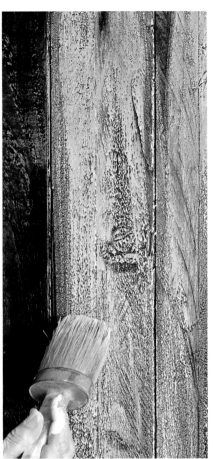

2 Create a wash with the Old White by adding water to the paint, making sure it is quite watery and runs easily over the still "wet" wax, while still remaining opaque. Use the oval bristle brush to paint the wash over the dark wax without working it in too much—just make sure that there are no drip marks.

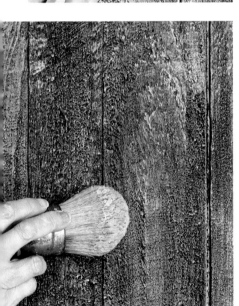

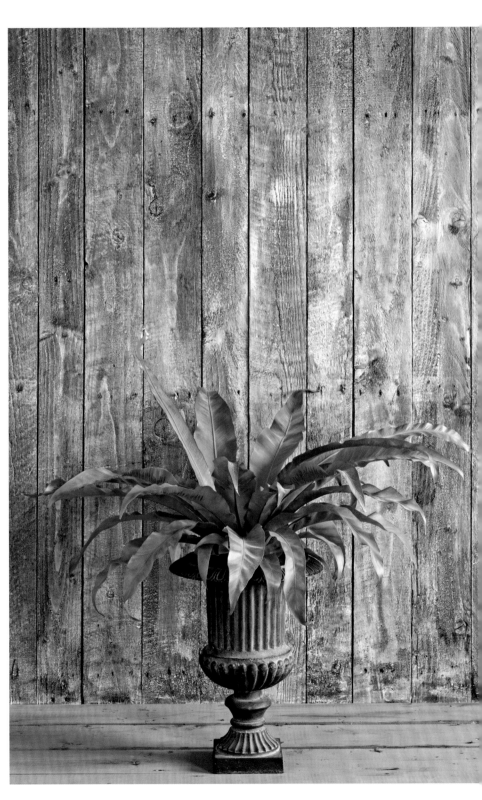

3 Once the paint and the dark wax are dry, use the other wax brush to apply clear wax to seal the wood completely. Remove excess wax with a dry cloth.

painting rough walls

As with many old houses in France, the ground-floor walls of our French house are built of stone, while the upper levels are made from a mix of mud and straw. Some of the wall in what is now our bedroom was in a very poor condition, as it had been left unattended for years—chickens had once roosted there, then some owls moved in! It was originally made from a mix of mud, cow manure, and straw, and we followed tradition when we repaired it, although we omitted the manure. This has given us a sturdy wall but with some fine cracks. To cover these and lighten the overall effect, I chose to paint it over with diluted Old White.

I had to be careful not to overbrush because the paint would end up being discolored by the mud. However, as the paint was absorbed and dried quickly, it was easy to go back to an area and give an extra coat of paint. This technique can also be used on other absorbent and uneven surfaces, such as brick and limestone.

you will need

• Chalk Paint in Old White

• Bucket

• Wooden stick or brush, to stir the water and paint

• Wide, flat bristle brush, to apply the water and the paint

• Clean, dry, lint-free cloth

1 Pour the Old White paint into the bucket—a 1-liter can of paint will cover roughly 140sq ft (13sq m) before you add the water (see step 2), which will give you almost double the coverage.

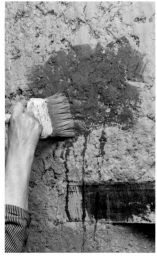

2 Using the wooden stick, stir in water to make the paint thin enough to paint on easily but not so thin that it is runny and won't cover well. You will probably end up adding about 1 liter (2 pints) of water.

3 Paint the wall generously with water—this will make applying the Old White much easier, as the water will draw the paint into the wall.

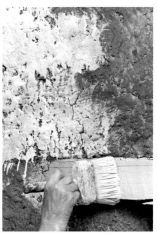

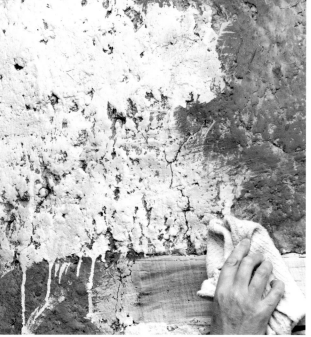

4 Brush the diluted Old White on the wall, stabbing with the bristles to make sure the entire surface is covered.

5 Paint a coat of diluted Old White over the wooden lintel, then wipe it over with a clean, dry cloth, covering up the dark contrasting color but leaving the texture of the wood still visible.

The fine cracks in the wall and the uneven surface of the mud and straw add real character to the bedroom.

This room originally had a dado rail but all that remains now is part of the original wiring system at the same height. I decided to treat the area beneath the wiring like a dado, using paint to delineate it. Traditionally, the dado is painted in a darker color than the area above the rail—I chose Country Grey. I then painted thin blue lines to represent the panels.

painted panel wall

The staircase that we installed in our house in France, to reach the new rooms we had created upstairs meant that the stenciled wall had to be re-plastered, obliterating my original design. This led me to look at the wall in a fresh way. I felt it needed a calm and quiet design that would work harmoniously with the staircase and the rest of the old stenciling in the room. I have long been a fan of 18th-century Swedish, where painted lines—just one or two of various thicknesses, often in blues, grays, or the traditional earthy Swedish pink—were used on walls to indicate panels.

Painting lines on walls is difficult and requires a lot of practice, so I have devised a method that can allow you to be less precise. A roughly textured wall, rather than a perfectly smooth one, gives the best results. To make a smooth wall rough, paint it first with a bristle brush in different directions, allowing the paint to be uneven with brush marks, or plaster it with an uneven finish.

The brushes I used for this project are specialist fresco brushes, with a long pointy tip designed for painting lines. They are not essential for this project but you do need to use fine, long-haired brushes with soft but strong bristles. The brush also has to be able to hold a lot of paint so you can pull it along without having to reload. I used brushes of two different widths to create the lines of different thicknesses.

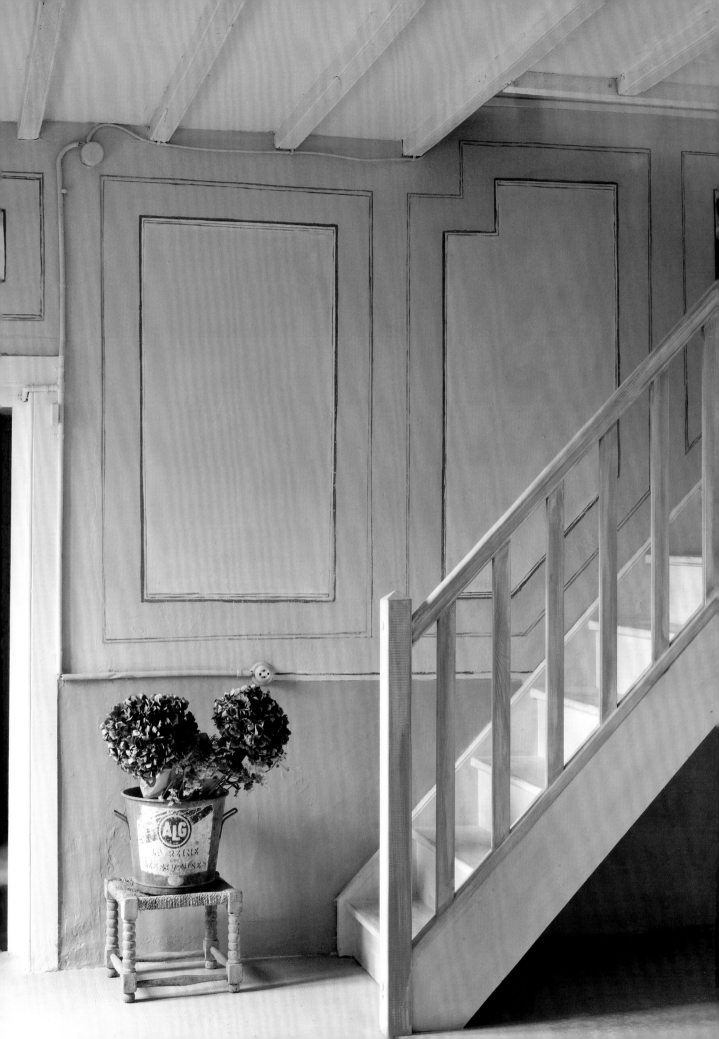

you will need

• Chalk Paint in Old White, Country Grey, and Aubusson Blue

• Pencil

• Long, straight piece of molding

• No. 2 flat brush, to paint the Old White and Country Grey

• Round-sided molding, to act as a guide

• Oval brushes, to paint the Old White

• 2 fine brushes of different widths, to paint the lines

• Fine sandpaper

• Clear wax

• Clean, dry, lint-free cloth, to rub the wax on and off

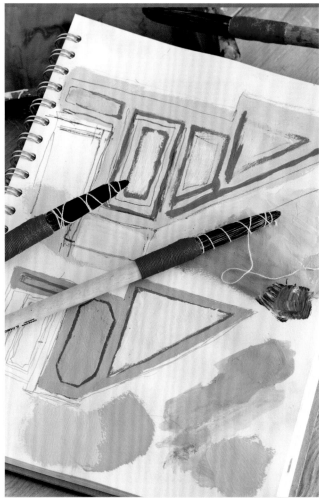

I worked out beforehand where the panels should be on the stairway by doing a rough drawing and making some notes about the colors. I decided on using Old White in the center panels; Country Grey, a warm soft pale brown-gray on the outer areas; and Aubusson Blue lightened with Old White for the lines. The lines around the center panels were painted more thickly than those of the outer frame.

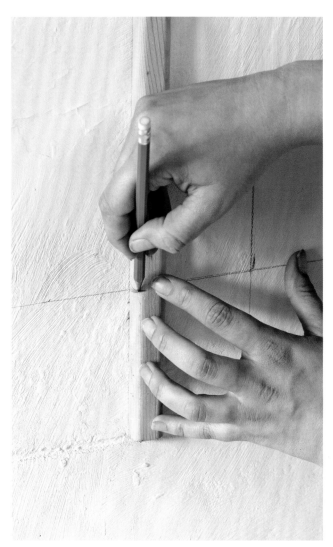

1 Paint the entire wall in Old White with a flat brush. Roughly work out the size and shape of the panels by eye and, with a pencil, lightly mark where you think they will go on the wall. When you have finally decided on the size of each panel, mark them out on the wall using a long straight piece of molding as a guide. Paint the outside area between the panels in Country Grey using a flat brush to work up to the pencil lines.

2 Lighten the Aubusson Blue by mixing it with Old White (roughly two-thirds blue to one-third white, but the quantity of white depends how light you wish the blue to be—a larger room can take a more distinct difference between the two tones). Hold the molding against a pencil line, to act as a guide—this will allow a loaded brush to glide along it without paint seeping underneath. Load the thinner fine brush with paint. As you paint the lines, use your little finger as a guide, letting it slide along the side of the wood as you paint, keeping your finger and wrist firm so the brush stays steady and straight. This will allow paint to flow from the brush evenly and at the same rate. Paint thicker lines in the same way, using the thicker brush.

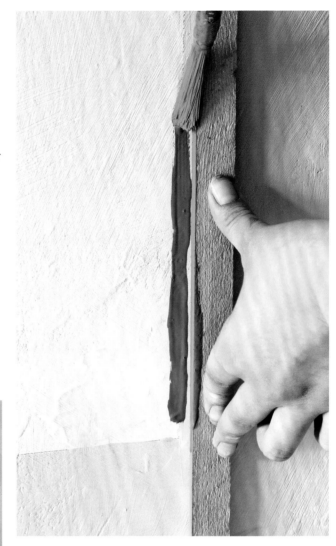

tip Before painting the lines, have a dry run first to apply the paint evenly. You may need to hold your body in a certain position to do so.

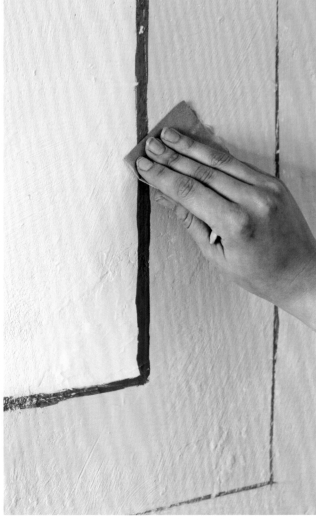

3 When the paint lines are dry, rub them gently with fine sandpaper, particularly where they are too thick or wobbly, to let the texture of the wall come through. Lightly wax the wall, taking care not to polish it so that it remains matte and not shiny.

ceiling and rafters

The previous owners of our old house in Normandy had tacked a ramshackle and unattractive arrangement of hardboard sheets onto the kitchen ceiling. When we took them down, we not only found a large layer of hard, caked mud (this was the traditional material for making floors) but also that some of the original rafters were either missing or rotten and had to be replaced.

After this work had taken place, I was left with a ceiling made up of a mix of old, black-stained rafters and some new ones.

Both the ceiling and the rafters had to be painted. I decided against white because that would have left the room looking rather cold. Color, on the other hand, would brighten things up. Blues and greens are recessive, which means that they help to give a room a feeling of space. I opted for Duck Egg Blue paint for the rafters and Louis Blue for the ceiling, both of which were already used in the kitchen: Duck Egg Blue on the cabinets, the interior of a cupboard, and one of the chairs, and Louis Blue on another chair.

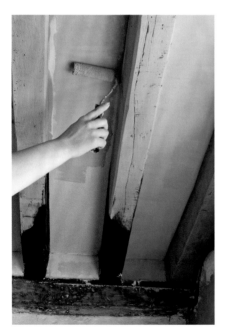

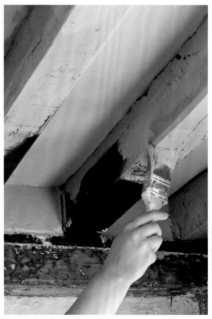

you will need

- Chalk Paint in Duck Egg Blue and Louis Blue
- Sponge roller
- Large flat brush

tip When painting a ceiling and rafters, use two colors that are very close in tone, such as the Duck Egg Blue and Louis Blue that I used here.

1 Using a sponge roller, which has a cleaner edge than a woolly roller, apply the Louis Blue to the ceiling. I chose this color because it looks like a summer sky and also has depth. Go right into the edge of the rafters—it doesn't matter if you get paint on them.

2 Paint the rafters with the flat brush—most of these rafters are old, very gnarled, and uneven, so they required a lot of painting. Use the flat end of the brush to get into the join between the ceiling and the rafters. There is no need to apply any wax or varnish, so the end result is a ceiling with a very matte finish.

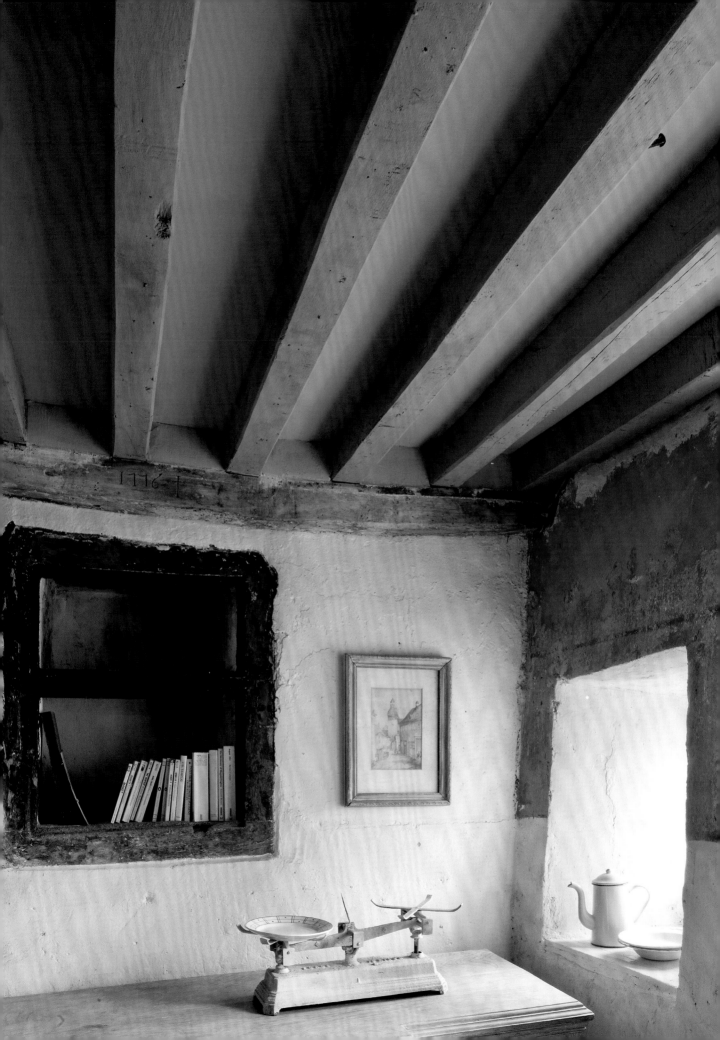

you will need

• Chalk Paint in Duck Egg Blue and Old Ochre

• 2in (5cm) paintbrushes for applying paint

• Tin of clear wax

• 1in (2.5cm) paintbrush for applying wax

• Cloths for removing excess wax and polishing

• Fine- or medium-grade sandpaper

carved oak chest of drawers

I love the simple square shape of this 1930s oak chest of drawers, but I like furniture to be light and airy and wanted the interesting relief carving on the top drawer to be easily visible.

The design and shape are strong so I decided to try to bring this out by painting using just one simple color. I also wanted to highlight the carving and shape of the legs by rubbing them with sandpaper. All I had to do to prepare was to treat the plywood sides for a little woodworm damage and wipe away the cobwebs, then I was ready to paint.

1 I chose Duck Egg Blue for the drawer interiors and Old Ochre, a pale milky caramel color, for the outside. With such dark brown wood you will need to paint two coats to fully cover both the color and the texture of the wood. On the carving I had to apply the paint with a stipple movement of the brush to make certain all the grooves, ruts, and indents were covered.

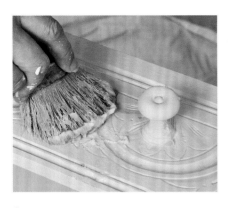

2 When the paint is dry, apply a layer of clear wax. This is best done with a large bristle brush to help reach the intricate carved areas. Wax the chest all over, wiping off any excess as you go to avoid a waxy build up.

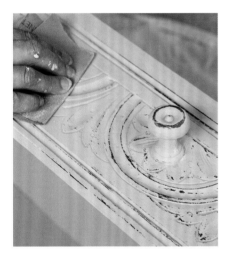

3 For the carving take some fine- or medium-grade sandpaper and tear off a piece so you can work with it easily. Rub gently at first, then harder if necessary, to sand away the higher parts of the carving and allow the relief to show up. The sides of the chest are chamfered so I rubbed the paper along the edges here, and also along the handles, drawer fronts, and top as a way of accentuating the character of this piece of furniture. I finished off by applying another coat of wax and then polished with a cloth the next day.

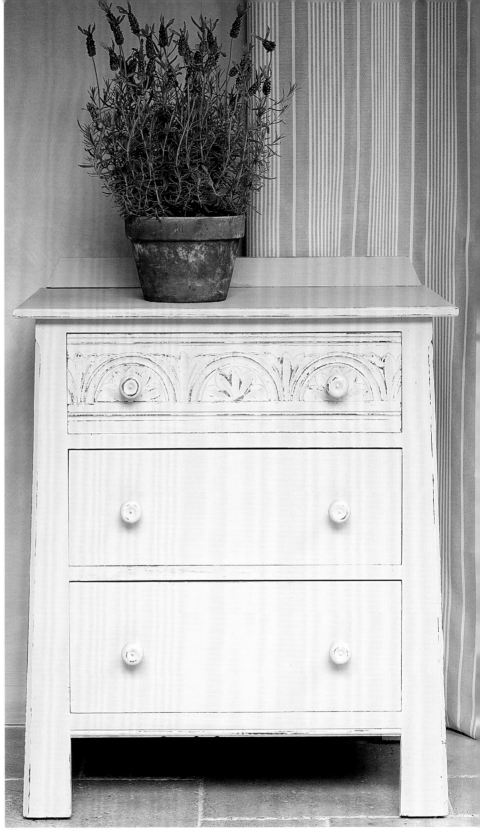

The chest of drawers now looks light, fresh, and clean. The relief carving has been made more apparent by using one color and giving a gentle rub with sandpaper to reveal a little bit of the brown wood. Old Ochre is a soft antidote to the dark wood—and don't forget the surprise of the Duck Egg Blue inside the drawers.

warehouse rustic chest of drawers

I sometimes come across really old, beaten-up pieces of furniture, particularly chests of drawers, which have layers of paint that often finish with a modern, brightly painted color. They look as if someone has tried to scrape off the colored paint, but given up halfway through, revealing all the layers underneath. I really appreciate these "chance" layers, random markings, and hints of other colors in places.

This is quite different to the subtle, worn look of old painted pieces in muted colors. It is a much more robust and rugged look in clear colors. I find it particularly appealing when the colors are quite strong; perhaps it's a little to do with an appreciation of modern abstract painting.

This old, mahogany-veneer piece was in very bad shape and destined for furniture heaven because large areas of the veneer had chipped, cracked, and lifted. The piece also had gouges, a few cigarette stains, and missing moldings. It would once have been a lovely piece of furniture, but by lifting and cutting the veneer and using a little wood filler, it became paintable.

I developed this method by experimenting with the paint and using a combination of techniques, including brushwork, using bleach to weaken the paint, scraping, and waxing to create a great warehouse rustic patina.

you will need

• Chalk Paint in Paris Grey, English Yellow, and Provence (optional)
• Large oval bristle brush
• Thick household bleach
• Clean, dry, lint-free cloths
• Latex (rubber) gloves
• Mixing stick
• Scraper
• Clear wax
• Wax brush
• Dark wax
• Black wax
• White wax

1 Leave the lid off the can of paint overnight so that it really thickens up. Use the large oval bristle brush to apply Paris Grey over the whole piece of furniture, very generously and in uneven layers. This stage may take some time to dry.

2 When the paint is dry, drop thick household bleach onto it in patches. If you wish, you can also use a clean cloth to apply the bleach to the paint. Take care with the bleach to protect yourself and your clothes—you may want to wear latex (rubber) gloves.

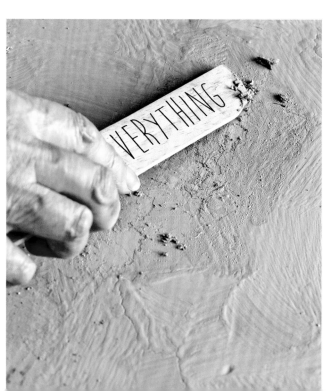

3 Dab a cloth on the wood to soak up some of the excess bleach. This will also remove some of the unwanted paint.

4 The longer you leave the bleach, the more paint it will remove (although the bleach will eventually dry out and this will leave a different mark when you try to scrape it off).

5 Using the end of the mixing stick, held at a 45-degree angle, gently scrape the surface, taking some of the paint away completely to reveal the layer of wood underneath. Pressing harder or softer will produce different marks.

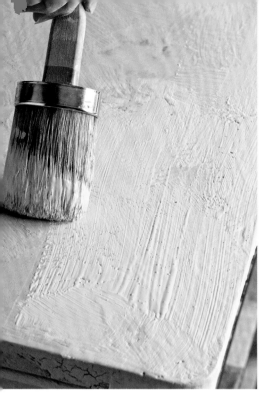

6 Use the oval bristle brush to paint slabs of English Yellow on the piece, but leave some gaps. The paint should be thick, but try to use a light hand so that the paint sits on the surface. At this stage I also applied a little Provence in a few areas, such as the very base of the piece and the moldings.

7 While the paint is still wet, but starting to dry, use the edge of the mixing stick to scrape off some of the English Yellow, applying quite a lot of pressure in places. The more pressure you apply, the more paint will be removed. Then re-apply this thick wet paint by scraping it back onto the Paris Grey paint. This is a little like using a palette knife.

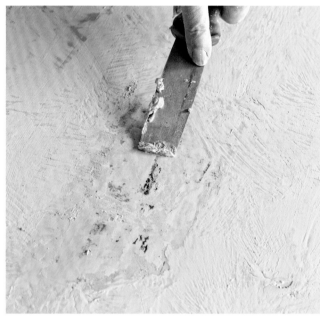

8 Use the scraper to get even further into the layers. This is particularly useful when the paint has dried, but not yet hardened.

9 Apply clear wax all over the piece and then remove any excess wax with a cloth. I then used dark and black waxes in places and, finally, white wax all over in parts to soften the effect of the darker waxes.

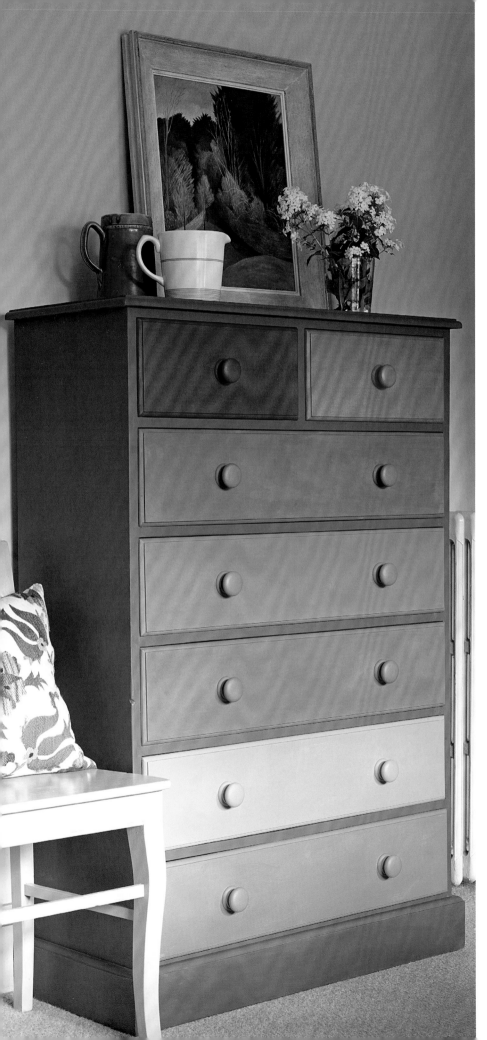

patchwork drawers

To make lots of colors work together without the end result looking too garish, choose ones that are roughly in the same tone band. That way you can avoid one color being much lighter than the others. For my chest I have chosen mainly cool shades, but with warm colors for the top two drawers. The deeper tone of the framework will help to soften the brightness of the drawers.

you will need

- Chalk Paint in:
 - Burgundy
 - Emperor's Silk
 - Old Violet
 - Greek Blue
 - Giverny
 - Aubusson Blue
 - Provence
 - Antibes Green
- 2in (5cm) paintbrush
- Tin of clear wax
- 1in (2.5cm) paintbrush for applying wax
- Cloth for polishing

tip If you want the colors to look more vibrant, choose a very light color for the framework. Avoid using white because unless the wall that the chest stands against is a strong color, the framework would not "hold" the colors. Instead try using a pastel color such as Duck Egg Blue. A darker paint does help to contain the colors, although something like Graphite would be much too stark.

1 Before you begin, plan the colors and their order on the drawers. After choosing my seven colors I arranged the pots in order, moving them around until I was satisfied. I decided on a very logical order, which is the hot reds first, then the blues with the most red in them, the Old Violet and the Greek Blue following, then the blues moving toward green, and ending with the final drawer painted in Antibes Green, a bright Mediterranean color.

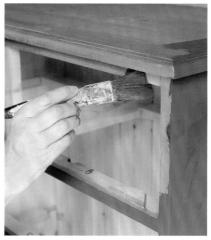

2 Take out all the drawers and start painting the framework of the chest in a strong color; I chose Aubusson Blue. This is cool, like most of the other colors, so will absorb their brightness—but is slightly deeper in tone so it frames and contains them.

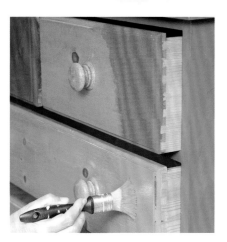

3 Paint each of the drawer fronts with two coats of your chosen color. Pick one of the brighter colors to use for the interiors of the drawers.

4 Apply a layer of clear wax all over the chest, including the insides of the drawers. Finish by polishing with a cloth.

pastel chest of drawers

This chest lent itself perfectly to painting in a delicate palette of pastel colors, using Paris Grey as a base coat to unite them all. The beading around the drawers creates a clear border so this is a good piece for painting. If you prefer stronger colors, see the patchwork drawers on page 42. When choosing your colors, look at other furniture and fabrics in the room for inspiration.

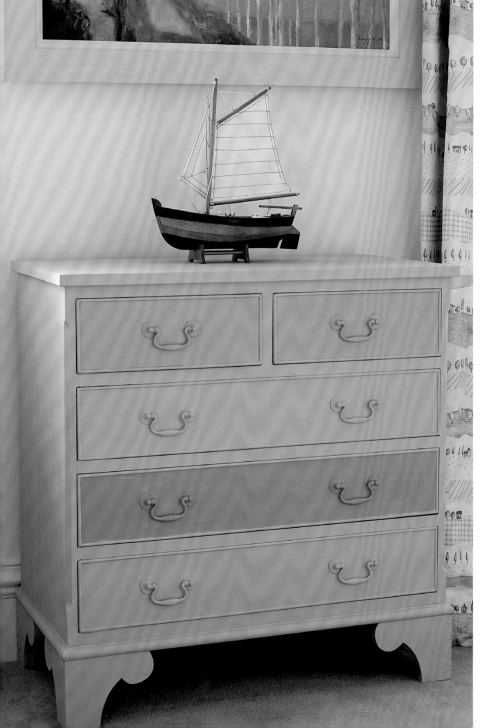

you will need

- Fine-grade sandpaper
- Chalk Paint in Paris Grey, Versailles, Duck Egg Blue, and Louis Blue
- 2in (5cm) paintbrushes for applying paint
- Tin of clear wax
- 1in (2.5cm) paintbrush for applying wax
- Cloth for polishing

tip Paint is to a certain extent translucent so the underneath color will change the top coat. For instance, if you paint red on one drawer and blue on another, then paint them both in the same neutral color, the neutral color will look different depending on the base coat.

1 I started by sanding the piece quite lightly, especially on the edges and corners, as the finish was a little bit shiny and I was certain I did not want any of the orange color of the wood coming through. I then painted the whole piece in Paris Grey, including the handles as these should not be apparent and get in the way of the colors.

2 Pick colors that are similar in tone both to each other and to the Paris Grey base—I chose Versailles, Duck Egg Blue, and Louis Blue. All are not only similar in tone but also occupy the same cool part of the color wheel— Versailles and Louis are furthest apart.

3 Paint each drawer front in a color using any combination you like. I divided the blues and had the greener color on two drawers. Apply a layer of clear wax with a brush and then buff it up afterwards using a cloth to remove some of the wax. For this piece I felt the emphasis should be on the colors rather than the finish.

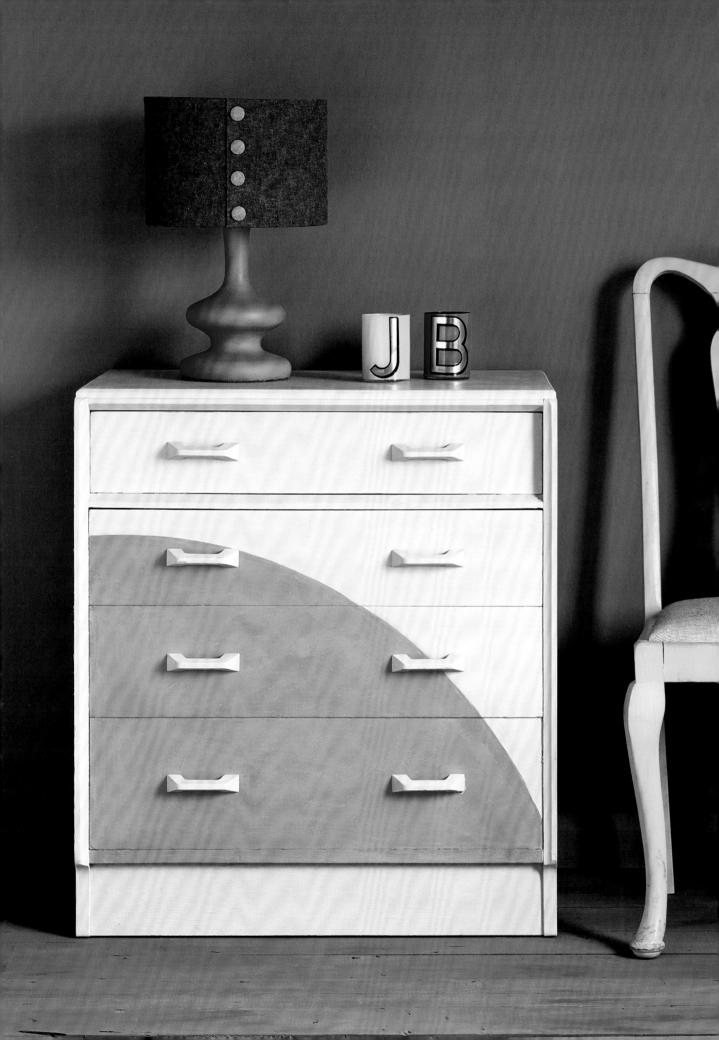

arc painted chest of drawers

I came to do this piece after painting a huge circle on a wall of stacked furniture for some exhibitions. On taking the wall apart, I noticed how good each piece looked painted with an arc. I loved the simplicity of the effect and how the focus became the two colors. So, I started thinking about how I could create a large arc on a single piece of furniture. To make the arc large, you need a pivot point outside the chest of drawers. I achieved this by lifting the chest of drawers onto a second chest. I used a project pot tied with a loop of string as my pivot, tied a pencil to the other end of the string, and drew a line. For this mid-century piece, I chose two colors that were popular in the mid-1960s. Putting a pink and an orange together was daring back then. Other combinations from the 1950s and '60s would be English Yellow and Louis Blue, or Scandinavian Pink and Giverny.

you will need

• Chalk Paint in Antoinette and Barcelona Orange

• String

• Small project pot or round object, to act as a pivot

• Pencil

• Small flat brush

• Large flat brush

• Clear wax

• Large wax brush

• Clean, dry, lint-free cloths

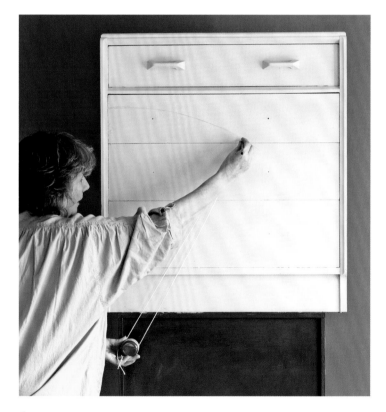

1 Before you start making the arc, paint the chest of drawers all over with Antoinette and allow to dry. Raise your chest of drawers up high, so that you can make the center of your "circle" outside the piece you are painting. Make a large loop in a length of string and attach one end to the project pot and the other end to the pencil. Find your pivot point and then use the string to guide the line of the arc.

2 Paint the edge of the arc very carefully in Barcelona Orange, using the small flat brush, to get a really smooth, clean, consistent edge.

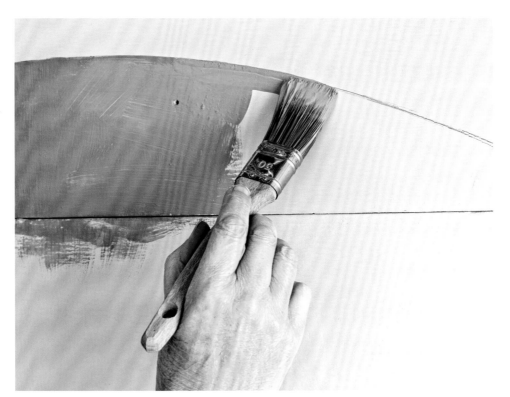

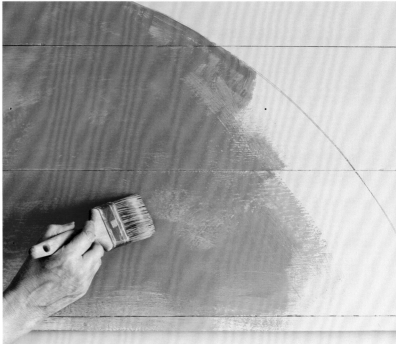

3 Paint the rest of the circle in Barcelona Orange using the large flat brush. Once the arc of paint is thoroughly dry, apply some clear wax with the wax brush. Remove excess wax with a clean cloth.

tip If your piece of furniture has handles, then make sure you remove these before you start painting.

white wax bureau

Oak is a very distinctive wood that is characterized by a deep grain. It also has interesting irregular markings, depending on how it is cut. I particularly love oak when it's very old, unvarnished, and natural because it is a lovely, soft, light gray in color. Sadly, in my opinion, pieces from the 1940s are often spoilt by being stained dark and coated in varnishes. This makes the wood look heavy and obliterates the beautiful grain. Similarly, many modern pieces are stained so that they look yellowish and shiny.

The idea with this project is to bring out the natural grain of the oak by putting white wax in the grain, but leaving the smooth wood free of wax. The finished result is a light-looking piece enhanced by a fairly obvious grain.

This particular bureau is from the 1940s or so, and had been lightly varnished with a dark color. The grain was still textural, but the wood was darker than I would have liked. I could have removed the varnish— a rather long and tedious job—but this would have made the whole piece lighter. So, instead, I opted for the easier method of applying white wax to lighten the varnish and bring out the grain of the wood. If I had taken the varnish off, the finished effect would have been a lot lighter and the grain probably more pronounced.

The trick is to allow the wax to harden for long enough that it hardens a little in the grain, but not for so long that the wax does not come off where you want it to.

you will need

- White wax
- Small wax brush
- Clean, dry, lint-free cloths
- Clear wax
- "V" and triangle shaped stencil and a 4 oz. (120ml) pot of Chalk Paint in Graphite, to decorate the edge of the bureau's desk (optional)

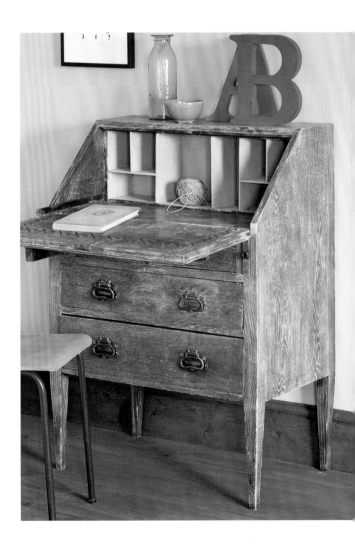

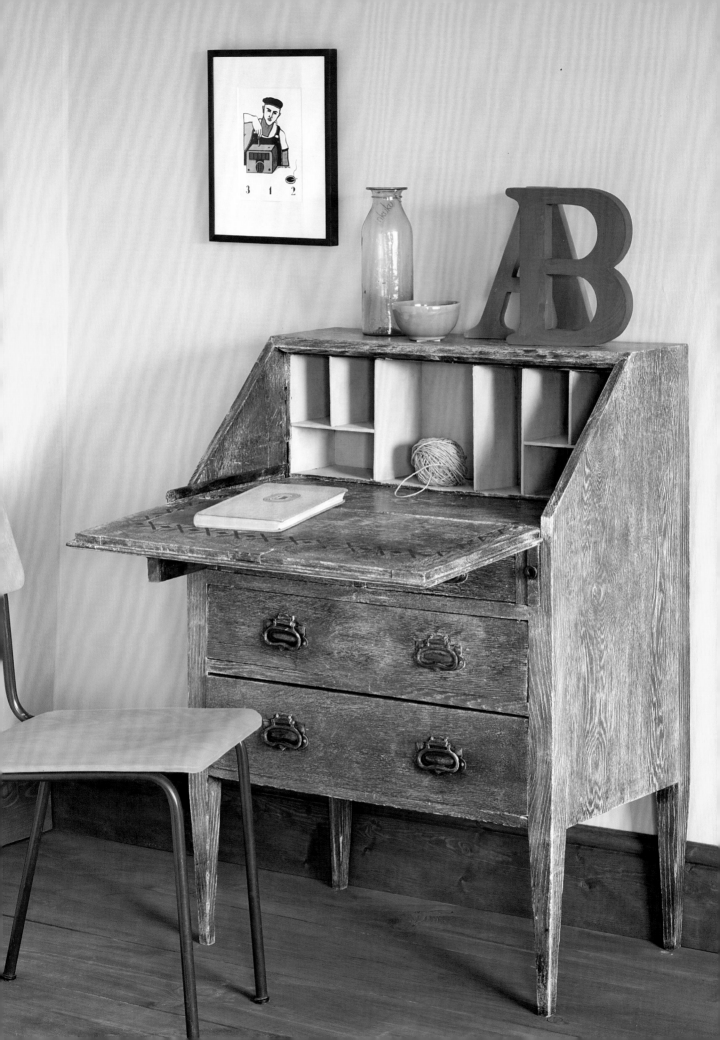

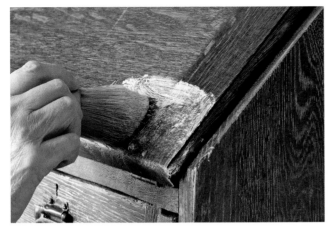

1 Take the wax brush and apply a generous amount of white wax, working it both across and in and up and down the wood. Make sure you get the wax into the indents of the grain. Some of the indents may be quite deep and so it may take a few brushstrokes to fill them. Leave to set for 1–3 minutes, so that the wax can harden a little.

2 Use a clean cloth to wipe off the excess white wax lying on top of the wood, leaving the wax in the indents. If you find you're removing too much wax and there is nothing in the grain, simply re-apply the white wax and leave to harden again. Use a clean cloth to ensure the wax is rubbed in well. You can use a tiny bit of clear wax to remove any unwanted white wax that has hardened.

3 Apply more white wax with the brush to the handles and any metal work—there is no need to remove these first. Wipe off the wax with a cloth before the wax dries.

I used my "V" and triangle shaped stencil to paint two lines in Graphite to create a decorative border of crosses.

smooth and shiny bureau

This bureau probably dates from the 1950s and I felt it would benefit from a slick and shiny modern look, rather than a distressed and shabby one. I love this style of writing desk, the main reason being it is a great opportunity to create a bright interior and make some surprising color contrasts. The inside of the bureau is now rather like the red silk lining of a tuxedo.

you will need

- Chalk Paint in Graphite, Emperor's Silk, and Barcelona Orange
- Synthetic wide, flat brush
- Wooden stick, to mix the paint
- Paint roller tray
- Clear wax
- Clean, dry, lint-free cloth, for polishing

One of the most enjoyable and intriguing things about working with color is the way in which any color will appear to change depending on the color alongside it. Each one will be given certain characteristics, making it appear lighter, duller, or brighter. Red, for example, will look dazzling if placed alongside any color within the opposing segment on the color wheel, such as bright turquoise-blue or green. On the other hand, if red is placed alongside black, the effect is the exact opposite. This is because these colors are similar in tone—to test this, half-close your eyes and look at the black and the red side by side; you will see that both colors almost disappear, with neither appearing darker than the other. Graphite next to English Yellow on this bureau would have made a powerful combination because of the high contrast of color. The impact of Graphite with a more muted color with less contrast would be much less.

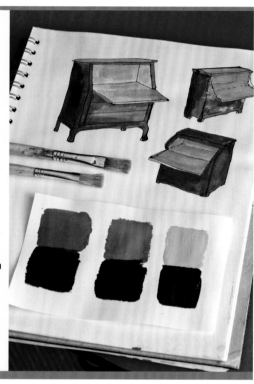

My inspiration for the red and black color combination came from a vintage French print of an advertisement for silk stockings. I re-created the stunning tomato-red by mixing Emperor's Silk with some Barcelona Orange, giving just the right glow.

1 Make sure that the paint will go on smoothly by seeing if it drips easily from the brush. If it doesn't, add some water and stir well.

2 Paint Graphite all over the exterior of the bureau with the wide, flat brush. As you go, brush out the paint so there are no brush marks—a few will be fine, as these will flatten as the paint dries. Paint a second coat, then let dry thoroughly.

3 Mix the Emperor's Silk with some Barcelona Orange, a little at a time, in the roller tray with the wooden stick, until you get the desired shade of tomato-red. Paint the inside of the bureau and the drop-down lid. Paint on a second coat, then let dry thoroughly.

4 Using the medium, flat brush, apply clear wax all over the bureau, including the inside, making certain that it is completely absorbed into the paint. Apply a second coat of wax, again allowing it to be well absorbed. The next day, polish the bureau all over with a cloth—leaving the wax overnight makes it easier to polish.

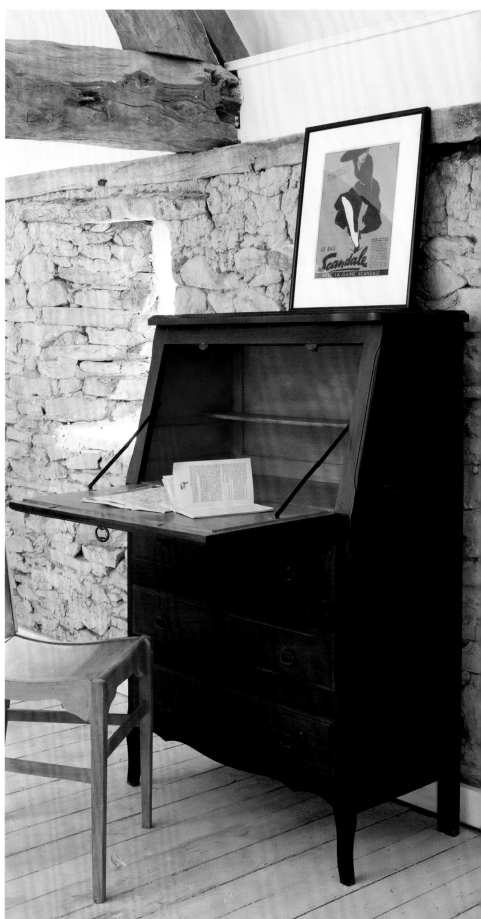

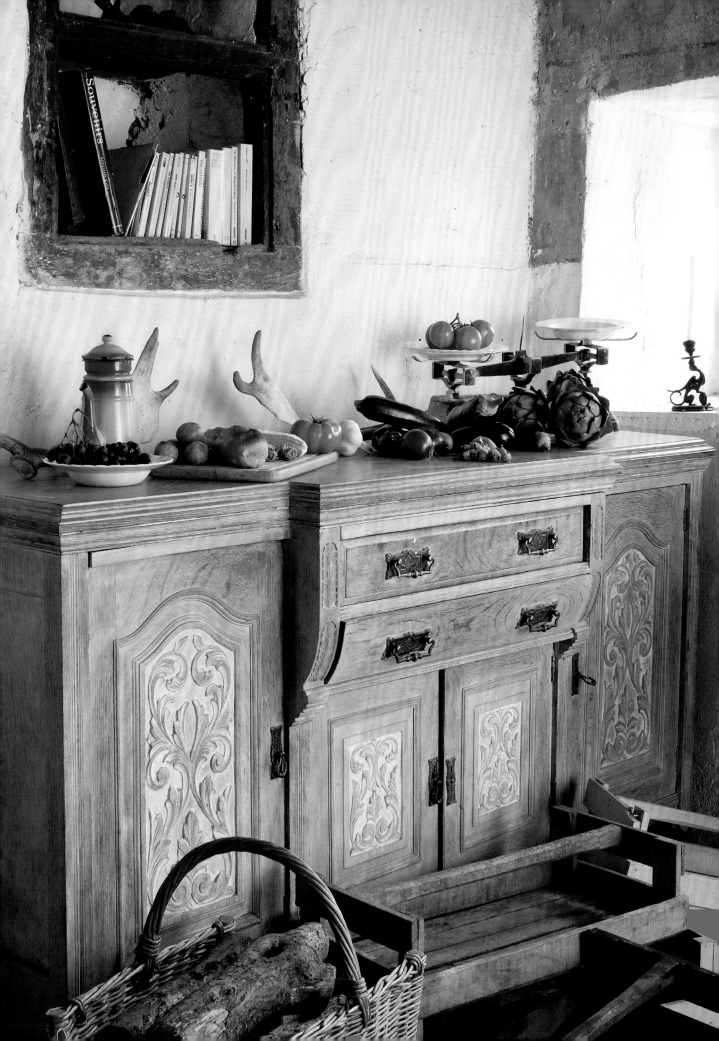

limed oak look sideboard

The beams and the basic structure of old farmhouses were traditionally made of oak because this wood hardens with age and becomes stronger. To preserve the wood and keep the bugs at bay, the oak was whitewashed with lime every year—the caustic nature of the lime in the whitewash killed the bugs.

Oak is a rough wood with a deep grain that traps paint, which is why very old whitewashed oak often has a soft gray/silvery look about it. Over the years, the whitewash would gather in the recesses, creating an effect that is now known as limed oak. It's a beautiful look, as it shows up the quite distinctive and decorative grain of the wood. In contrast, 20th-century oak furniture has often been stained and varnished to a dull brown, which does not bring out the best of the grain at all.

Oak furniture covered in a heavy, modern varnish will need to be stripped before being painted, otherwise the paint won't be able to enter the grain. However, it is surprising how some stained and/or varnished oak still retains its grainy texture, so I always test a piece first by painting a small area that won't be visible. If the paint enters the grain, then I don't need to strip it.

you will need
- Chalk Paint in Old White
- Medium oval brush
- Clean, dry, lint-free cloths
- Clear wax
- 1in (2.5cm) brush, to apply the wax (optional)

tip Old White is the perfect color to use with oak but other colors that work well are blues and grays, in particular, Paris Grey and Duck Egg Blue, which give the wood a silvery, bleached look.

1 Paint over the surface with the oval brush, a small area at a time, so that none of the paint really dries before you reach step 2.

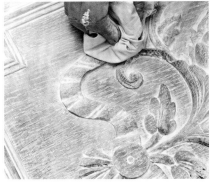

2 As the paint dries, gently wipe it off so that it is just left behind in the grain. If the paint is too dry, add a spit of water to the cloth. Don't remove too much of the paint because the wax, applied in step 3, will lighten the paint and give the desired transparent effect.

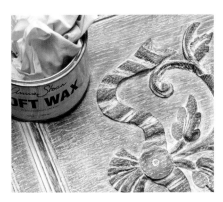

3 If there is any carving, apply clear wax with a brush, so that you can reach the more inaccessible areas. Otherwise, use a clean, dry cloth. Work on a small area at a time, wiping off any excess with a cloth as you go to avoid a build-up of wax.

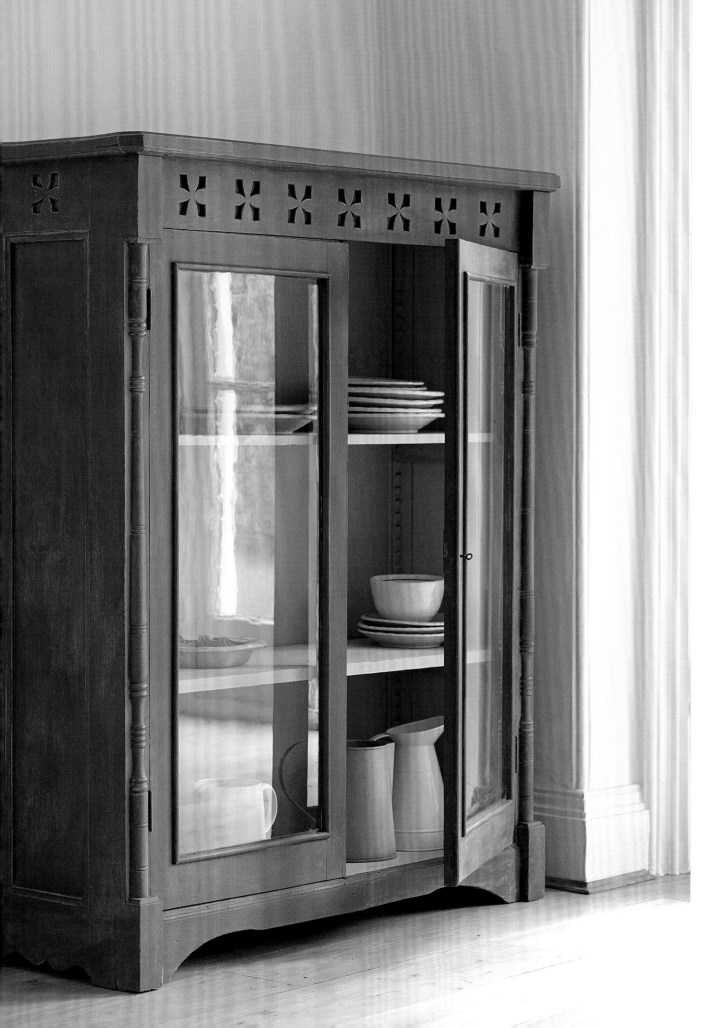

bookcase with glass doors

I had been looking for the opportunity to use the combination of Barcelona Orange and Olive for some time and this bookcase seemed like the ideal piece to try it out on. I painted the interior with Old Ochre to keep it light and neutral, so it would work with the strong orange and green shades of the exterior. I decided to use the water and wax method because I wanted to do something very soft and delicate that would show off the color combination.

you will need

- Chalk Paint in Old Ochre, Barcelona Orange, and Olive
- 2in (5cm) paintbrushes for applying paint
- Tin of clear wax
- Water
- 1in (2.5cm) paintbrush for applying wax and water
- Cloth for polishing

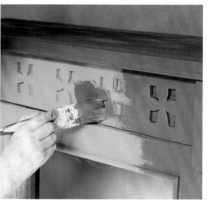

1 Start by applying a coat of Old Ochre inside and out. Once dry paint the outside in Barcelona Orange, working the brush in different directions to make the surface uneven. Some of the raised marks will show through when you start distressing the piece.

2 When the first coat is dry, paint a coat of Olive all over the exterior and leave to dry.

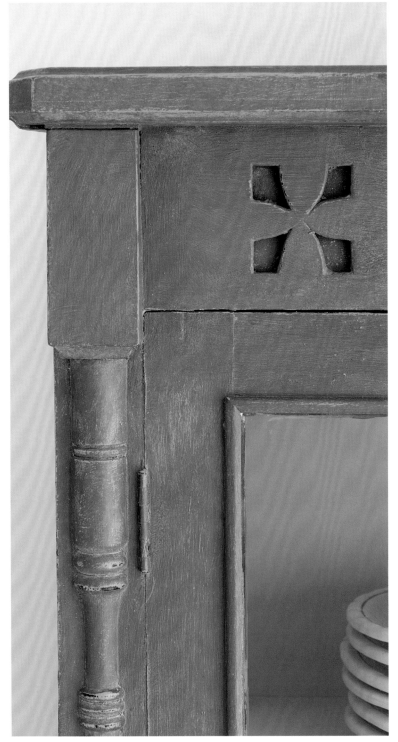

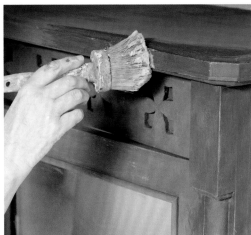

3 Take a brush dampened with water, put a dab of wax on it, then wipe it over the Olive paint, pressing harder in areas where you want to remove the green color, such as the corners and edges. The water in the brush will very gently take off the top layer of paint, while the wax acts to protect it.

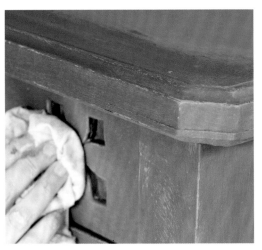

4 Leave the bookcase overnight, then polish the paint and wax with a cloth to give the finished piece a really lovely mellow sheen.

tip Choosing the right color combination is the most enjoyable but also the most difficult part of painting furniture. There are no hard and fast rules to follow, such as painting dark on light or cool on hot, but those principles can be a starting point. Looking for something in the room that catches the eye or will complement the finished piece, such as curtain fabrics, might also help you to make a selection.

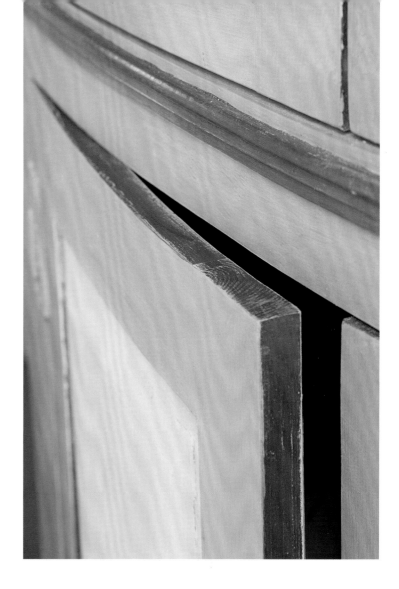

Venetian-inspired cupboard

This piece is fairly simple but it does have nicely shaped door panels and there is a gentle curve along the front that gives it some elegance. The colors I have used are Old White, Duck Egg Blue, and Primer Red, but instead of painting them flat I have made the blue lighter in some places. To do this add a little Old White by dipping the end of the brush into the paint and then merging the two colors on the piece of furniture.

you will need

- Chalk Paint in Duck Egg Blue, Old White, and Primer Red
- 2in (5cm) paintbrush for applying paint
- Small soft bristle artists' brush for panel edges
- Medium- and fine-grade sandpaper
- Tin of clear wax
- 1in (2.5cm) paintbrush for applying wax
- Tin of dark wax
- Cloth for polishing

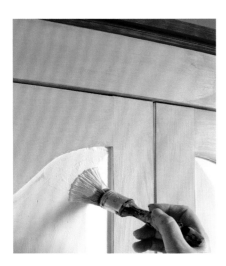

1 I painted the main part of the cupboard in Duck Egg Blue. Vary the color by dipping a corner of the brush into the Old White and applying it onto the blue, causing the colors to almost merge. The finish will be uneven all over—very light in some places and darker in others. Apply a coat of Old White to the panels, having taken the lid off the night before to allow the paint to thicken and give it texture (see tip box on page 81).

2 I painted the inside of the cupboard, the cornice, and the edges of the inner panel in Primer Red to help define the shape of the cupboard, as on the original piece I was influenced by. To keep the finish neat on the panels you need to use a small brush. Don't worry too much if paint goes over the edges as this helps to make it appear more handpainted, and any excess can be rubbed away with sandpaper.

3 Apply a coat of clear wax all over the painted areas with a brush. Add some dark wax to a few places to deepen the shade in certain parts of the cupboard. Next, make a mix of one part clear wax and one part Old White to form a colored wax. Put a layer of this mixture on the surface with a brush to soften the piece and lighten areas that look too dirty. Rub the surface lightly with sandpaper and finish by adding a final coat of clear wax.

tip The hinges on the cupboard were black and particularly unattractive. Like all my pieces I usually just paint over all handles and hinges and then wax them. Some of the paint does come off but this is better than seeing bare metalwork glaring at you.

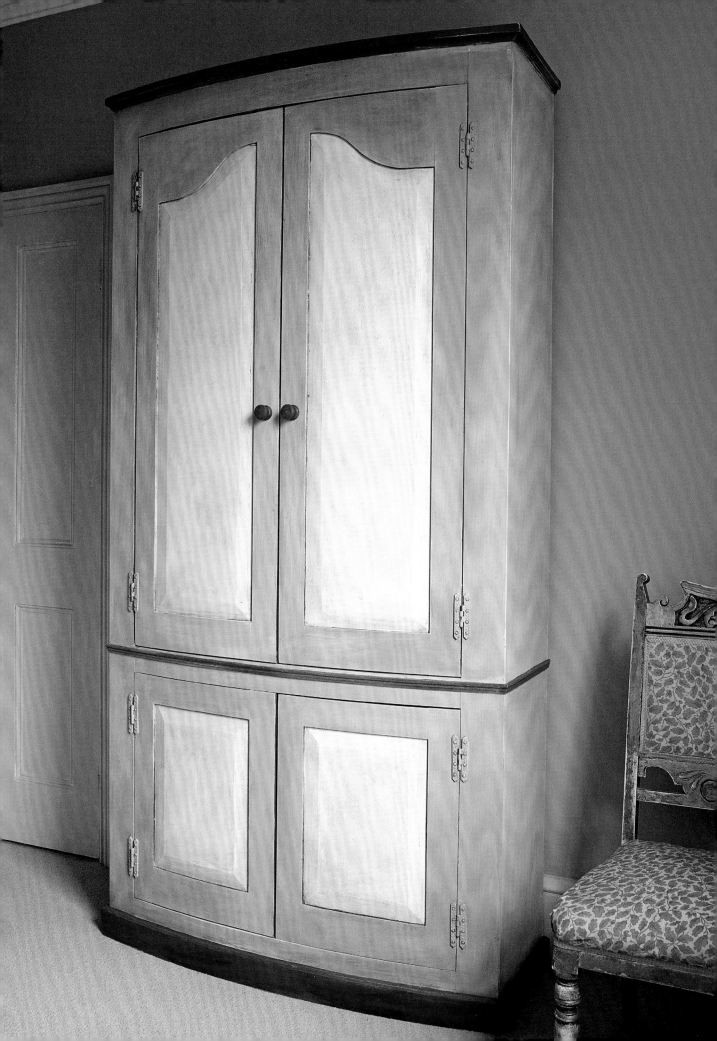

wax-resist bed

I found this wonderful bed, with its low footboard and elegantly understated headboard, in France. Its size and shape were perfect for the room I had earmarked for it, and the low footboard meant that it didn't get in the way of the light coming in through the single window.

Even though the bed was rather elegant, I wanted to give it a soft, lightly textured country look that wouldn't be at odds with the very rustic wall behind the headboard, which was painted in Old White. I decided to try an old technique using a wax candle to make a resist for the paint, where the textured effect would be obvious but not overly distressed.

you will need

- Chalk Paint in Aubusson Blue, Greek Blue, Duck Egg Blue, and Old White
- Paint roller tray
- No. 8 or 12 brush
- Wax candle
- Clean, dry, lint-free cloths
- Coarse sandpaper
- Clear wax
- Brush, for applying the wax

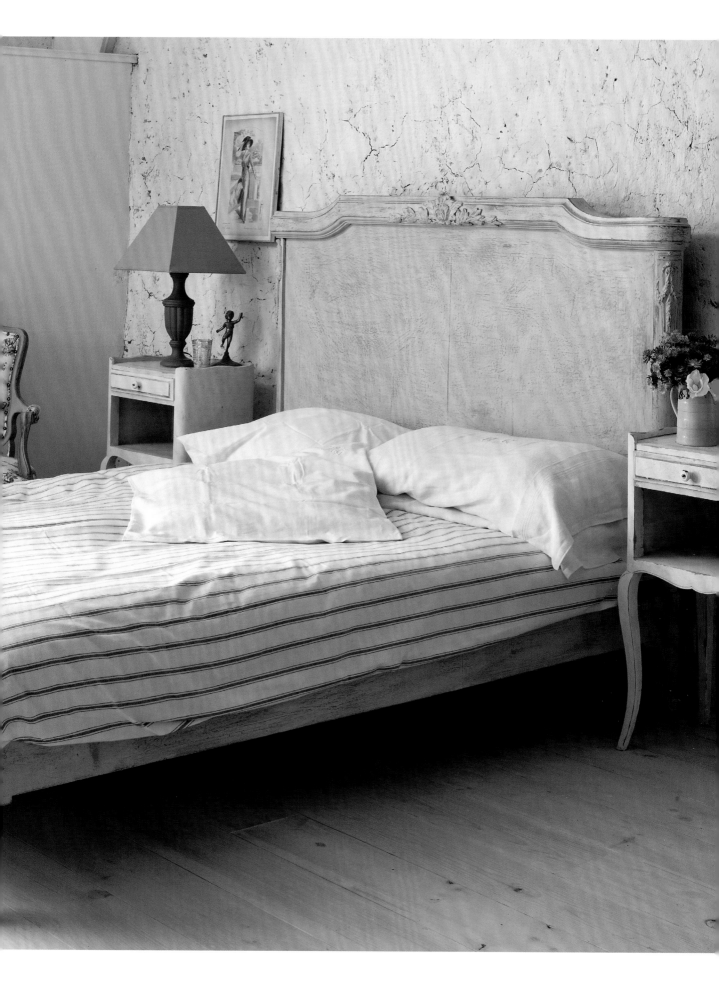

The color theme in the room had already evolved into mainly blues and whites. To develop this further, I chose three tones of blue for the bed—Aubusson Blue, Greek Blue, and Duck Egg Blue— painting on the darkest first and finishing with the palest.

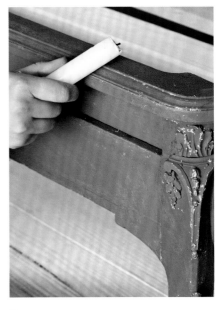

1 Mix the Aubusson Blue and Greek Blue paint together in equal measures in the paint roller tray. Apply the paint all over the bed with the brush, then let it dry.

2 Rub the wax candle hard over the wood, using its length as well as its pointy end. Wherever there is wax, the next layer of paint will not stick. Wipe away any loose wax with a clean, dry cloth.

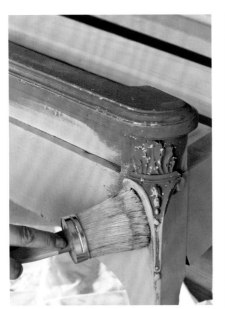

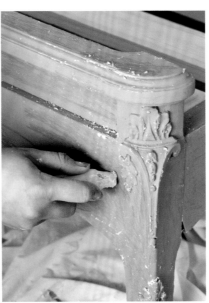

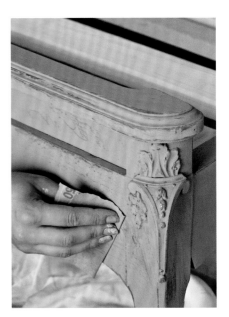

3 Paint over the Aubusson Blue and Greek Blue mix with a coat of Duck Egg Blue. Let it dry.

4 Rub the wax candle over the wood here and there, where you want a more textured effect. Remove any loose wax with a cloth.

5 Rub the wood lightly all over with coarse sandpaper to reveal patches of darker blue underneath. The sandpaper will also give a slightly scratchy look.

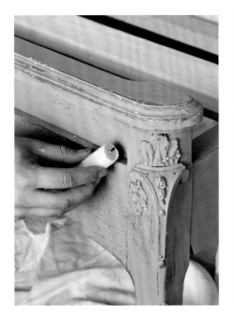

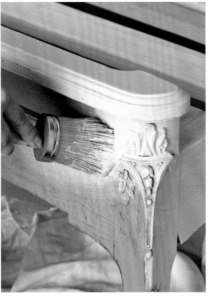

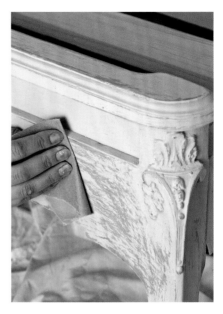

6 Rub the candle again all over the wood, including over the areas where the darker blue color is coming through.

7 Mix one part of Duck Egg Blue with four parts of Old White in a clean roller tray, then brush on a coat of the paint all over the wood. Let it dry.

8 Rub the wood all over with coarse sandpaper, using strong and light pressure, to reveal the two different paint colors underneath.

9 Apply a coat of clear wax with either the brush or a clean, dry cloth. Wipe away any excess wax with a cloth.

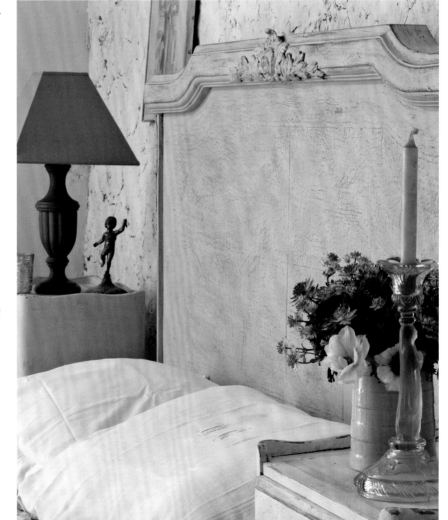

The wax-resist technique works extremely well on the elegant headboard and complements the rustic wall behind, which has been painted in Old White.

Swedish rustic table

There are so many different ways in which paint can age and distress furniture. On really old pieces that have been painted many times and perhaps been cleaned a lot in the past, the paint can become very textured and worn.

I have had this old table for some years. It was covered in a turquoise-blue gloss when I bought it, and I initially painted it Sienna Yellow, a color no longer available. I then thought it would suit this room so much better if it were Scandinavian Pink but that didn't look great. Immediately, I tried Primer Red. Perfect. The tabletop has been painted with a colorwash.

you will need

- Chalk Paint in Primer Red
- Clear wax
- Large oval brush, to apply the wax
- Medium oval brush, to apply the paint
- Plenty of clean, dry, lint-free cloths
- Coarse sandpaper

tip Changing your mind about paint colors is so easy with my paint, Chalk Paint. Simply cover the paint you no longer want with the one you do!

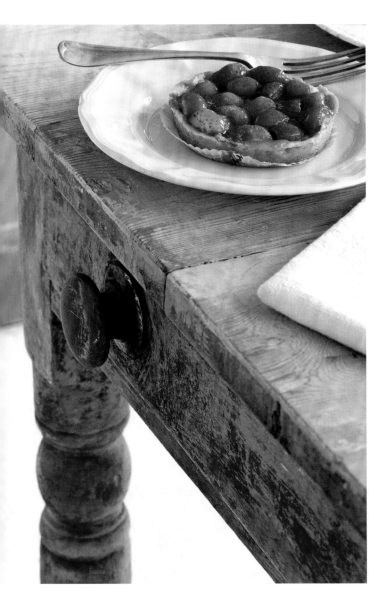

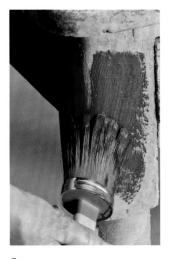

1 While the Scandinavian Pink paint is still a little damp in places (by that I mean, not completely dry all over), apply a generous amount of clear wax with the large oval brush. Don't rub the wax into the surface of the paint. Where the paint is a little damp, the Scandinavian Pink will come off, revealing the yellow underneath.

2 If the weather is cool, leave the wax to dry out a little but if it is warm, follow this step right away. You need to be painting on soft "wet" wax. Apply one solid coat of Primer Red over all the waxed wood with the medium oval brush. Leave for an hour or so, depending on the temperature —I left it for an hour in cool weather.

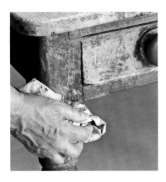

3 Wipe off the Primer Red with clean, dry cloths—you will need plenty of them, as this is a pretty messy business. Some paint will stay and some will wipe off easily.

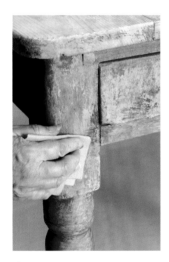

4 Rub all over the surface with coarse sandpaper. Vary the pressure you apply, rubbing hard in some places to reveal the colors underneath, including the original turquoise-blue. Brush all over with clear wax, removing any excess with a clean, dry cloth.

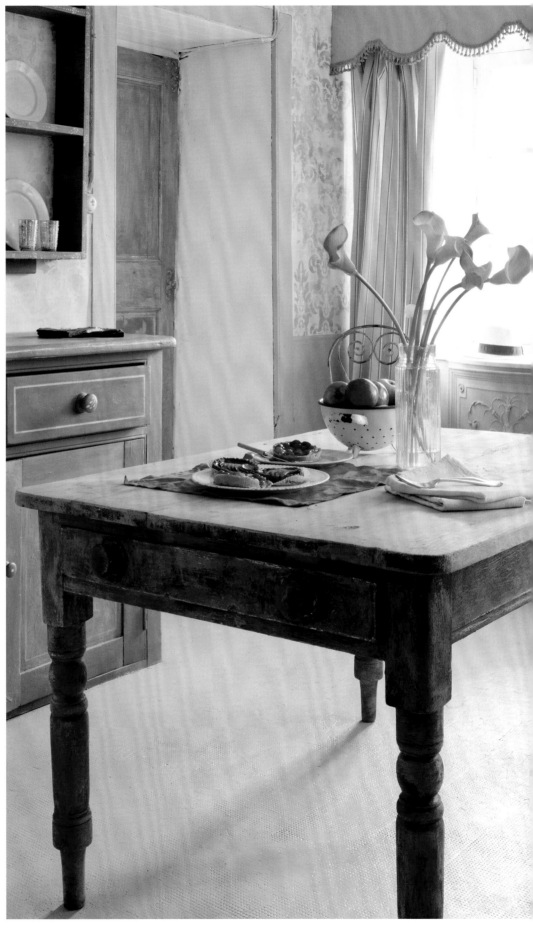

painted teak table

The table in our kitchen is used for many things, from preparing and eating food to working on the computer. It was given to us by a friend, who had acquired it many years ago from a school that was clearing out its old chemistry labs. Being exactly the same length as the old pew that runs along the wall, it was the perfect addition, except for its color, which was rather too dark and formal.

I decided that covering the table with a wash would be a good idea, lightening it but also retaining some of its wonderful patina. This proved a lot more difficult than I had thought, though. I struggled to get the paint to cover and it was far too easy to wipe it off. My husband took a look and said cheerily, "Ah, you're painting the teak table." Then the penny dropped as to why the painting was so hard.

Teak is an extremely oily wood, perfect for boat decks, outdoor furniture, and chemistry tables, where the wood will not absorb chemicals and cross-pollute. It is so oily that, despite the age of the table and the fact that I had never applied any wax or oil to it, the wood was repelling the paint. Armed with this knowledge, I persevered with my painting and won!

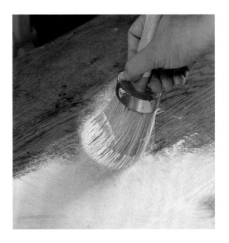

1 Add a little water to the Old White paint, if necessary, to allow it to glide on easily. Working in areas of an arm's length, paint on the first coat, pushing the paint into the wood, even when the paint becomes quite dry.

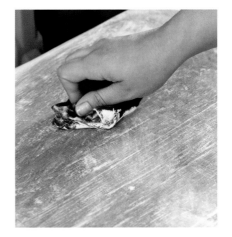

2 Once an area is completed, take a clean, dry cloth and wipe off the paint, rubbing it into the wood as you go, to help the teak absorb the paint. I found the absorption rate was a little uneven, with more paint being absorbed in some areas than others. Repeat steps 1 and 2 for the entire table. Let the paint dry for a few hours.

you will need

- Chalk Paint in Old White
- Medium oval brush
- Clean, dry, lint-free cloths, to rub in the paint and to apply the wax
- Clear wax

tip The natural oiliness of teak may vary in a single piece of furniture, making it impossible to control the opacity of the paint, no matter how much you apply.

The finish was a beautiful, uneven wash of white. In places translucent, in others opaque, the paint highlights the table's many nicks, dents, and scratches, giving it extra character and texture.

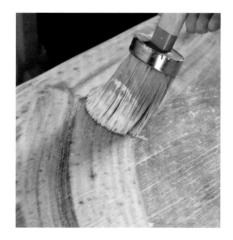

3 To make the surface more even, apply a second coat of paint, diluted with a little more water. Wipe a dry cloth over the surface, as you did in step 2. You will see how the oil in the wood still repels the paint but don't be put off. Leave the paint to dry overnight.

4 Once the paint is completely dry, apply clear wax with a clean, dry cloth. Use circular movements but be sensitive about the amount of pressure you apply—if you are too firm, you will remove all the paint. In places, the paint will appear translucent or disappear altogether; in others, it will stay opaque.

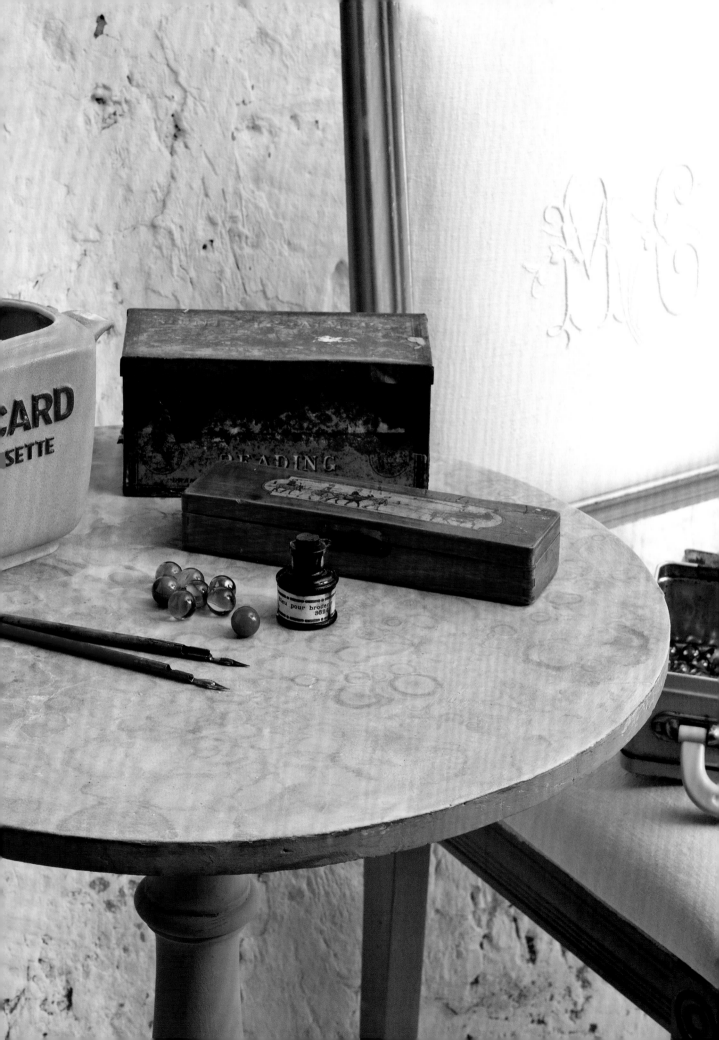

faux marble tabletop

Traditional classic Swedish interiors, which many people love, often include decorative paintwork inspired by the lines and colors of marble. However, pieces of furniture treated in this way were very often painted in a quite fanciful and decorative style rather than trying to imitate marble exactly.

I've chosen to show my interpretation of this technique, which has to be done on a flat surface, on a little, round pedestal table. You need a dark paint for the base color and a light one for the top coat so there is enough contrast to show the ring marks made by the denatured alcohol (methylated spirits) rejecting the paint mix.

you will need

- Chalk Paint in a dark color, such as Aubusson Blue or Olive
- Chalk Paint in a light paint color, such as Old White
- Medium oval brush
- Annie Sloan Image Medium decoupage glue and varnish

- Paint roller tray
- Sponge paint roller
- Denatured alcohol (methylated spirits)
- Small, flat bristle brush, to spatter the denatured alcohol

- Small, flat bristle brush, to spatter the paint
- Clear wax
- Medium flat brush, to apply the wax
- Clean, dry, lint-free cloths

The chair has been painted in French Linen and upholstered with one of the old monogrammed linen sheets given to me by my neighbor (see page 218).

1 Paint the table with a dark color—I used Aubusson Blue here. Mix Old White paint and decoupage varnish together in roughly equal measures in a paint roller tray. With a clean, dry brush, paint this mix over the Aubusson Blue, spreading it so it appears a little translucent and you can see the base color through it.

2 Using a dry sponge paint roller, roll over the surface, so the paint and varnish mix is even and like a translucent film on top of the dark base color.

3 While the surface is still wet, take a small, flat bristle brush and spatter the surface with denatured alcohol (methylated spirits). This quickly forms ring spots but they are very faint at this stage.

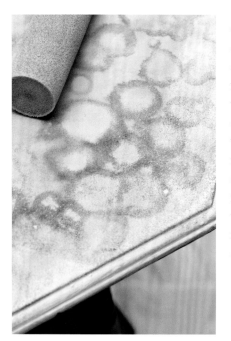

4 Use a fresh, dry sponge roller (or clean and dry off the one already used) and roll it over the tabletop gently but firmly. This will lift off the paint where the alcohol has formed rings. Roll the sponge over several times to remove the maximum amount of paint and make the effect more striking. Be aware, though, that if you do this too many times, the rings will start to blur together. If there aren't enough spotty marks, then spatter on more denatured alcohol and roll again.

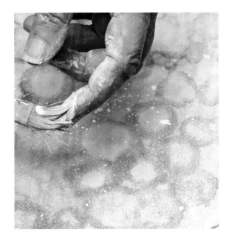

5 Dilute some Old White paint with just enough water so that it remains opaque and can be easily spattered. This will give the marbling effect a little more depth. Avoid spattering the paint all over the surface—leave some areas either free of Old White altogether or less densely covered.

6 Roll a clean, dry sponge roller over the white spots, to flatten them and make them more varied in size and shape. When the paint is completely dry, apply a coat of clear wax with a brush, wiping away any excess with a clean, dry cloth.

This finished marble-effect pedestal table had a base color of Olive, with Old White on top.

tip The paint effect looks best when there are no plain, unmarked areas. Vary the amount of denatured alcohol you drop on the surface so some rings are bigger than others.

ombré coffee table

Ombré means "shaded" in French, and the gradual blending of colors on pieces of furniture seems to be a crossover idea from the world of fashion, where hair or clothes are dipped into a dye to change their color. Furniture painted in this way is sometimes also called ombré or dipped, and refers to pieces where the color changes gradually from one to the other. It's usually the legs of the piece that are treated in this way, since they lend themselves easily to the technique.

The colors should merge seamlessly, so choose colors that work well together when they are mixed. I chose two colors near each other on the color wheel to be sure they would look good when blended. Many people opt for a color with white, so that the color made in between is a pastel. Some color combinations are less successful, however. Choosing, say, blue and yellow means you'd have a band of green in between, which would be distracting.

This little table is fairly featureless, but I thought I would draw attention to the legs, which are sweetly pointy. Although the technique looks easy, it was quite difficult to achieve on this particular table because the legs are angled. Rounded legs would have been easier to paint.

You will need

- Chalk Paint in Amsterdam Green, Provence, and Old White
- 2 medium oval bristle brushes
- Clear wax
- Large wax brush
- Clean, dry, lint-free cloths

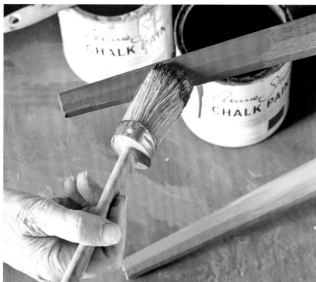

1 Paint the lower half of the table legs with Amsterdam Green using one of the oval bristle brushes.

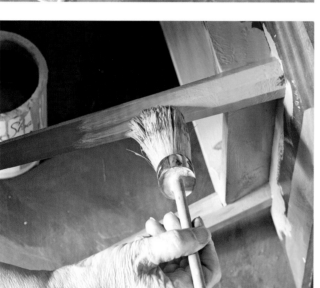

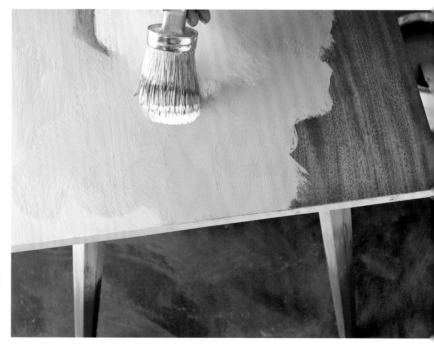

2 Paint the other half of the legs with Provence using the other brush.

3 Blend the two colors where they meet in the middle of the table legs to create a mid-tone. To blend, stroke very gently and, if anything dries, alternate the brushes with the two colors.

4 Paint the top of the table in Provence and wait until the paint is almost dry before you blend. I added some Old White to the top of the table to lighten it and create a cloudy effect. Once the paint is dry, apply clear wax to the table with the wax brush. Remove excess wax with a clean cloth.

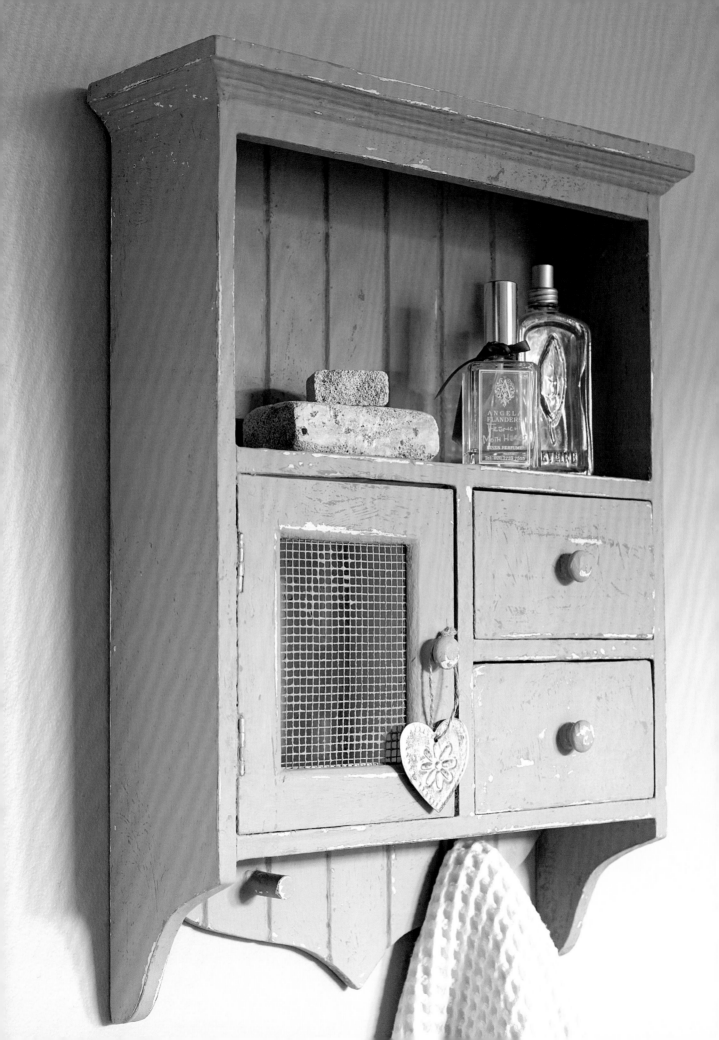

bathroom cabinet

While I liked the shape of this piece, I felt it didn't look right or have any impact in white. To rectify this problem I decided to paint it but still incorporate some of the original white. I have chosen a darker gray and a lighter blue color to make three different tones.

you will need

- Chalk Paint in Château Grey and Duck Egg Blue
- 2in (5cm) paintbrushes for applying paint
- Tin of clear wax
- Cloth for applying wax and polishing
- Medium- or fine-grade sandpaper

1 Paint all over the cabinet with a coat of Château Grey, working the brush in all directions and applying the paint quite thickly to give texture. Don't worry if there are any small lumps of paint, these add to the finished look.

2 When the first layer is dry, paint a second coat using Duck Egg Blue, which is medium in tone. Apply this fairly smoothly and allow to dry.

tip Use the sandpaper by taking a sheet, folding it into quarters, and tearing it into four pieces. Fold a quarter in half and use that to work all over the piece. When it becomes full with paint and wax, turn it over and use the other side.

When sanding the furniture take care not to rub away areas of a similar size because this can make the piece look rather spotty. It should be evenly uneven—in other words, there should be balance.

3 As this piece is quite small I applied a layer of wax with a cloth, but you can use a brush if you prefer. Wipe the wax all over the surface, then take off any excess so it doesn't feel "wet" with wax.

4 You can start sanding immediately using medium- or fine-grade sandpaper. Start sanding softly at first, then apply more pressure in places to remove the layers of blue and gray so you can see the white. Sand the whole piece, then rewax and polish.

textured paint cabinet

For this project I've chosen Giverny, a bright Mediterranean color positioned toward the green end of the blue spectrum, which will turn a beautiful, rich, sophisticated blue with the application of the dark, tan-colored wax. To achieve a finish in this rich color you need to start with a bright paint, but bear in mind the effect that the tan wax will have on the finished piece.

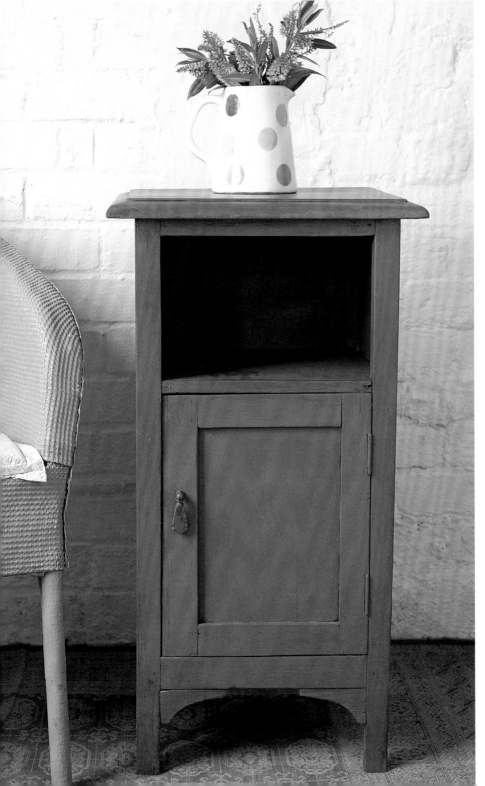

you will need

• Chalk Paint in Giverny

• 2in (5cm) paintbrush for applying paint

• Tin of dark wax

• 1in (2.5cm) paintbrush for applying wax

• Cloth for removing excess wax

• Tin of clear wax (optional)

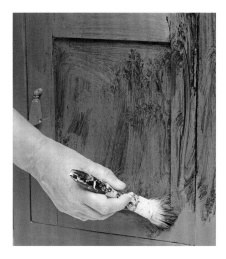

1 Paint all over the cabinet unevenly, making brush marks in all directions. Allow the paint to dry thoroughly. This may take slightly longer than usual as the paint will be thicker in some places.

2 Apply a second coat, again thickly and unevenly. It is a good idea to return to an area of paint that has begun to dry a little and make more apparent brush marks. Try stabbing the brush in just a few areas to make a different texture.

3 When the paint is thoroughly dry apply the dark wax to the whole of the chest one side at a time, making certain the brush goes in several directions to get into the texture of the paint.

tip To achieve a good texture with your paint, allow it to thicken slightly by leaving it with the lid off for a while. The paint will not form a skin but will thicken and become less fluid. If it becomes too thick, you can add a little water and stir. Using brush strokes in many different directions and going back over an area that has begun to dry will create additional texture. Don't worry about trying to keep the finish consistent throughout.

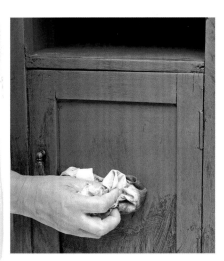

4 Wipe off the wax with a clean cloth quite firmly. The idea is that the dark wax stays in the textured surface of the paint. If you find that too much of the dark wax is being removed then leave it on to dry out a little more. Conversely, if too much dark wax is staying on the cabinet then use some clear wax to clean it off. If you leave the wax until it dries then it becomes difficult to remove.

washed pine bookcase

Some people hate the idea of losing the wood grain when you paint, so I have
used a wash of color on this bookcase. To make the piece more interesting
I have given it a look inspired by a side table I saw in a French antiques shop,
which had inlaid wood to create the striped drawer front. To replicate the texture
of inlaid wood I have softened the edges of the masking tape by tearing them.

you will need
- Chalk Paint in Country Grey
- Paint tray
- 2in (5cm) paintbrush
- Cloth for removing excess paint
- Masking tape
- Tin of dark wax
- Tin of clear wax
- 1in (2.5cm) paintbrush for applying wax
- Cloths for removing excess wax and polishing

tip Use only neutral colors to dull down pine as any additional color may highlight the orange. I have used Country Grey for my wash as the putty tone dulls down the color of the wood.

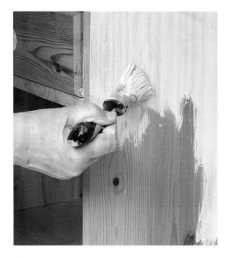

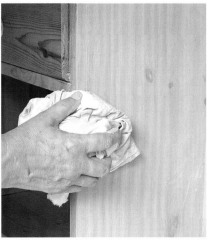

1 Pour out some Country Grey paint into a container and set aside to dry slightly, ready for use in step 5. See tip box on page 81 for details of how to thicken the paint. With the remaining Country Grey, paint the bookcase one side at a time. While the paint is still wet move on to the next step.

2 Wipe the wet paint with a cloth so the paint is even but dispersed and the wood grain is visible. Remember that the wax can cause the paint to become a little more transparent, so leave the paint slightly more opaque at this stage than you want the finished coat to be.

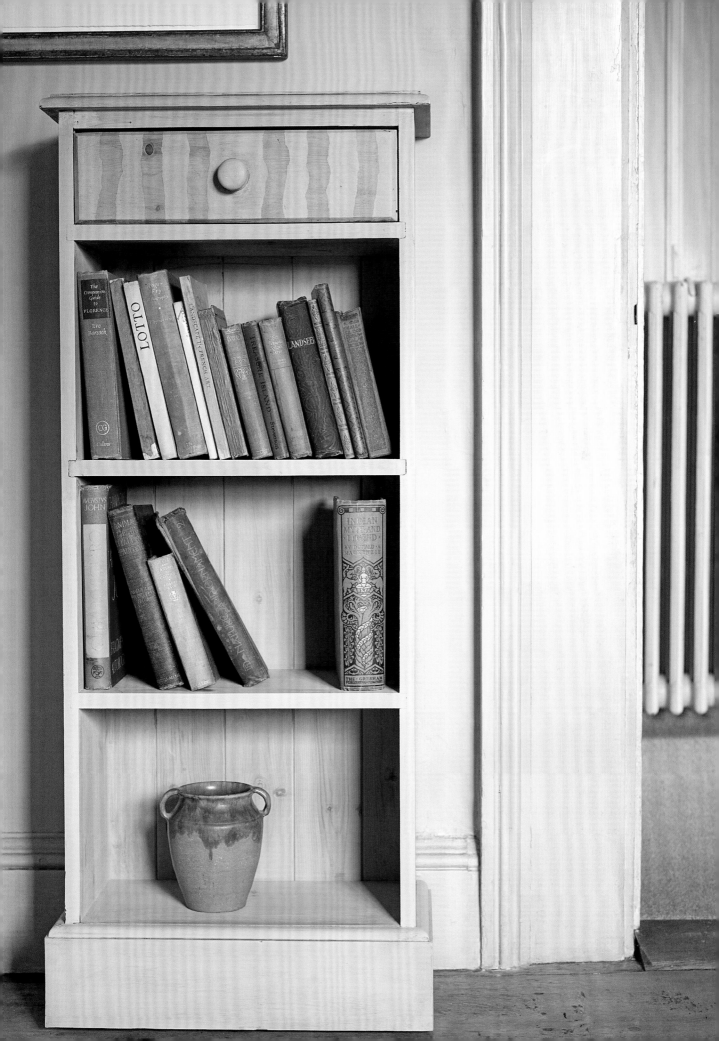

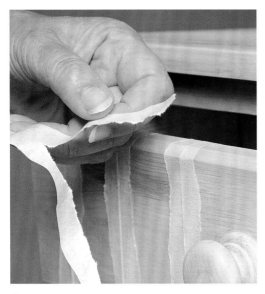

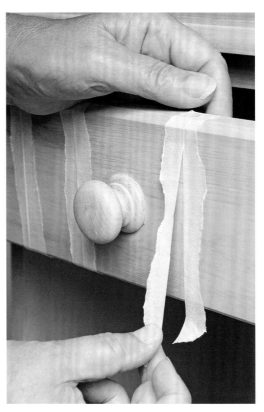

3 For the drawer front, take small pieces of masking tape and tear them carefully down the center so that each strip will have a torn edge and a straight edge.

4 Stick two pieces of masking tape onto the drawer front, butting straight edge to straight edge, to create a stripe with uneven sides running vertically down the drawer. Leave a gap and repeat, to give a series of uneven and rough edge stripes.

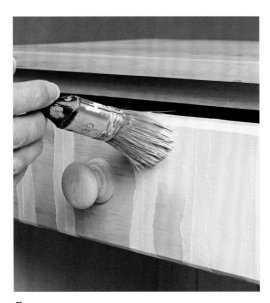

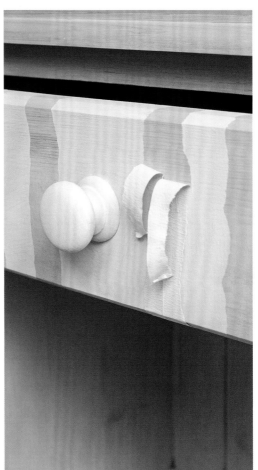

5 Paint the drawer front with the Country Grey, but this time using the paint you set aside to dry in step 1. Make sure there is good opaque coverage across the whole front.

6 Once the paint has dried, remove the masking tape carefully to leave a series of stripes on the drawer.

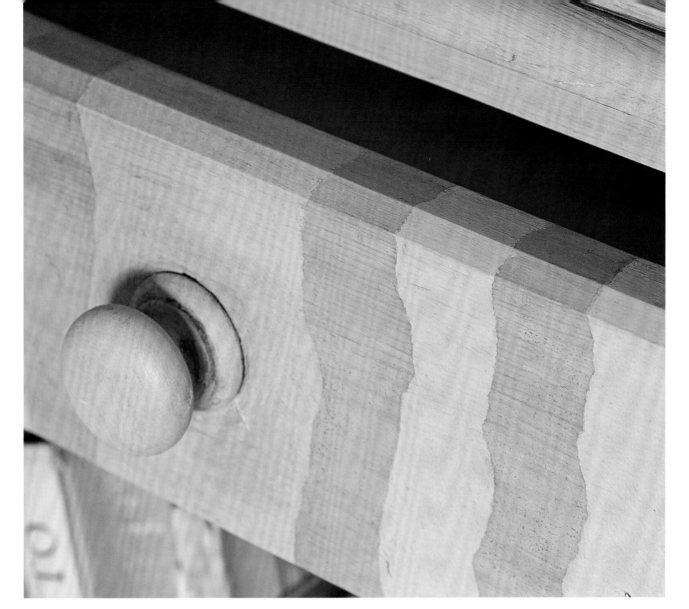

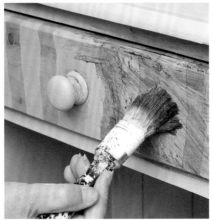

7 Prepare a mixture of one part clear and one part dark wax.

8 Apply a thin layer of wax with a brush all over the piece to give it a warm, knocked-back look. Wipe off the excess with a cloth.

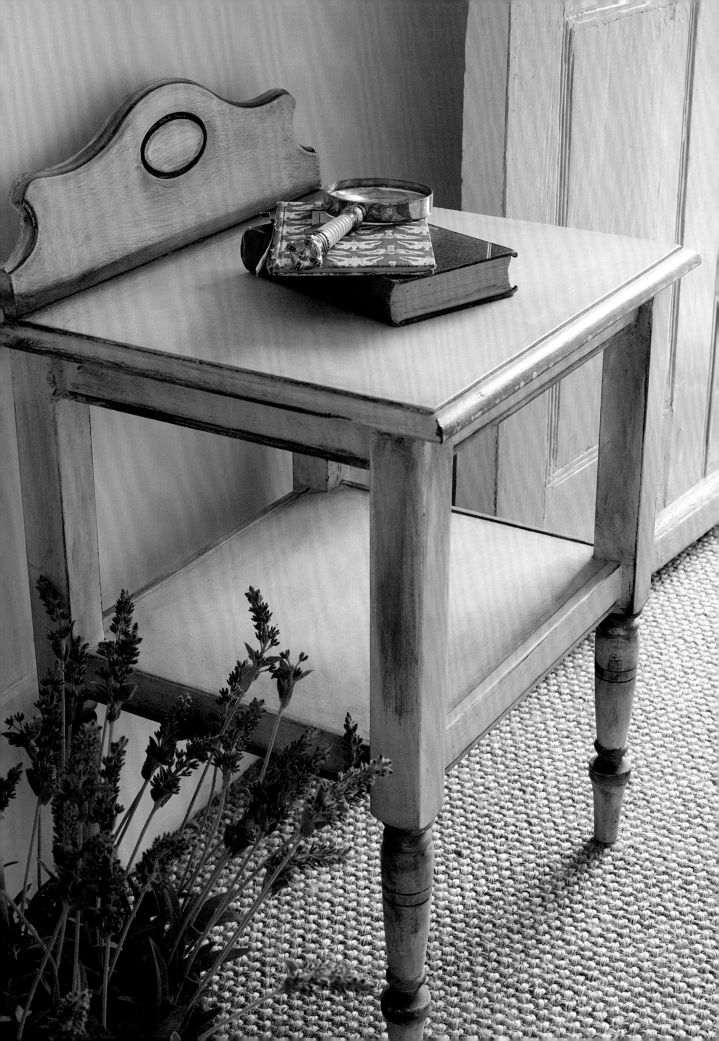

Swedish-colored side table

The dresser that this project is based on was finished just in white and deep blue, and the decoration consisted of very loosely painted moldings with some handpainted figures. I thought I would recreate this from memory but without the figures. The particular aspect of this piece of furniture that I liked was the loose style of brushstrokes and the specific Swedish blue that had been used with the Old White.

you will need

• Chalk Paint in Old White and Aubusson Blue

• 1in (2.5cm) paintbrush for applying paint

• Tin of clear wax

• Tin of dark wax

• 1in (2.5cm) paintbrush for applying wax

• Cloth for removing excess wax

tip To achieve the Swedish look the right colors need to be used. Aubusson Blue is a particularly Swedish-style shade—it is based on Prussian Blue, a color that was discovered in the 18th century and became available to all. Other Swedish-style colors include Château Grey, a natural brownish-green, Scandinavian Pink, an earthy natural brown pink, and ochers such as Arles.

1 The trick to painting this piece in a loose way is to add a little blue onto the side of a paintbrush that is already loaded with Old White. Use the brush to coat the moldings with blue, but allow some blue to spread onto the main parts of the furniture where it can be blurred and blended into the white.

2 I painted the whole table, giving the central oval shape emphasis by working the blue into the molding. Allow the blue to make a gentle "blush" in and around the middle of the oval. I applied clear then dark wax to the whole table with a brush, again emphasizing the oval shape by filling the molding with dark wax. Remove any excess wax with a cloth.

rustic seaside chairs

When I came across these chairs they were not particularly elegant with their short backs but I thought I could transform them into some simple seaside-inspired seating. I have chosen two rather obviously marine colors for the distressing that contrast quite a lot with each other. For this reason I have chosen to use the white on only part of the chair so it does not look too busy. I also needed to re-cover the seats and did so with some simple blue ticking used horizontally.

you will need

- Chalk Paint in Old White and Greek Blue
- 2in (5cm) paintbrushes for applying paint
- Tin of clear wax
- 2in (5cm) paintbrush for applying wax
- Cloth for removing excess wax
- Medium-grade sandpaper

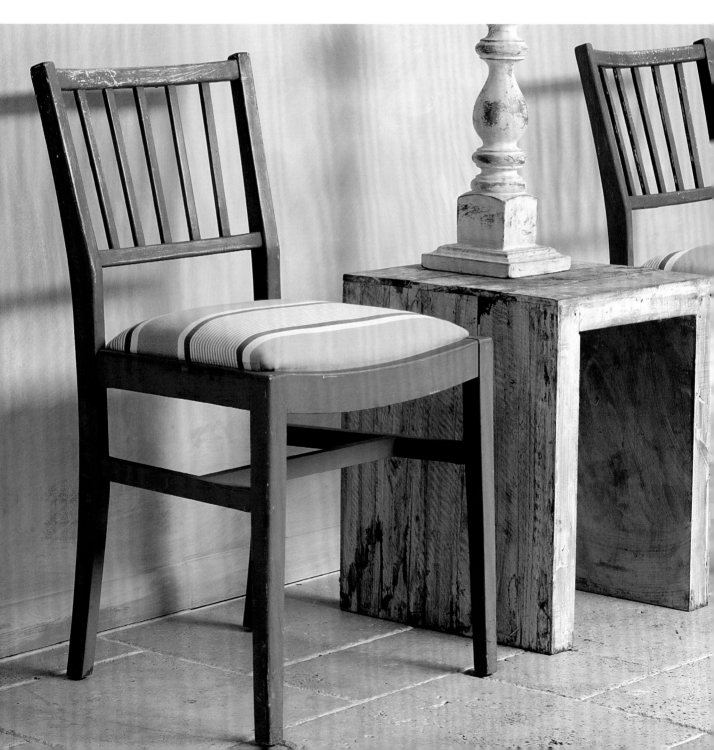

1 Apply Old White paint to the back of the chair using a dabbing motion. This will make the surface uneven once dry and give the piece a different sort of wear, making it less fussy looking. Wait for the paint to dry completely before moving on to the next step. Unfortunately, because the paint is thick, this will take a little longer than normal.

2 Take Greek Blue paint and apply it smoothly all over the chair and thinner than the first coat of white.

3 Wax all over the piece with clear wax, using a big brush to reach all the intricate details of the chair rails.

4 Wipe off the excess wax with a cloth, taking extra care to look for any build ups of wax around the vertical bars, as they can be easy to miss.

5 Rub all over the chair with medium-grade sandpaper to give it a worn look. Rub gently at first so you can gauge how much pressure you need to apply to give a worn look to the paint.

6 On the legs, rub through to the wood. Don't rub through in too many places—just a few edges, the bottom of the legs, and a little along the side. Finish with a final coat of clear wax.

tip When you paint a small piece of furniture with two contrasting colors like this blue and white piece, only do the two colors in one part, like the chair back for this project. Paint the rest in just one color, otherwise it will look too busy.

sanded kitchen chairs

I bought this set of six sturdy chairs with rush seats mainly for use in the kitchen as dining chairs (you can see them with the painted teak table on page 69), but they do get moved around to other parts of the house. The traditional design on the back of the chairs is typical of Brittany, which neighbors my area of Normandy. Although quite modern and abstract, the design manages to have a country look as well.

As in so many very old farmhouses, with their small windows, the kitchen is generally dark. I needed to introduce some color to brighten it up. It is a common misunderstanding that when a room is dark, it should be painted white, but white can just look gray and dull in the shadows. Painting strong pastels, on the other hand, will make a room look lively and bright.

you will need

- Chalk Paint in:
 - Duck Egg Blue
 - Louis Blue
 - Château Grey
 - Old Violet
 - Versailles
 - Provence
- Medium oval brush
- Fine or medium sandpaper
- Clear wax
- Clean, dry, lint-free cloths

tip Rush seats are easily painted. These were covered with slightly watered-down paint in the same color used for the wood, and then waxed.

Before starting on my chairs and the kitchen decoration, I made a color plan. The predominant colors for the whole room are cool: Duck Egg Blue and Louis Blue on the ceiling, with the kitchen cabinets in Duck Egg Blue. These are set against the warm soft plaster-pink of Antoinette on the walls. I continued with the cool color palette for the chairs, adding Château Grey, Old Violet, Versailles, and Provence, so they would work in the kitchen but also in any room in the house.

Each chair has been treated in a different way. On some, the tops have been sanded back; on others, the legs. Sanding back to the wood adds to the charm.

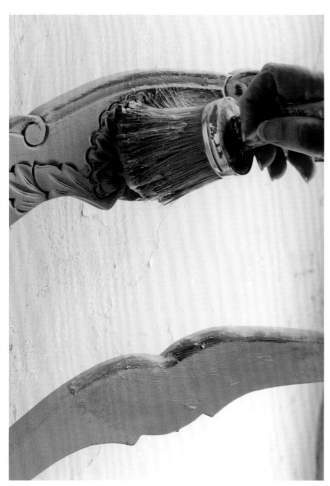

1 Remove the chair seats and paint them separately (see tip on page 90). Using the medium oval brush, paint each chair all over with your chosen color, covering the wood well but not too thickly. Make the brushstrokes go in all directions over any carving, to make certain everything is covered. Allow to dry.

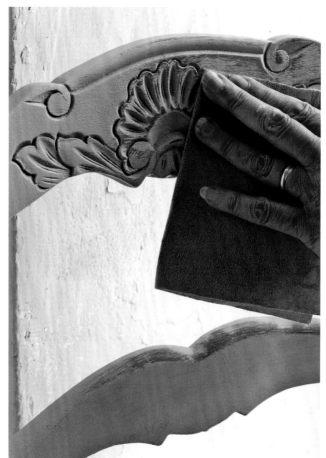

2 Rub the sandpaper all over the chair. As the sanding is done before the waxing, more paint is taken off, so take care not to be too enthusiastic! This method is quite dusty so it is best done outside or where the dust won't matter.

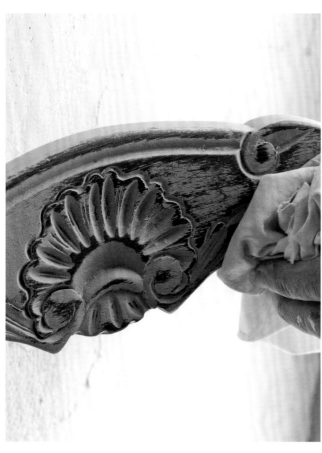

3 Wipe the sanding dust away, then apply clear wax all over with a clean, dry cloth. This will make some of the sanded paintwork more apparent. Repeat all the steps for the remaining chairs.

limed look oak chair

These chairs had been dipped to remove all the varnish, revealing a natural, soft brown-gray wood and allowing easier access to the hollow lines of the grain. To bring out the beautiful markings of the wood the best thing to do is fill the grain with a light color. Old White is the perfect choice because it is white without being too sharp. The finished effect looks like bleached, weather-worn wood and works well with the seaside appearance. To match this theme, I changed the seat covers to a blue and white ticking to give a more jaunty and nautical look.

you will need

- Chalk Paint in Old White
- 2in (5cm) paintbrush for applying paint
- Water
- Sponge
- Cloths for removing excess paint and polishing
- Tin of clear wax
- 1in (2.5cm) paintbrush for applying wax

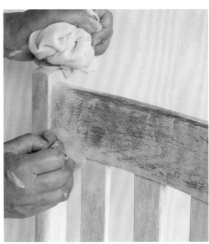

1 Apply a thin coat of Old White with a firm brush to the whole chair, pushing the paint into the hollow grain of the wood. Apply the paint in different directions, even stippling in certain places to make certain the paint goes into all the hollows, before leaving to dry.

2 Take a damp sponge and wipe the paint off the piece. Although the paint is dry, the moisture on the sponge means the paint will be removed easily. Have some water near to hand so you can keep wetting the sponge.

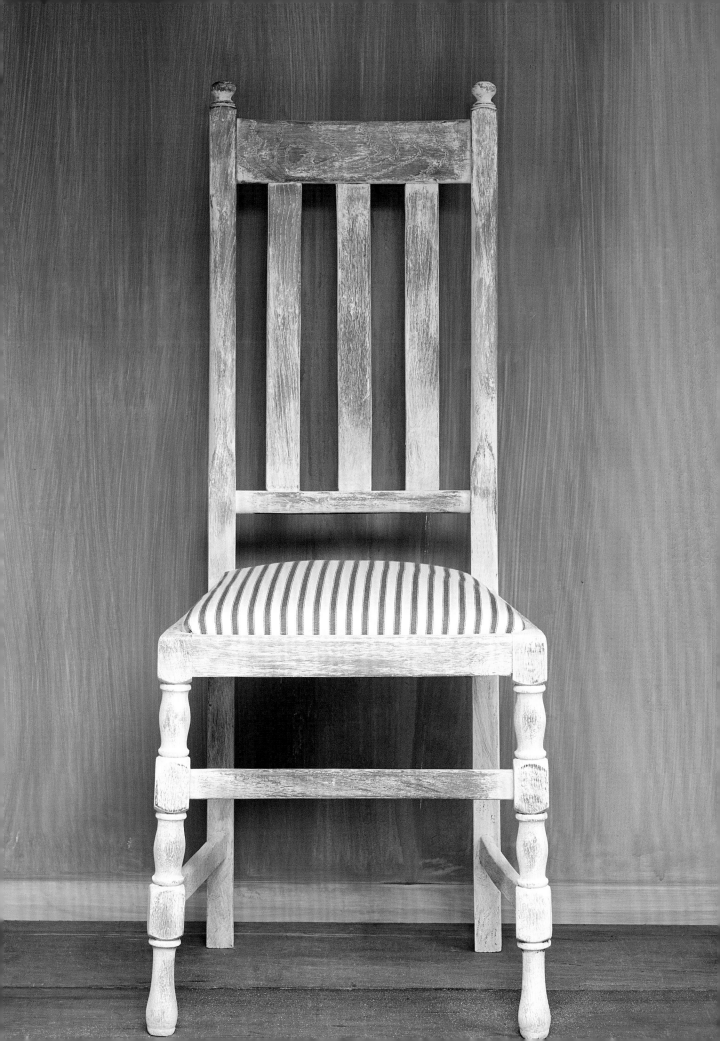

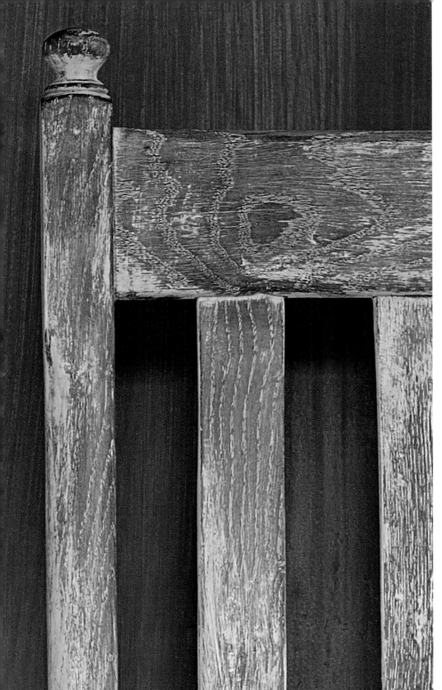

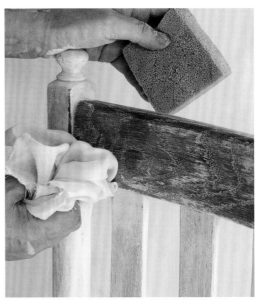

3 In your spare hand hold a piece of dry cloth and use it to take away the now wet paint. This process keeps the paint dry in the hollows but removes it from the main surface of the wood.

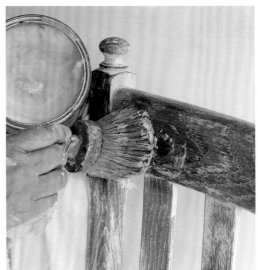

4 Apply a layer of clear wax all over the surface of the chair with a brush. This will bring up the color of the wood, helping to make the contrast between the paint and the wood more apparent. Polish the surface all over with a cloth to give a smooth finish.

tip The sponge needs to be damp but not wet. As it fills up with paint you will need to rinse it out, but be sure to squeeze it almost dry before you start working on the piece again.

painted fabric chair

I found a perfectly shaped Louis XV-style armchair in a French market, but the seat and back were upholstered in an old-fashioned, dirty yellow mock velvet. Rather than having the chair re-covered, as I was in a hurry to use it, I simply got out my paintbrush and set to work. Painted fabric, even if it has a pile, is perfectly comfortable and does not leave you covered in paint, as you might think!

Painting the wood was easy enough but this was the first time I had ever tried to paint fabric that had a pile, so it was all down to trial and error. The fabric needed to be painted in such a way that the pile didn't disappear or get clogged with paint, making it hard and crusty. Adding the right amount of water to the paint was crucial, so that it covered the fabric and was absorbed. At my first attempt, I applied the paint too thickly in places but it was not until it had dried that I was aware of how hard and thick it had made the fabric surface.

I chose Paloma, a gray color made by mixing yellow and purple together with white, to paint both the fabric and the wood. Purple and yellow are complementary colors, and painting Paloma over the yellow mock velvet resulted in a harmonious blend.

you will need

- Chalk Paint in Paloma and Old White
- Large oval brush, for painting the fabric
- Paint roller tray
- Medium oval brush, for painting the wood
- Clear wax, for the wood
- Brush and/or clean, dry, lint-free cloth, to apply the wax
- Fine sandpaper

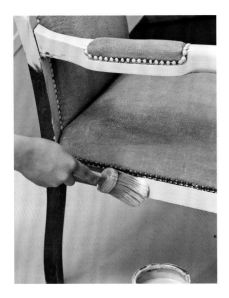 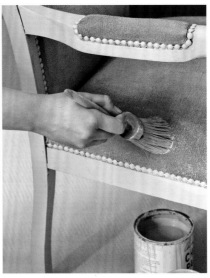

1 Paint the wood with Paloma paint using the oval brush. The paint should be of standard consistency, so that it flows on smoothly and easily. Let the paint dry. (I added the Old White line once the chair was finished as I felt it needed something more.)

2 To cover the fabric, dilute the Paloma paint with water so that it is liquid enough to be absorbed. I mixed mine in a roller tray. The paint needs to soak into the "top" of the chair, rather than all the way through—what you are trying to avoid is thick paint that clogs up the pile and feels hard and crusty on drying. If you think the paint might still be too thick, add some more water and use a scrubbing motion with the paintbrush to spread the paint around. Let the paint dry—it took a few summer days for the fabric on my chair to dry out thoroughly.

3 Use a brush or clean, dry cloth to apply clear wax thinly and evenly over the woodwork. Wipe off any excess with a cloth, and wipe the upholstery studs. Sand them gently to reveal the gold color underneath.

An alternative to using Paloma for this project is to mix Emile, a warm soft eggplant (aubergine) color, and Arles, a rich yellow. This creates a very dark gray, which you can then tweak according to how much of each color you use. Adding a little Old White to the mix gives a color close to Paloma, shown here on its own to the right.

tip To make certain of the consistency of the paint is a question of trial and error. Test a small patch on the back of the chair first before painting the entire thing.

The whole chair is painted in Paloma, with just a little Old White added to the arms and around the back. Only the woodwork was waxed. The paint on the upholstery studs was wiped and softly sanded to reveal a touch of gold. Here and there on the fabric, I painted the Paloma on a little thicker for added interest. The cushion is made from my Normandie toile fabric, in a pale lilac.

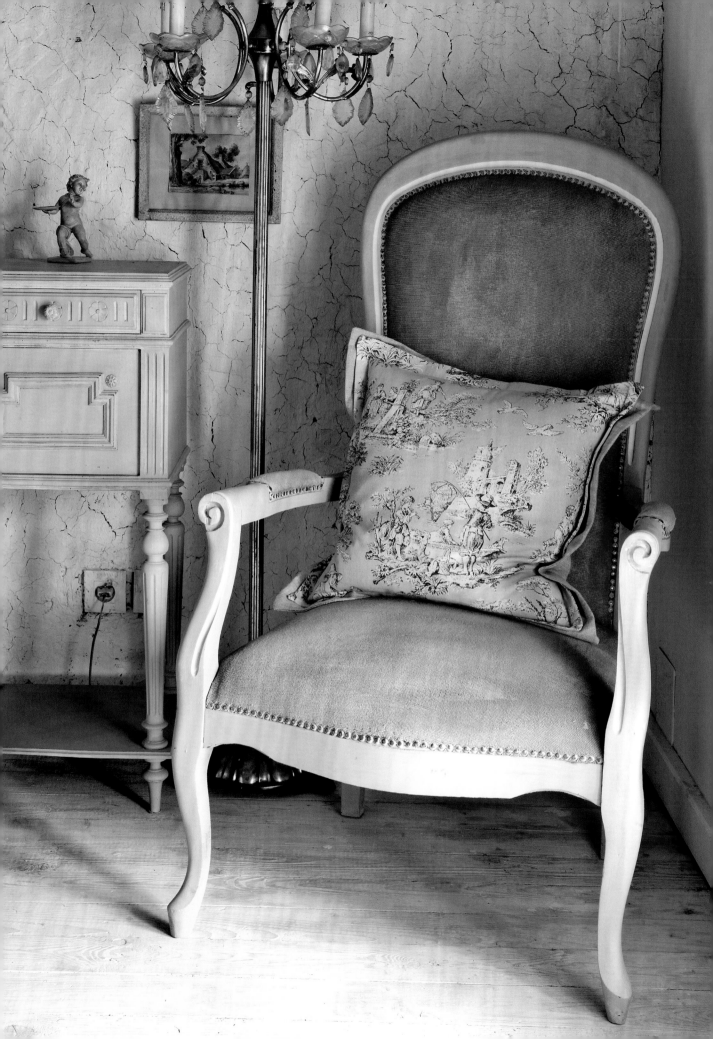

wicker chair

Wicker chairs are readily available and are a great way to decorate a bedroom or bathroom, or to use in the garden. I find they look better with some color to them rather than in their natural state. Painting them in matte chalk paint gives them a soft naturalness in keeping with the materials they are made with.

The most common way to paint these pieces is to spray them, but this is usually a very messy and smelly job. My solution is to do a simple and relaxed paint job on them, aiming not to cover every nook and cranny.

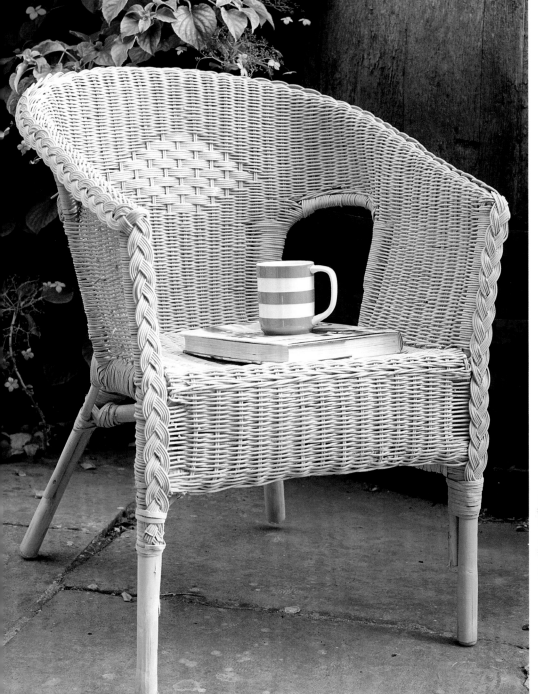

you will need

• Chalk Paint in Duck Egg Blue and Old White

• Water

• Paint tray

• 4in (10cm) paintbrush for applying paint

• 1in (2.5cm) paintbrush for painting the detail

tip Wicker furniture just means a piece that is woven from plant material—cane, bamboo, rattan, and willow—or from twisted paper or synthetic material.

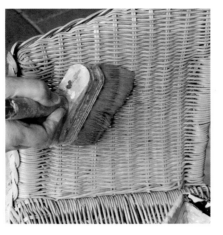

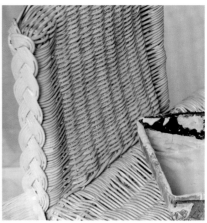

1 Mix the Duck Egg Blue in a tray with about one third water so it is really workable and fairly sloppy.

2 Apply a coat of paint all over the chair with a brush. Use just the tip of the brush when wiping over the top of the wicker to bring out the weave rather than trying to cover the whole thing.

3 Vary the density of the application by applying more paint on areas where there is a different weave, such as along the edges.

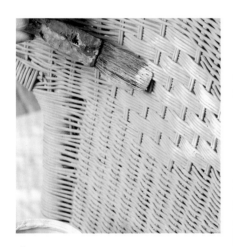

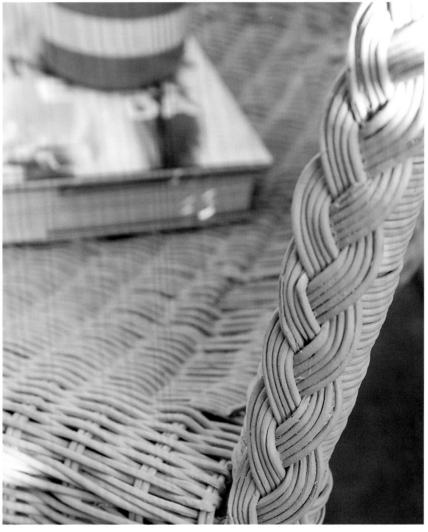

4 This particular chair has a diamond-shaped lozenge on the back, which I have painted in Old White with a smaller brush. There is no need to varnish or wax the finished result because a matte quality is what is wanted.

warehouse leather chair

This warehouse-style chair with leather upholstery needed a good clean before it was painted. Both the leather and metal were painted, transforming the chair. Most leathers and, indeed, some vinyl coverings are fine for painting, but a few have a finish that stops paint adhering, so test a small patch before you paint a similar chair. Also bear in mind that squishy leather is more prone to folding and cracking than stretched leather. Any geometric design, such as arrows, circles, or lines, would be in keeping with the style. Use bright colors or very neutral, practical, machinery-like colors such as grays and blacks.

you will need

• Chalk Paint in Emperor's Silk, English Yellow, and Graphite

• Large flat brush

• Masking tape

• Small flat brush

• Clear wax

• Large wax brush

• Clean, dry, lint-free cloths (optional)

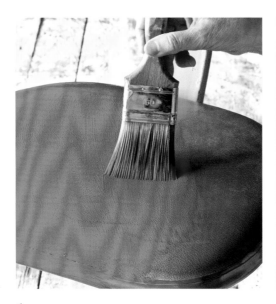

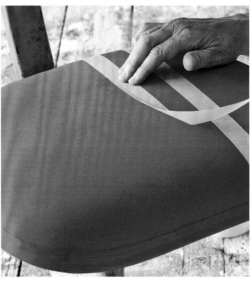

1 Use the large flat brush to paint the whole chair seat in Emperor's Silk, feathering out the paint as you work to achieve an even surface. (To feather out means to hold the brush at right angles to the work, lightly and speedily sweeping across the surface without over brushing.) Paint the back of the chair in English Yellow. Let the chair dry.

2 Using masking tape, mark out the stripe, bearing in mind that you will be painting the gap between the two pieces of tape. Make sure you stick the tape on straight.

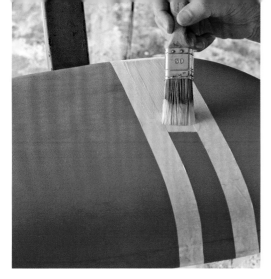

3 Paint the stripe in English Yellow with the small flat brush. You may need to apply two layers, or touch up where the coverage isn't completely even.

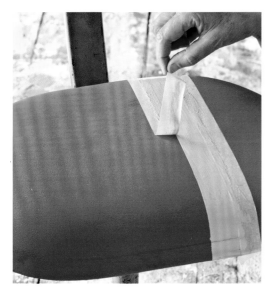

4 Carefully remove the tape as soon as the paint is dry or even before it's completely dry. If you leave the tape on for too long, you run the risk of removing the red paint underneath. When the paint is thoroughly dry, apply clear wax with the wax brush. For a high shine on the chair, buff the following day with a clean, dry, lint-free cloth. (I painted the metal parts of the chair in Graphite using the same brush.)

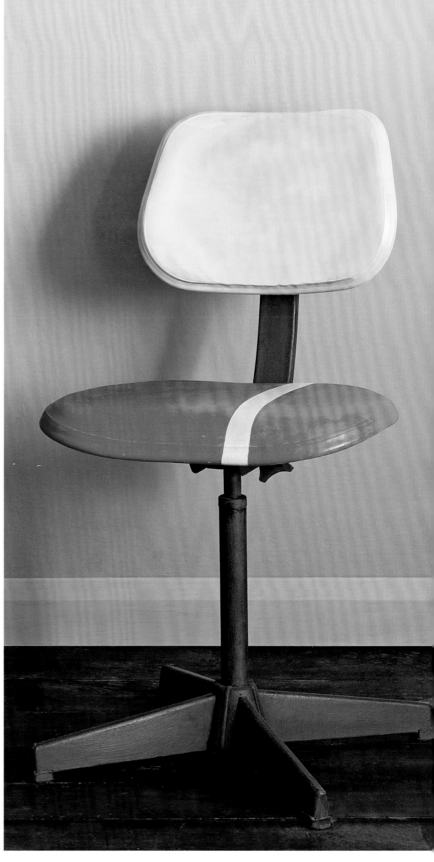

tip When using Emperor's Silk or one of the other reds in the Annie Sloan paint range, it's sometimes a good idea to use two coats of wax to seal the color thoroughly.

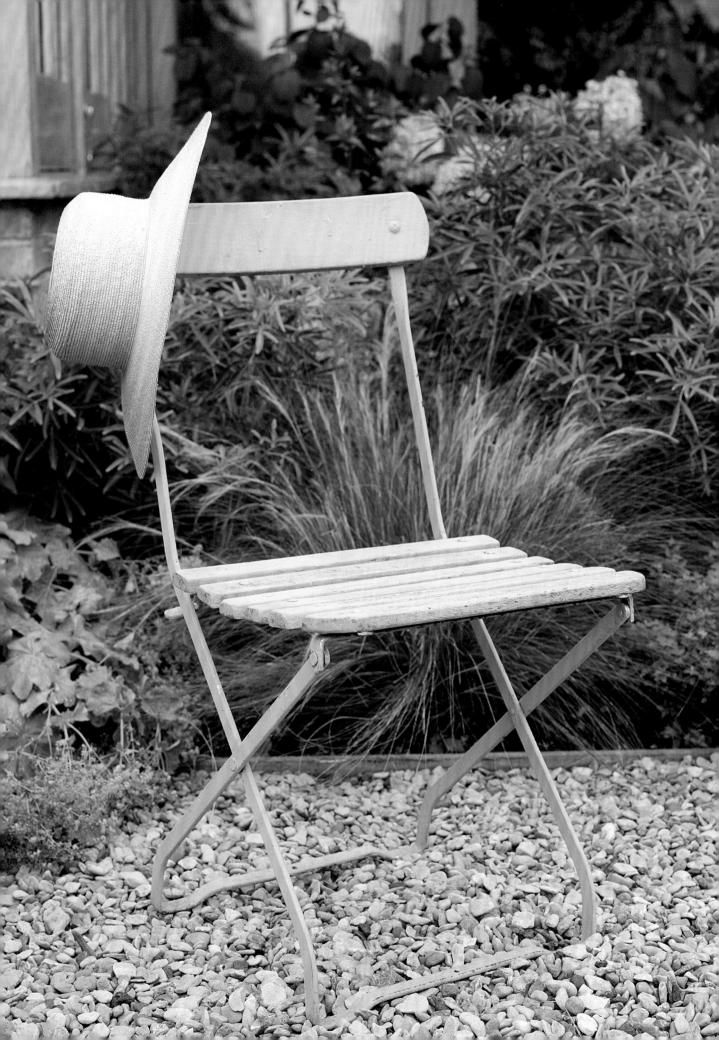

garden chair

This project is slightly different to the others in this book because the effect achieved with the paint has developed naturally over several seasons in the garden. This old wooden slatted garden chair was painted several years ago and left out in the garden through all weathers—from snow to baking sun. This is not an effect that can easily be achieved without time, and is simply a matter of painting the chair in the color of your choice—Duck Egg Blue in this case—and leaving it to gradually succumb to wear. It will look good to begin with and gradually age with time. Upright areas like the back of the chair will take longer to start aging than the chair seat or a table. A garden shed, fence, or wall could also be done in the same way.

tip Color for the garden needs to be cool to complement the foliage and not compete with the flowers, which are mainly light, bright, and warm. The softness of Old White is good, as is Paris Grey, Country Grey, Château Grey, and the Duck Egg Blue I've chosen here. For something more contemporary Graphite and Old Violet will look stunning—these are colors that work well for both furniture and walls. If you do want to make a statement, perhaps in an urban garden, the shock of bright red such as Emperor's Silk also looks very smart on a garden bench.

For a garden wall that acts as a backdrop and is made from wooden planks, brick, or is rendered, more natural colors like Arles and Scandinavian Pink can be used so the wall will set off the green foliage against it. A wall that is more noticeable needs to be painted in cooler colors, so it blends with the foliage rather than standing out.

you will need

- Coarse sandpaper
- Chalk Paint in Duck Egg Blue
- 2in (5cm) paintbrush

1 Start by removing the peeling paint and smoothing the surface with coarse sandpaper.

2 Paint the chair with a coat of Duck Egg Blue then leave to dry and let nature take its course.

garden planter

I considered painting this planter with a wash of Old White but because it was so classic in shape I felt it needed to be a little more traditional. I decided the best option was to make it look as though it was made of lead. This is simply done using Graphite and rubbing with fine sandpaper. Where there is a straight ridge the fine sandpaper smooths the paint and makes it look silvery gray, rather like pencil marks. This is in contrast to the matte paintwork and it is this subtle contrast that creates the effect.

you will need

- Chalk Paint in Graphite
- 2in (5cm) paintbrush
- Fine-grade sandpaper

tip I have left this pot out in torrential rain and the finish stayed the same, but I have not tested it for a long period of time. It could be used inside as a planter, or the same technique could be used on other pieces of carved furniture.

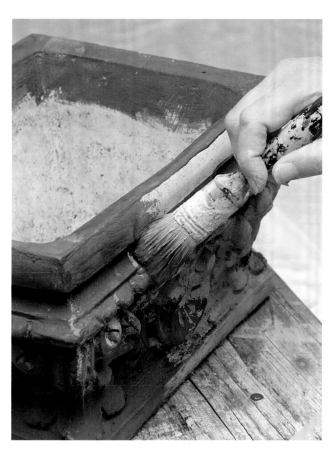

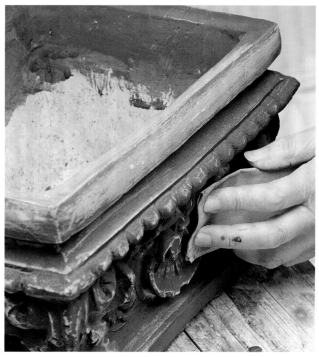

1 Brush all over the planter with Graphite paint and leave to dry. Apply a second coat to make certain you have covered everywhere including all the little nooks and crannies.

2 With fine-grade sandpaper rub all over the paintwork, or at least the raised molded parts. Here the top edges, which are long and uninterrupted, were rubbed finely to make them smooth and give them a slight sheen. Stop sanding when you are satisfied with the look. There will be two different-colored grays; the lighter shade will be very smooth with a lovely sheen.

French workman's shelf

This is a copy of shelves that can often be found in the flea markets, or "brocantes," of France. Originally they were a working man's simple open wardrobe with a shelf for hats and pegs and a rail for hanging clothes. Now they are used not only in the bedroom, but also in the hallway, the bathroom, and even the kitchen. There are a number of ways that this one could be painted, but I decided to use the fact that it is new smooth wood and show a little of it.

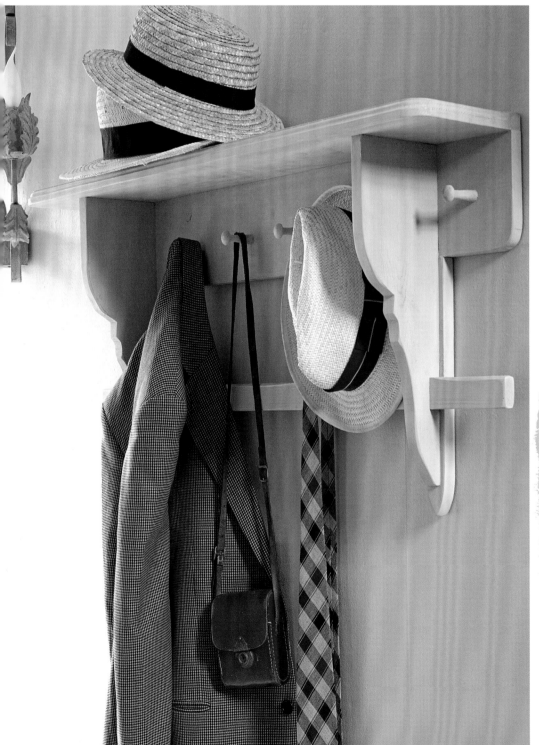

you will need

- Chalk Paint in Paris Grey
- 2in (5cm) paintbrush for applying paint
- Fine-grade sandpaper
- Tin of clear wax
- 1in (2.5cm) paintbrush for applying wax
- Cloth for removing excess wax

tip New pine wood is pale and warm—although it will darken with time—so bear this in mind when you choose a paint color. On this surface a cooler color will probably give a better result than a much warmer one.

1 Apply a thin coat of Paris Grey paint evenly on the shelf going in the same direction as the wood grain. Leave to dry. When the wood is waxed the paint will become slightly translucent allowing you to see the grain.

2 With some fine-grade sandpaper rub down parts of the shelf, focusing on areas that can be easily seen or where the wood grain is more apparent. Rub smoothly all over to make the wood and paint very flat.

3 Work some clear wax into the paint with a brush to achieve a thin even layer. You could use a cloth here but a brush is better because it will allow you to reach the most inaccessible areas more easily.

4 Wipe the piece gently with a cloth to leave a smooth layer of wax all over and to bring out the grain of the wood. Depending on the thickness of the paint the grain will be more visible in some areas than others.

5 Finally, rub the whole shelf with the sandpaper to give a really smooth and flat finish. At this stage you could also take more of the paint off if you feel that not enough wood is showing. Finish with a final thin coat of wax.

distressed ladder

Inspired by fruit-picking ladders, this ladder has been made from new wood to hang towels or clothes in a bathroom or bedroom. I like this one particularly because it has shaping on the rungs as if they had been already worn. You could use an old ladder here, but finding one can be difficult and a purpose-built one works just as well. It is a modern idea so I have chosen modern strong colors to reflect this.

you will need

• Knotting solution

• Cloth to apply knotting solution

• Chalk Paint in Old Violet and Emperor's Silk

• 2in (5cm) paintbrushes for applying paint

• Tin of clear wax

• Water

• 2in (5cm) paintbrush for applying wax

• Coarse sandpaper

tip If you are using the ladder in a bathroom, use colors that will be in contrast to the towels you use.

1 If you are using new wood you will need to check for knots in the grain. If there are quite a few then you will need to apply knotting solution, otherwise the sap will bleed though the paint in a few months time. Luckily knotting solution is cheap, easy, and quick to use. Just dab the liquid onto a cloth and wipe over the knot. It will be dry almost immediately.

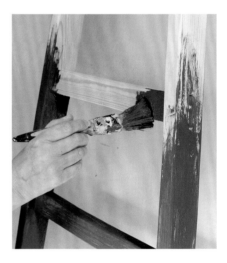

2 Paint a coat of Old Violet all over the ladder, remembering to start with it upside down first.

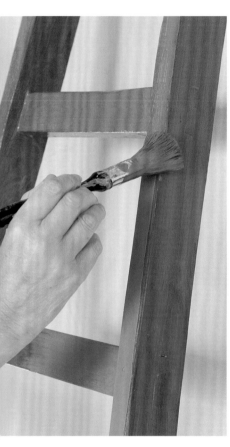

3 Paint over the Old Violet with Emperor's Silk, the red second coat, and leave to dry. Wipe the surface with a damp brush dipped in clear wax to take off some of the top coat of paint (see page 58, step 3). This should cause the base coat to show through, but the effect can be a bit subtle. If so, rub the ladder with a piece of coarse sandpaper as I did here to show more of the base coat.

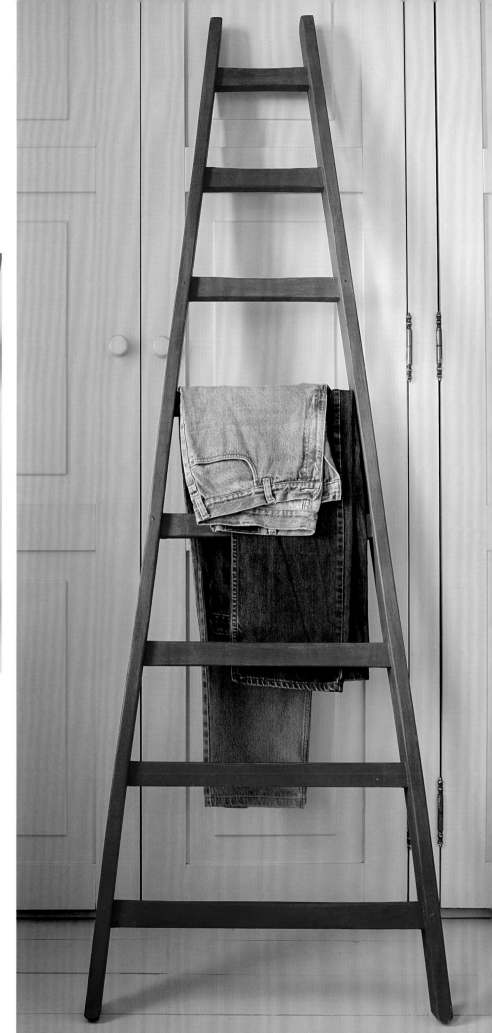

distressed mirror

This is a carved pine mirror with delightful small flowers and leaves. It works well with Old White as a contrast to the wood. Paris Grey, or a very dark blue, like Aubusson Blue, are colors that would also work well with this piece, providing a cool contrast to the warm pine. If the color is too similar or too blue, it can draw attention to the orange tinge of some pine. Similar carved or molded mirrors can sometimes be found made from other materials and the same ideas about color should be taken into consideration.

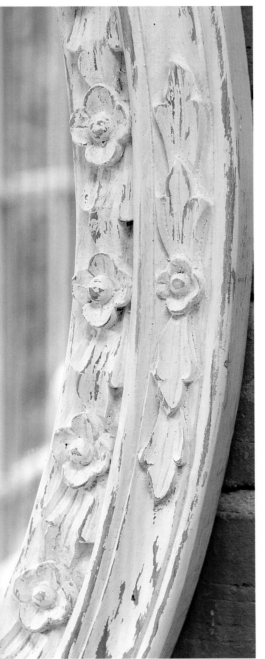

you will need

- Chalk Paint in Old White
- 2in (5cm) paintbrush for applying paint
- Paper
- Coarse sandpaper

tip The paint does not need to be waxed because mirrors get very little handling. Also the finish needs to be as matte as possible to contrast with the mirror.

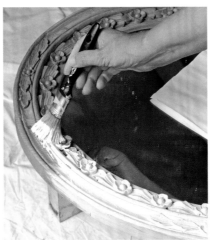

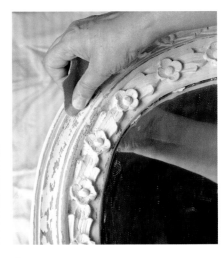

1 Paint the mirror all over with Old White, making certain you reach into the difficult-to-reach carved intricacies. To stop the paint getting on the mirror use a piece of paper tucked into the space between the glass and the frame. Allow the paint to dry thoroughly.

2 Tear off a piece of coarse sandpaper and work it around the mirror, pressing firmly to take large parts of the paint away. If you take too much off you can always reapply the paint.

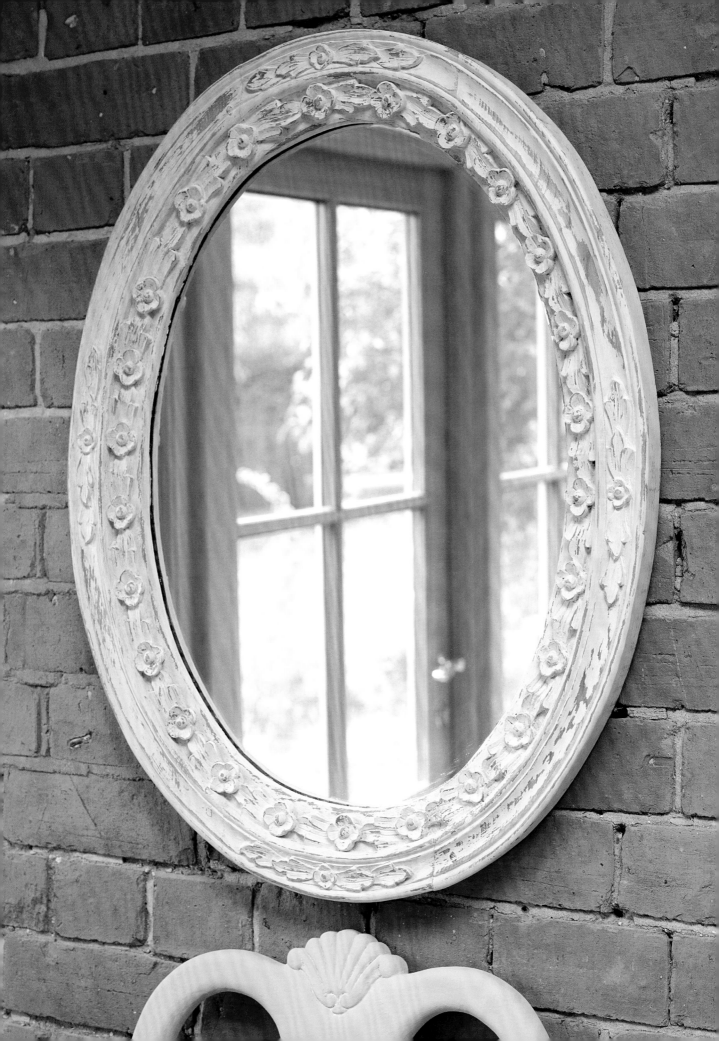

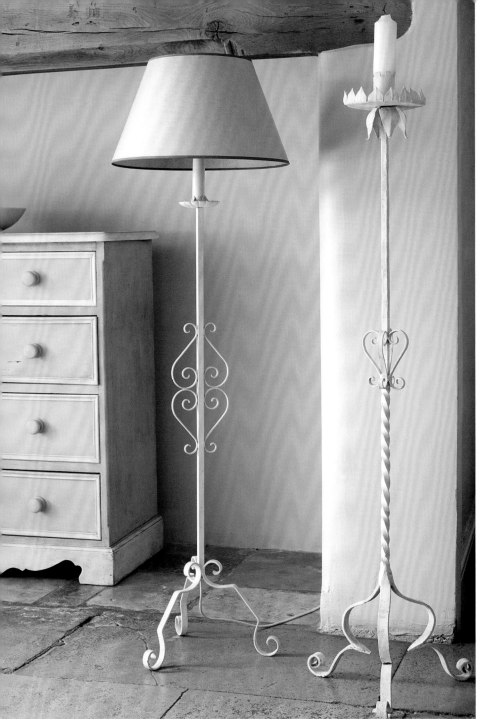

you will need

- Coarse sandpaper

- Chalk Paint in Old White

- 2in (5cm) paintbrush for applying paint

- Cloth for removing excess paint

- Tin of clear wax (optional)

- 1in (2.5cm) paintbrush for applying wax (optional)

ironwork lamps

Although the rustiness of these types of lamp is often part of their charm, these pieces were just plain dirty and needed work—but I still wanted to retain the aged vintage look. The usual thing to do is to cover rust with paint to stop it spreading, but this would make them look characterless and new, definitely not an effect I like. My method is really just a patch up and it is probably not the best long-term solution. However, I find it seals the rust and by keeping it inside it will slow down the corrosion of the metal. I've kept one of the stands as a lamp but the other one I converted back to a romantic candle holder.

1 Use some coarse sandpaper to rub the surface of the metal down, getting rid of any loose paint and rust.

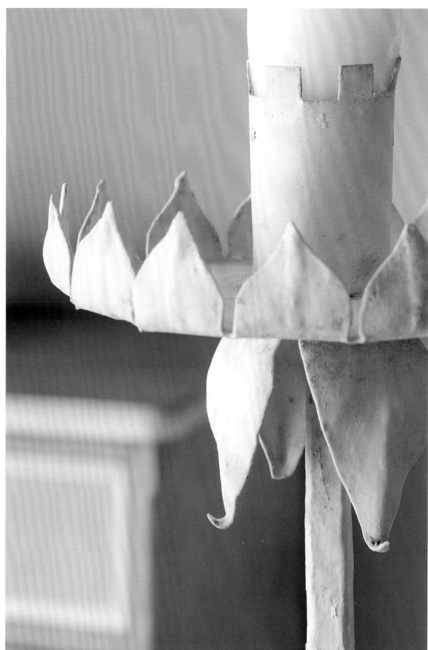

2 Apply Old White to the lamp, working on one defined area at a time rather than applying all the paint in one go. Once the section you are focusing on is finished, move on to the next step while the paint is still wet.

tip If you find a metal lamp painted black, as many are, then try the same technique using Graphite.

3 Wipe off the paint with a cloth to leave a film of white. This will allow the imperfections to show but they will not be quite as obvious. Repeat for the rest of the lamp. Once the whole lamp has been painted you can leave it as it is or alternatively apply a coat of clear wax with a brush to help seal the surface.

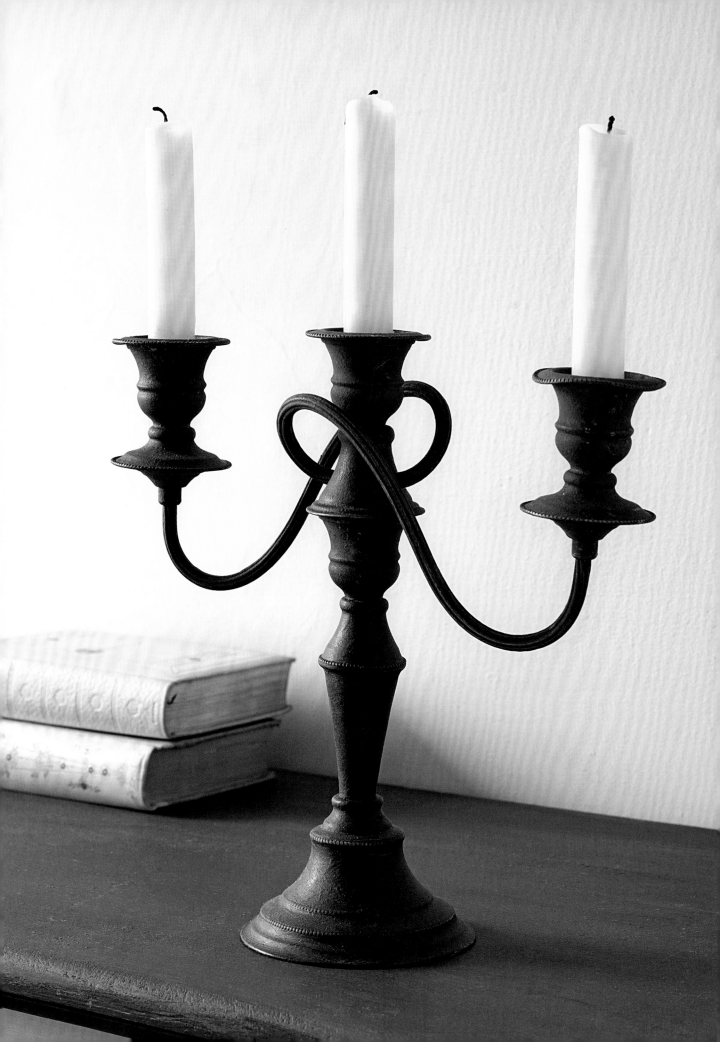

candelabra

I found the shape of this piece, with its twisted flowing arms, particularly inspiring and I knew it could easily be restored to its former glory. By painting it in Graphite, the candelabra takes on a baroque look that gives it more weight and presence.

you will need

- Chalk Paint in Graphite
- 2in (5cm) paintbrush for applying paint
- Tin of dark wax
- 1in (2.5cm) paintbrush for applying wax
- Cloth for removing excess wax
- Fine-grade sandpaper

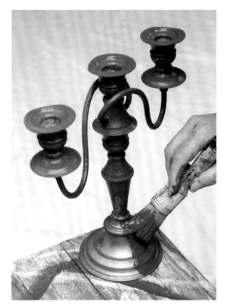 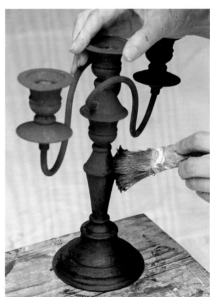

1 Old candlesticks often have dry, dripped wax on them that needs to be removed. The best way to do so is by painting the area where the candles go first to show up the wax, then scrape it off. Then paint all over the rest of the piece with Graphite, turning the candelabra upside down and starting at the base first.

2 When the dark gray Graphite is dry, take a well-charged brush of dark wax, and apply all over. The wax will darken the color of the paint to a soft black.

3 Wipe off the excess wax with a cloth then gently sand some parts of the candlestick, such as the edges with decorative molding, so the brass shows through. Polish with the cloth to achieve a soft sheen.

tip Chalk paint can be used on a variety of metal items, including brass candlesticks or silver chandeliers, and wiping away the black to reveal a little of the gilt always looks very elegant.

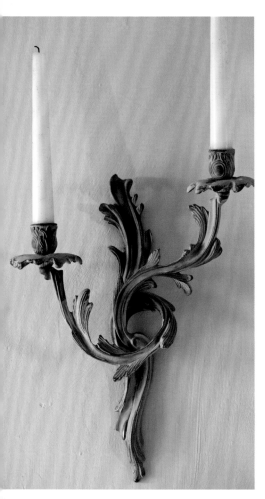

wall sconce

This cast-bronze wall sconce is one of a pair. Although I found them in France, I could see them being used to stunning effect in a Swedish-style interior. Their beautiful shape is pure rococo—sinuous and elegant—but the bronze color was just a little heavy.

Any metal is easy to paint with my Chalk Paint, even if it is much shinier and brighter than this bronze, which is particularly mellow. I chose to paint over the sconce in cool colors, primarily Paris Grey, then wiped away some of the paint to reveal the metal underneath. This lightened the overall look and created a playful contrast.

you will need
- Chalk Paint in cool colors, such as Paris Grey, Olive, Château Grey, Old Violet, Duck Egg Blue, Louis Blue
- Small oval brush
- Clean, dry, lint-free cloth

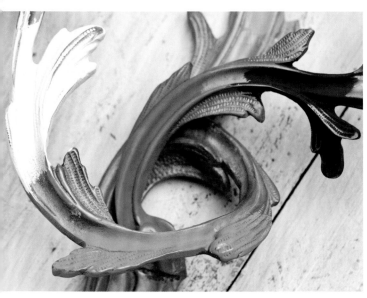

I tried out several colors on the sconces. From left to right: Old White, Old Violet, Olive, Paris Grey, and Graphite. Graphite and Old White contrast strongly with the sheen of the metal and reduce its warmth and patina.

1 Experiment with several different colors on the metal, painting them on with a brush and removing them with a clean, dry cloth. Using sample pots of paint will make this simple and inexpensive to do.

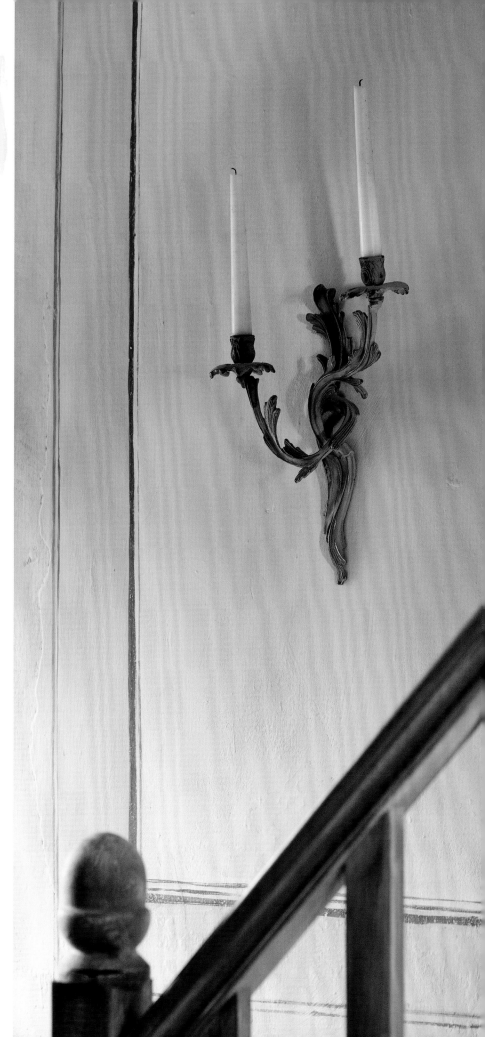

tip All metallic gold colors are warm, so they work very well with cooler colors, such as blues, grays, and greens, and they make an agreeable balance for the eye.

I fixed this sconce to the middle of one of the Country Grey painted panels at the bottom of the stairs and added some pale cream candles. Both sconces were painted primarily in Paris Grey, which picked up the colors in the rest of the room. Their very ornate, rococo style works particularly well with the restrained, classic painted lines on the wall.

2 Once you have decided on your color combinations and roughly where you wish them to be, paint them on, wiping off some of the color with a clean, dry cloth as you go, to reveal some of the bronze underneath. Along the curves of the foliage, slide a finger along instead, to wipe off the paint.

3 As wall sconces are rarely handled, they don't need to be waxed for protection, and the contrast between the painted areas and the bronze can be easily maintained.

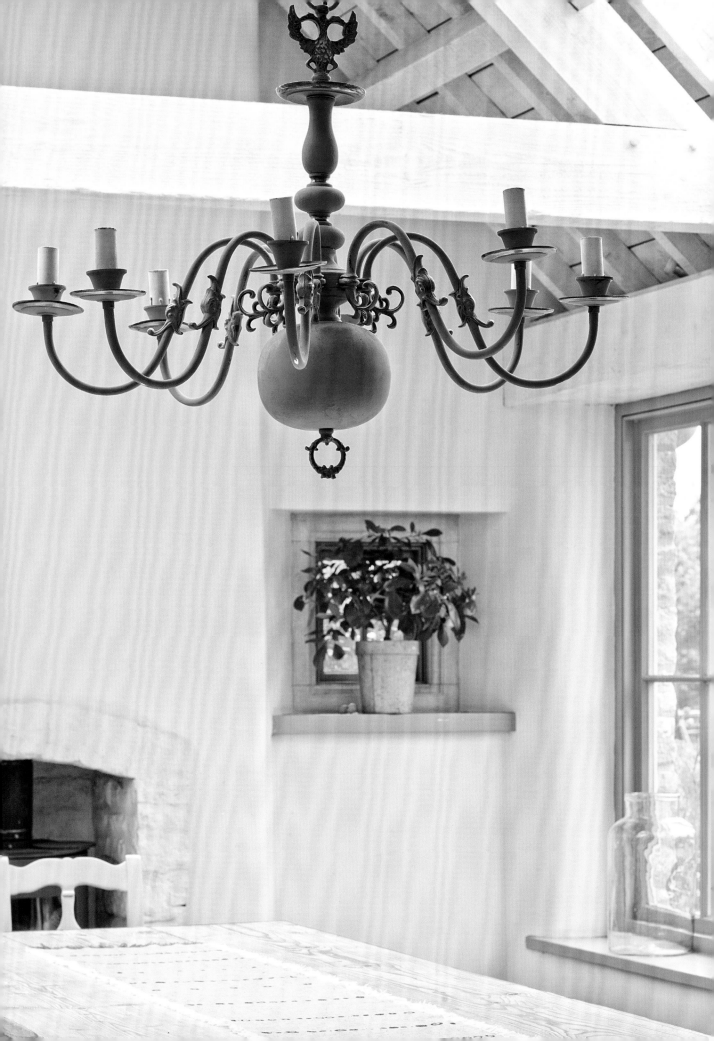

painted chandelier

I have a real soft spot for old brass lights such as these. This old French chandelier has interesting classical details such as the triumphant, open-winged eagle at the top and the open-mouthed dolphin heads.

I knew that a coat of paint would transform it. I decided to keep it simple by just painting it and wiping away some areas of paint to highlight the shiny brass and the delicate and interesting detail.

I chose to paint the chandelier in a strong color because I like the ease with which it can add color and make a great statement in a room. I used Florence, a strong, coppery verdigris-green, which contrasts softly with the brass, but other strong colors such as Giverny, Greek Blue, Napoleonic Blue, and Old Violet would also look good. I love to see the contrast of warm golden shiny brass with the cool greens or matte blue paintwork.

you will need

- Chalk Paint in Florence
- Medium oval bristle brush
- Piece of toweling or a sponge
- Clean, dry, lint-free cloths

1 Use the oval bristle brush to paint the chandelier all over with Florence, taking care that you get the paint into all the intricate areas. As these chandeliers can be very ornate, it's easy to miss parts, so I suggest you be very systematic—turn the piece upside down, so that you can paint all of the underside first, then paint it from above, and, finally, approach it from the side.

2 Once the chandelier is completely painted, take the absorbent piece of toweling or sponge and dampen it. Wipe away the paint from certain areas, especially on the raised details. Use a dry cloth to wipe off any excess wet paint. You may wish to wax the finished chandelier, but please note that the contrast between the matte Chalk Paint and the shiny brass won't be as strong if you do this.

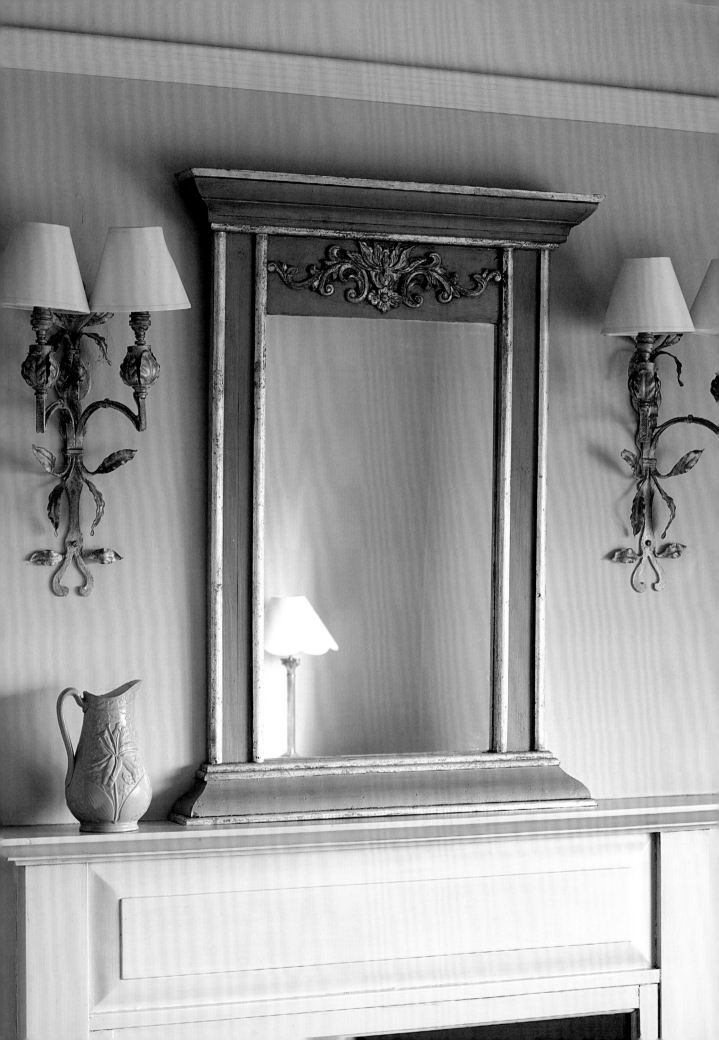

PART 2

paint effects and techniques **from** hand painting, **frottage**, gilding, **and** decoupage, **to printing**, **stenciling, and** dyeing

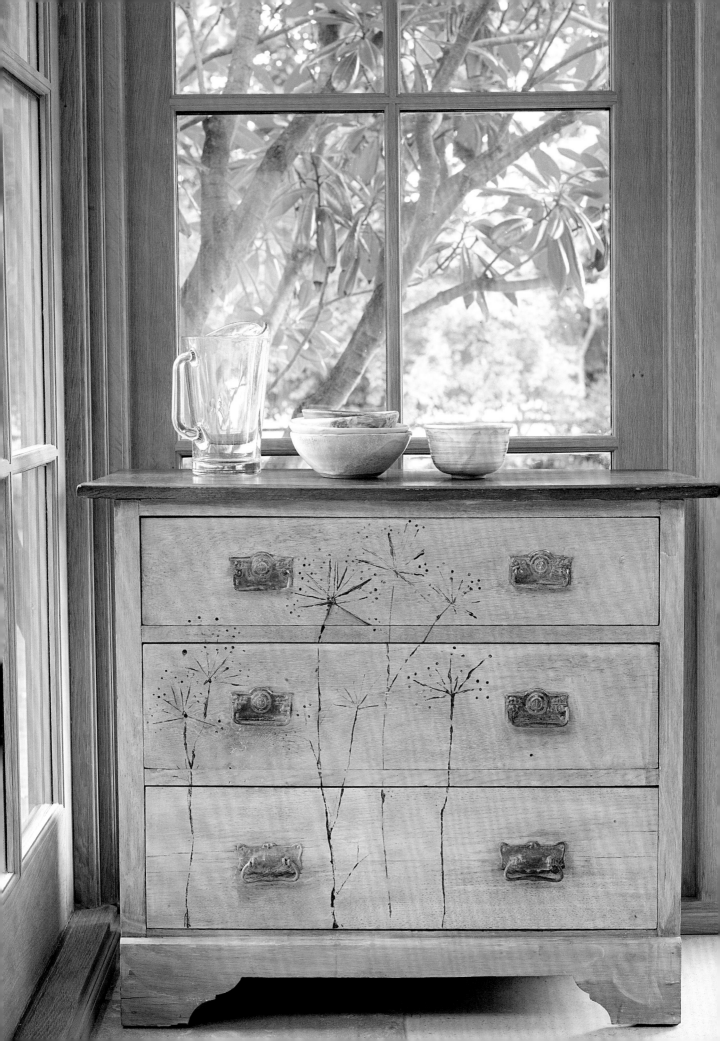

cow parsley chest

Oak is one of the few bare woods I like to see, but I also love it when it is softened with Old White. Cow parsley is a pretty country flower with a distinctive shape and I felt it would transpose well into print. The appeal of handprinting is the uneven random quality that you can achieve, which I felt would work well with the oak.

you will need

- Chalk Paint in Old White and Graphite
- Water
- Paint tray
- 2in (5cm) paintbrush for applying paint
- Cloths for removing excess paint and wax
- Card
- Matchstick
- Tin of clear wax
- 1in (2.5cm) paintbrush for applying wax

1 Mix ⅓ water and ⅔ Old White in a paint tray to make a paint with a runny consistency.

2 Paint the mixture onto the surface of the chest, one area at a time. Oak is a textured wood so make sure you reach all the grain with the brush.

3 Wipe off the paint with a cloth as soon as you can before it dries, to give a wash effect.

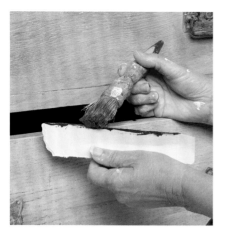

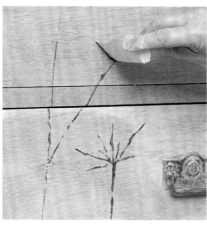

tip Choosing the card for the printing is quite crucial. A very hard thin card won't print and a very soft one won't be easy to manipulate.

I had a very vague plan before I started and had imagined one stem of cow parsley. I started to make this one where I thought it should go, and then carried on working until I had a few stems.

4 To print the cow parsley stems, tear off a reasonably strong piece of card from a cereal box or something similar. Tearing is better than cutting so the card edge is softer and more random. Load the brush with Graphite and dab the paint along the edge a couple of times so there is a good quantity of paint there.

5 Print the stems by pressing down lightly with the edge of the card, and then more firmly. Bend the card slightly to get the natural bend of the stem. You will need several lengths of card for different parts of the parsley. Change the card for a fresh piece when it becomes saturated—if it is too soft it will slip and print blurred lines.

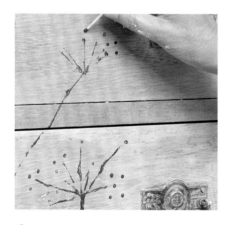

6 Use the flat end of a matchstick to print the dotty flowers of the cow parsley. Dot them on randomly so that some are heavy and others not so pronounced. Remember less is more! Apply a layer of clear wax when you are finished to seal, protect, and give a good even finish.

7 Add a layer of clear wax with a brush to the drawers and handle and rub off any excess with a cloth to finish.

8 Once I'd finished the chest I found that it looked slightly insipid with the Old White top. When I initially began the project I considered three colors for the top so I referred back to these and opted for Graphite instead, and was much more satisfied with the result. This is a great example of how projects never have to be rigid and set, so can sometimes evolve as you go along.

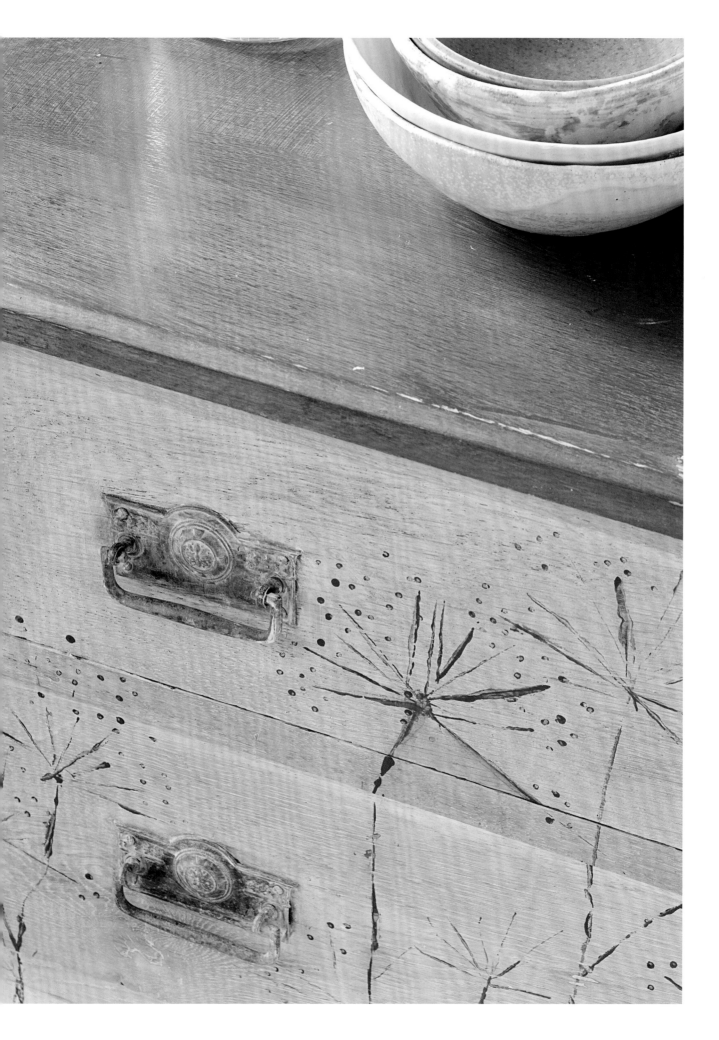

stenciled and hand-painted chest of drawers

Throughout history, stenciling has been used to paint a repeat design that looks as if it is hand-painted, and it is still used today to create a measured repeated pattern. In contrast, this stenciled chest of drawers has been made to look unique. I was inspired by one of my stockists to combine seemingly random stenciling and hand-painting. To begin with I was more or less copying. However, hand-painting allows your distinctive style and character to come through, so let yourself approach this project in your own way, because each person uses a brush differently. This is a project for anyone who loves to paint and is prepared to give it a go. Although the stencils appear to be placed randomly, they are, in fact, applied in a balanced way, with more or less space between them in different places. The cool, solid base of pattern is brought together with flashes of warm color that give the piece movement and pizzazz.

you will need

• Chalk Paint in Provence and Old White

• 4 oz. (120ml) pots of Chalk Paint in: Napoleonic Blue, Antibes Green, Burgundy, and Barcelona Orange

• Annie Sloan MixMat™

• Small sponge roller

• Oak leaves stencil

• Artists' pointed detail brushes

• Clear wax

• Small wax brush

• Clean, dry, lint-free cloths

1 I made a paint mix for the base color of the chest of drawers because I wanted to create a paler blue color by mixing Provence and Old White. I used my MixMat™ to work out the ratio of the colors—here I used 10½ fl oz (300ml) of Provence to 3½ fl oz (100ml) of Old White paint. I then used this ratio to make up a larger quantity of paint. Stir well and use the sponge roller to paint the base color on the piece of furniture, in this case a chest of drawers. Allow to dry.

tip Although I painted this chest of drawers on its side, it is much easier to lay it on its back when stenciling. Remove all the handles before you start, so that you have a flat surface to work on.

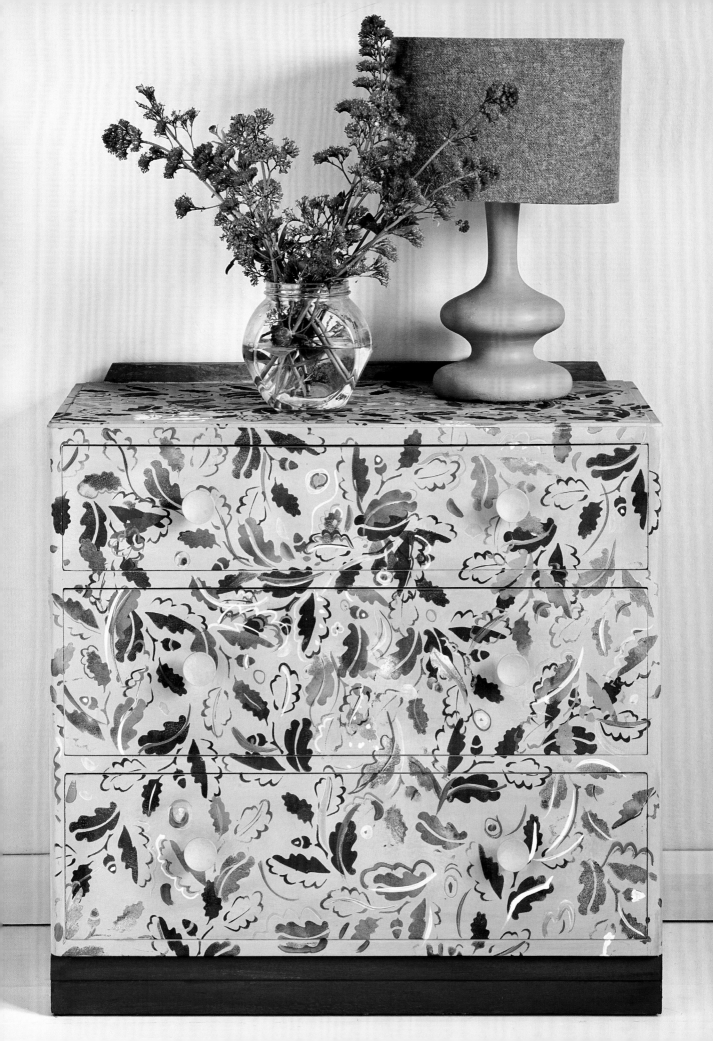

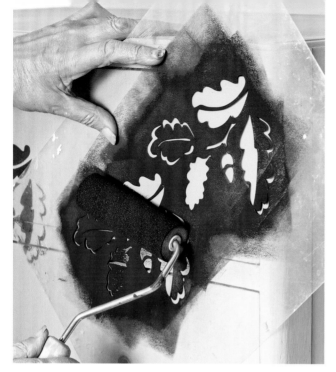

2 Use the MixMat™ to roll out some Napoleonic Blue, then stencil the Oak Leaves design randomly onto the piece. Hold the stencil firmly with your hand to stop it moving.

3 Place the stencil in different directions and leave some gaps in the arrangement as you stencil for the other colors.

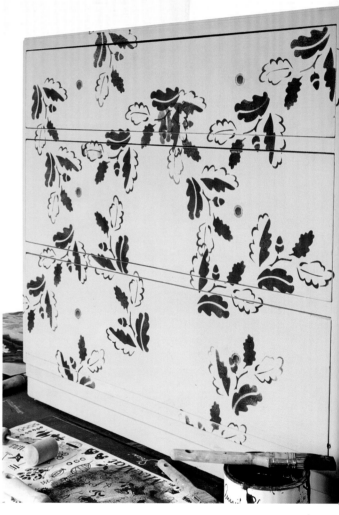

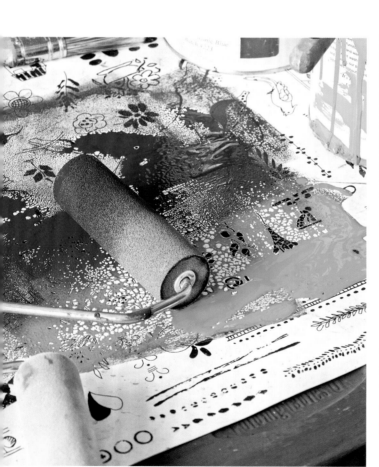

4 Add some Antibes Green to the MixMat™ and combine it with the Napoleonic Blue. Load the roller with paint (combining both of the colors) and start to stencil, gradually adding more Antibes Green until you only have Antibes Green left on the roller.

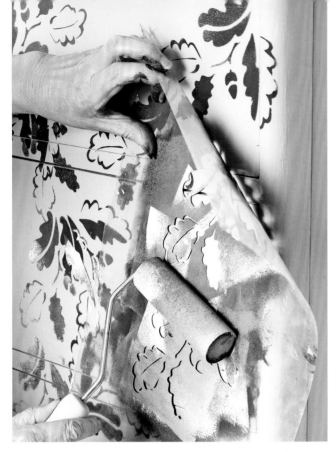

5 Use the roller to stencil those areas that do not have any blue stenciling with the Antibes Green.

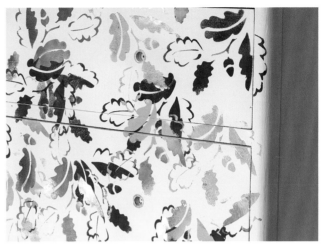

6 Overprint some of the stencils so that the Antibes Green stenciling covers the Napoleonic Blue in some places.

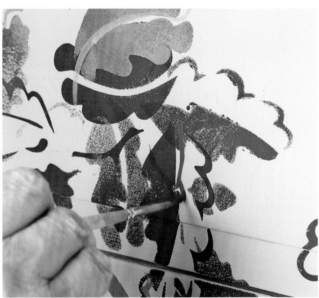

7 Using various artists' brushes, free paint in some small details by following the outline of a leaf, filling in an acorn, or echoing a shape with a flowing line. I used the warm bright colors of Burgundy and Barcelona Orange to act as a contrast to the cool blues and greens. Finally, use the wax brush to apply the wax. Remove excess wax with a clean cloth.

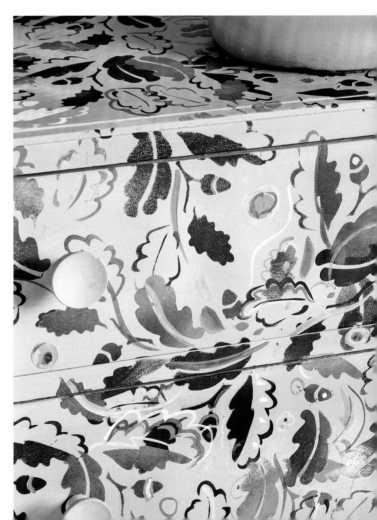

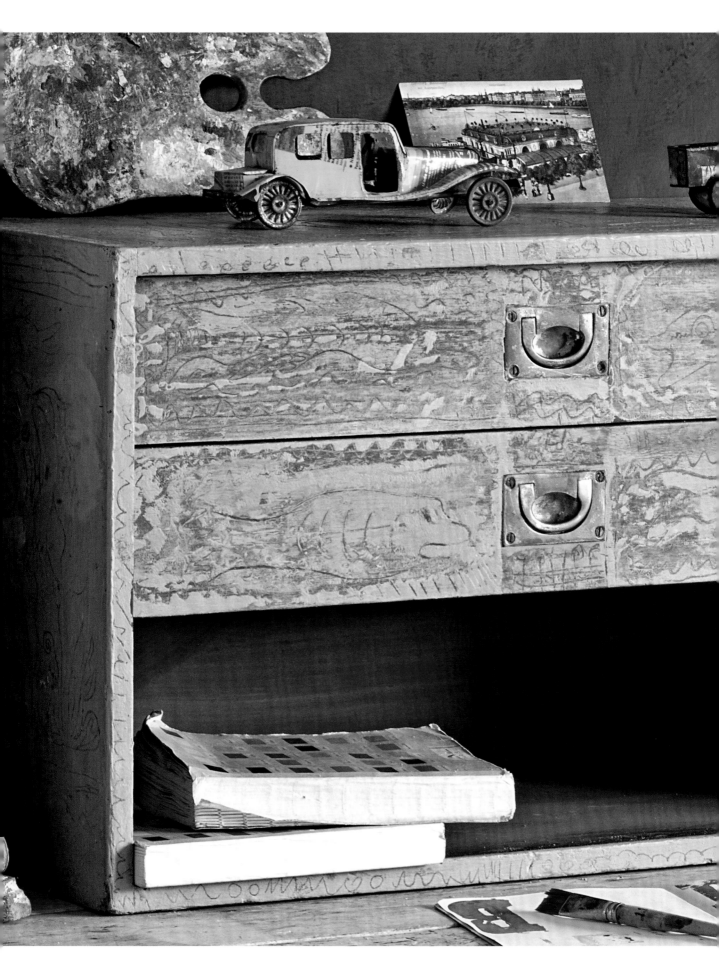

wet paint drawing drawers

This technique was developed after some experimentation by drawing through paper on a freshly painted piece of furniture. In fact, I thought the effect would be different to the result I actually got, but I like the look I achieved. As I drew on the paper, the paint was pushed to the side and made a wonderful line. Finding the right paper is essential for this project, because it mustn't be too absorbent. I experimented with several types of paper before I found the right type.

For the design you need something that is quite decorative all over, and also very linear—that is, it should be made up of clear lines. This piece was inspired by an issue of *World of Interiors* magazine, which featured the mud hut villages of Hazaribagh, in North India. In the spring and fall (autumn), the huts are emblazoned with beautifully bold murals and I found these very inspiring. The lines are clear and strong, and very decorative. The result of drawing on wet paint through the paper is a worn, delicate image with a printed or woodcut quality, where more of the paint is removed in some places than others. The trick is to work quickly and be free with your drawing.

you will need

- Chalk Paint in Amsterdam Green and Duck Egg Blue
- Small oval bristle brush
- Piece of paper
- 4B pencil
- Small flat brush
- Clear wax
- Small wax brush
- Clean, dry, lint-free cloths

1 Use the oval bristle brush to paint one coat of Amsterdam Green on the surface of your piece of furniture. I'm using a textured brush here, but it doesn't have to be overly textured.

2 While the paint is drying, sketch out your design on the piece of paper. I used a 4B pencil because it is dark and soft, and makes a wide mark. Make sure the paint you are using isn't too absorbent. Only work in one area at a time; otherwise, the paper will stick to the paint if it is left on too long or if it's too absorbent.

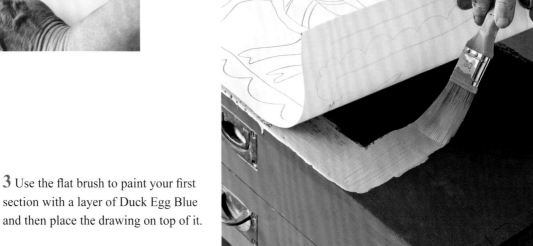

3 Use the flat brush to paint your first section with a layer of Duck Egg Blue and then place the drawing on top of it.

4 Go over your hand-drawn design with the pencil, pressing quite hard and then lifting off the paper as soon as you can.

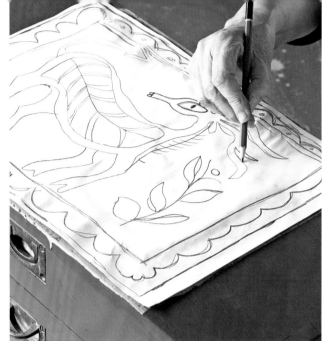

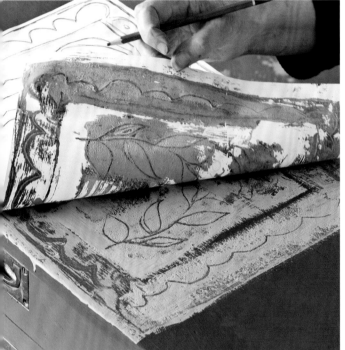

5 Divide your design into four sections and work on each of these individually, peeling back the paper and checking that the image has imprinted on the Duck Egg Blue paint underneath. Repeat all over the piece and then use the wax brush to apply clear wax once the paint is dry. Remove excess wax with a clean cloth.

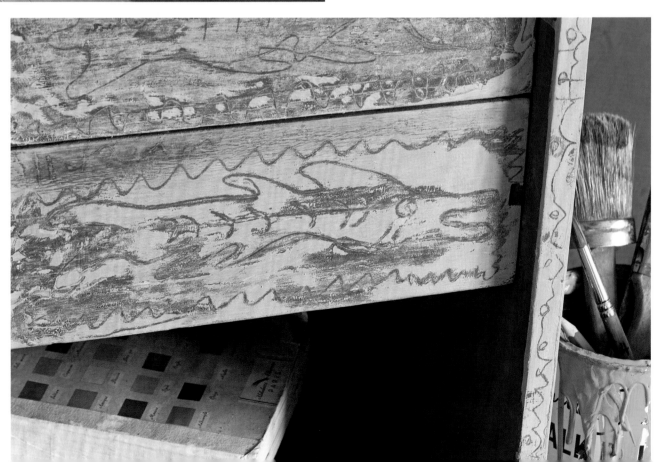

Victorian table

Recently I remembered the Victorian fashion for painting lines to embellish furniture in a very gentle and underplayed way. These would have been painted by hand, but this is a difficult skill to master. I have developed a great technique for achieving something that imitates the unevenness of old painted furniture, by using masking tape. I have also done some handpainted lines on the drawer using a small brush. The furniture is old and uneven and, of course, that is its charm, so the masking tape lines must be made a little random and uneven, too.

you will need

- Chalk Paint in Duck Egg Blue and Old White
- 2in (5cm) paintbrush for applying paint
- 1in (2.5cm) wide masking tape
- Small scissors
- Water
- Small long-haired artists' brush
- Tin of clear wax
- 1in (2.5cm) paintbrush for applying wax
- Cloth for buffing

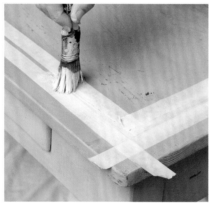

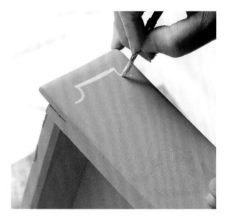

1 Paint the whole table with a coat of Duck Egg Blue and leave to dry. Mark out a rectangle about 1in (2.5cm) from the edge of the table top using the masking tape. Don't make the lines too close to the edge since this will look tight. Leaving a gap of about ½in (1cm), tape a second rectangle inside the first, cutting the tape with a pair of scissors to make square corners. The tape will stretch naturally so bend it slightly to make the line slightly irregular and not completely straight—although don't make too obvious curves.

2 Take a clean brush and dip it in the Old White paint. Wipe the brush gently on some paper to remove the wetness of the paint and dab it between the tape. Press firmly in some places and lightly in others so that the line is slightly uneven.

3 For the handpainted line choose a small area like the front of a drawer and use your little finger as a rest to keep your hand steady. Make a mixture approximately ⅔ paint and ⅓ water. It should be liquid enough to drip gently when you press a charged brush against the side of the paint pot. Dip the artists' brush lightly in the mixture, taking care not to pick up too much paint. Rest your little finger on the side of the drawer and slide it along the edge as you move the brush. The line won't be perfect but will be in character with old painted furniture.

tip Masking tape is naturally bendy so it is easy to make uneven lines of varying widths. This is important as in these days of factory-made perfection we have forgotten the warmth of characterful handmade furniture. When you remove the tape a little bit of paint comes off, which helps towards creating the distressed look. The longer you leave the tape on, the more paint will be removed.

4 Apply a thin coat of clear wax to the table with a brush. Polish the surface all over with a cloth to give the table a smooth finish.

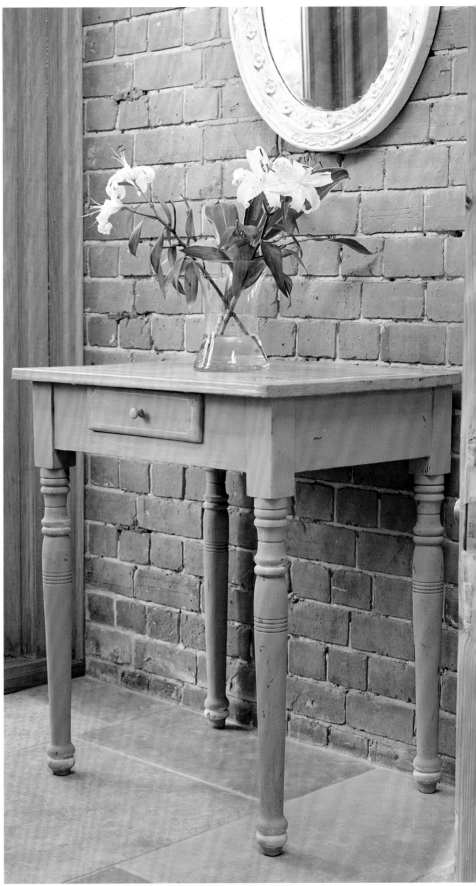

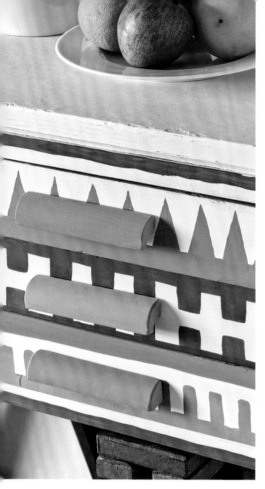

brush–shape patterned console table

My son Felix and I talked about making patterns using brushes and came up with this idea together. Making geometric designs with brushes presents a challenge, as most people are not used to this technique; the temptation is to draw the patterns and then fill them in with paint. However, the quick method is to begin the whole process with brushes that then help to dictate the patterns you make.

There are lots of different brush shapes, but these come down to two basic shapes: pointed and square-ended. Everything has been done using only the brushes and paint. I also measured everything by eye—even my initial sketch. This piece of furniture keeps the lines straight and the overall design square, so small changes in the width give the piece a natural appeal.

You will need

- Chalk Paint in Old White, Greek Blue, Primer Red, Antibes Green, and Scandinavian Pink
- Large flat brush
- Artists' pointed detail brush
- Artists' small, flat-ended detail brush
- Artists' medium, flat-ended detail brush
- Clear wax
- Small wax brush
- Clean, dry, lint-free cloths

1 Remove all the drawer handles before you start. Paint the piece all over with Old White first and allow to dry. Load the flat brush with Greek Blue, taking off the excess by wiping the brush gently on the edge of the can or basin. Then move the brush down the side of the drawer at a steady, but reasonably speedy, pace to make a band of color. This type of brush is ideal, as it holds a lot of paint and allows you to move quickly through the job. Repeat for all of the straight bands of color on each of the drawers, including the border in Primer Red around the whole piece and the extra line of Antibes Green at the top of the lower drawer.

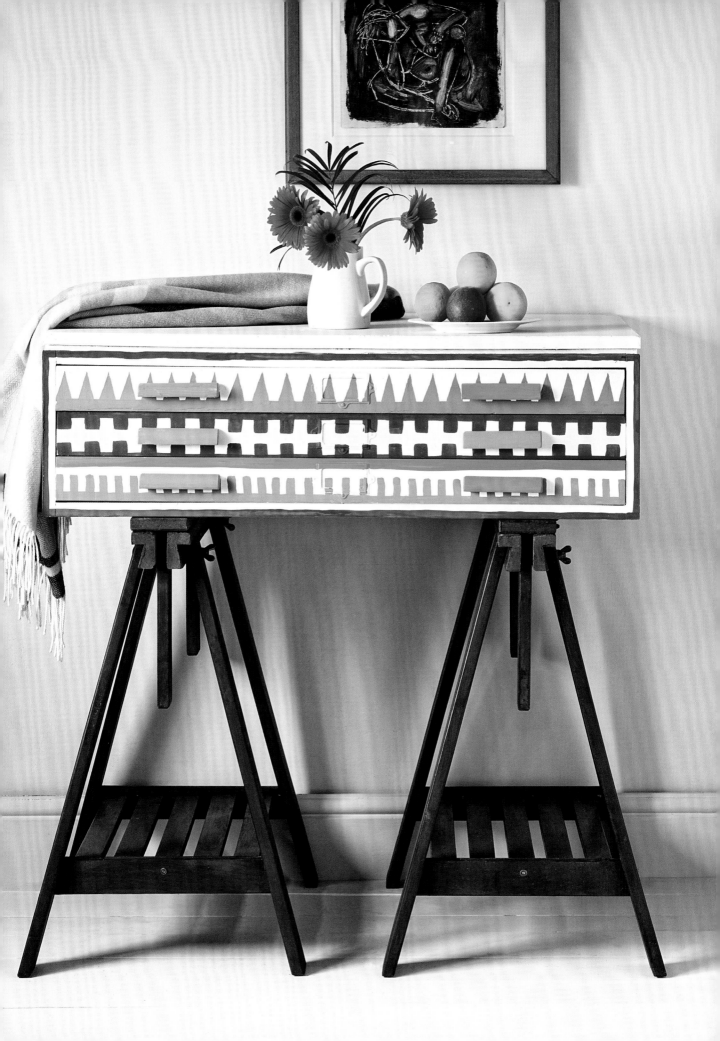

2 Take the pointed artists' brush and load it with Greek Blue, testing to see that the paint is flowing well. Add more water if it isn't. Hold the brush point at the height you want your triangle to be, then drop it onto the surface and immediately pull down, adding more weight as you go. Straighten the sides to make the angles of the triangle. Each triangle will need a fresh dip of paint.

3 Take the small, flat-ended artists' brush and load it with Scandinavian Pink, again testing to check that it isn't holding too much paint. Decide on the height and then pull down to create columns of color.

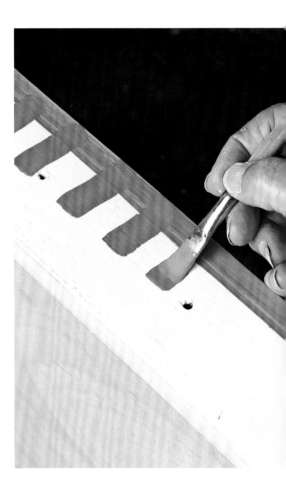

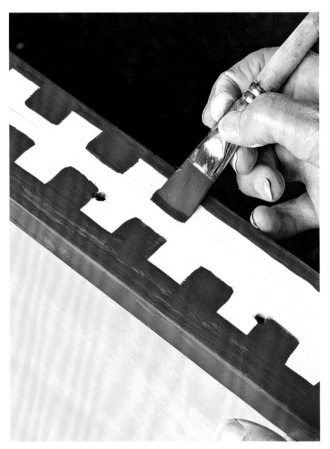

4 Use the wider of the two flat-ended artists' brushes in the same way as the other marks to make short, wide rectangles in Primer Red at the top and bottom of the drawer, resulting in an H-shape on the Old White. Replace the drawer handles and then paint them in three of the colors you used, but in contrast to the drawer color. Apply clear wax with the wax brush and remove excess wax with a clean cloth.

painted glass bowl

In this book I have included painting furniture of all sorts and finishes and fabric of all types, but I knew I needed another kind of surface. Then I remembered the glass bowls I painted many years ago, so this is a reworking of that idea. I have always loved painting these. It is very easy to do and achievable by anyone.

Painting bowls first started because I once needed a bowl for mixing paint in my studio, having run out of places and being too lazy to wash up. I found a bowl in my kitchen cabinet, thinking it would be easy to wash. In fact, it would have

been easy to wash if I had done it straight away, but I left it too long and the paint set and became very hard. However, I noticed how beautiful the paint looked though the glass, and so an idea was born.

In this design, I have kept everything very simple by choosing a set of blues with one light warm green, Versailles, by way of gentle contrast. I chose colors that are mid-tone—with white added to the Aubusson Blue and Napoleonic Blue— as they give better coverage. My design is very free and I wasn't aiming for perfection.

You will need

• 4 oz. (120ml) pots of Chalk Paint in: Greek Blue, Provence, Aubusson Blue (with a little Old White added), Napoleonic Blue (with a little Old White added), and Versailles

• Glass bowl

• 5 small flat brushes

• Clear varnish

1 Using one of the brushes, paint a fairly generous section of Greek Blue, which is a mid-tone color, on the inside of the bowl, without pressing too hard on the glass—or apply two layers to get a good coverage. While this first section is still wet, use another brush to apply a darker color next to it (here I used Provence), but in a narrow stripe. Don't worry if you leave any gaps.

2 Continue adding stripes in the other colors, using a clean brush each time, until the whole inner surface of the bowl is painted, including the base.

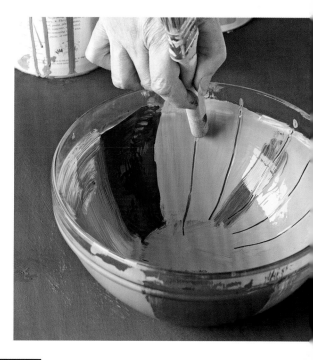

3 Using the handle of a brush, scratch lines into the wet paint. This step can be done once the paint is almost dry or when it's wet. Vary the width and frequency of the lines.

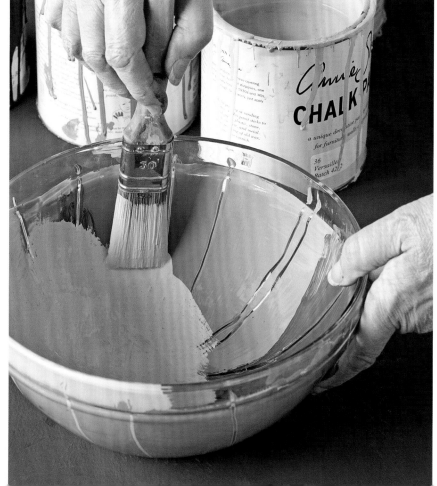

4 Paint and cover the inside of the bowl in the Versailles paint. Once the paint has dried thoroughly, apply varnish with a clean flat brush.

spotted shelves

There is something charming about a homemade piece like these shelves and although slightly damaged, they are perfect for painting. The edges were probably cut with a jigsaw and the patterns made by drilling holes in the side, creating a piece that was aching for some decorative painting. It is often quite difficult to make shelves look interesting since there is little to see, but dots, lines, and spots are quite achievable, even for an amateur with little experience.

you will need

• Chalk Paint in Country Grey and Scandinavian Pink

• 2in (5cm) paintbrush for applying paint

• Small artists' brush

• Water

• Tin of clear wax

• 1in (2.5cm) paintbrush for applying wax

• Cloth for removing excess wax

1 Paint the whole piece with Country Grey and allow to dry. You will probably need two coats as the brown wood underneath is quite dark.

2 Where and how you paint the lines and spots depends a lot on the shelves you find. These shelves had a molding with a groove in it, so I simply pressed lightly with the side of the brush and ran it along the raised edges.

3 Mix a small amount of clean water with the Scandinavian Pink to make the paint fluid, but not so that the mixture drips. Add a few drops to begin with, then some more if necessary to achieve the right consistency. Along the wavy edge of the bottom shelf I made a series of dots, and then added other spots to the rest of the shelves. Apply a layer of clear wax with a brush to protect and finish off the piece. Remove any excess wax with a cloth.

tip Choosing a brush for the painting of fine dots and lines is important. This doesn't mean you have to go out and buy an expensive sable hair brush, but you should avoid a very cheap child's brush as they have no "spring" in the hairs. Find a brush that has a bit of spring and comes to a reasonable point. Press the end of the brush—it should resist a little, and the hairs should return quickly back to their original position.

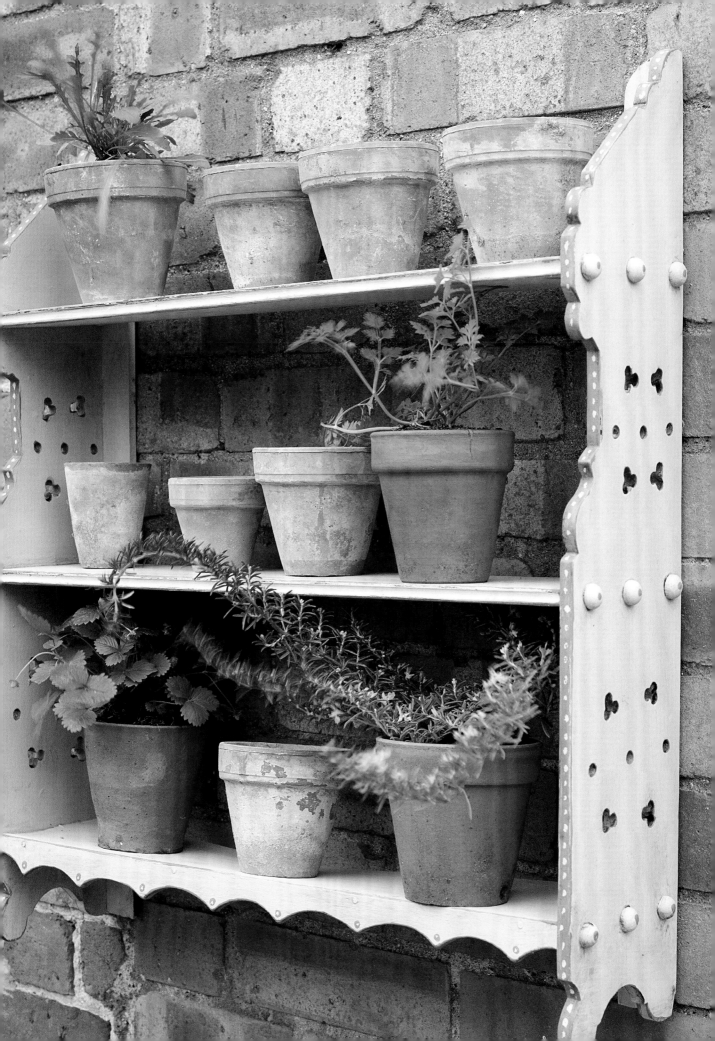

frottage wall

Frottage is a way of adding a random texture to walls or furniture, and is basically achieved by applying runny paint and then flattening crumpled-up newspaper over the chosen surface to create texture. It's fairly easy to do, but you need to be well prepared before starting, with plenty of scrunched-up newspaper ready to use and also plenty of translucent paint mix so that you don't run out of paint halfway. You'll need to work quickly and may have to add a little water as you go along. Check the absorbency of the wall with a test patch first—walls that have been painted many times will be less absorbent than new walls with fewer coats on them. The results of this technique can look very different depending on the colors. Muted colors such as Château Grey over Duck Egg Blue will create the effect of faded luxury and grandeur, reminiscent of marble. Or, as I have done here, use English Yellow underneath and Antibes Green and Provence on top for a very contemporary look.

you will need

• Chalk Paint in English Yellow, Antibes Green, Provence, and Old White

• Large oval bristle brush

• Old newspapers

1 Paint the wall in English Yellow and allow to dry. To make the paint wash, mix equal quantities of Antibes Green and Provence, adding a little Old White to soften the color. Dilute this paint mix with water until you achieve the translucency you would like. Use the wash to paint an area about 4in (10cm) larger than a sheet of the newspaper in the top left corner of the wall. You should still be able to see the yellow color underneath.

2 Scrunch up a sheet of newspaper, open it out, and then press the paper onto the wall, smoothing out the sheet and leaving borders approximately 3–4in (8–10cm) wide on the right and below so that you can work back into them. Peel back and discard the newspaper. Don't leave the paper on the wall for too long or it may begin to stick.

3 Work back into the already applied paint, which should not have dried yet.

4 Repeat the newspaper process as above until the wall is covered.

rough and luxurious wall

This wall finish appeals to me greatly, reminding me of the uncertain charm of old walls that are stripped and pared back to show remnants of old wallpapers and paint layers—hinting at a possibly rather grand or intriguing history. Combined and contrasted with luxurious architecture or furniture, this look is always a winner.

To give the wall depth and interest, I worked with three basic paint tones, building on the warm and neutral color of Old Ochre. I used mid-tone blues on this as my main color with a little of the warmth and depth of Coco in parts. I finished with Old White as my lightest tone.

This project will take time and care, and it can't be hurried. I like to apply the paint with a piece of cardboard because this is soft and doesn't make scratchy marks, and yet is still firm to hold. However, it absorbs the paint after you have used it for 5 to 10 minutes and becomes too soft, so a fresh piece is needed. A piece of soft pliable latex (rubber) might work too, but I've not found one yet.

The final finish, using an electric buffer to polish the wall and give it a beautiful sheen, is best done only when the paintwork is really dry. Waxing as a final effect is simply for protection.

you will need

• Chalk Paint in Old Ochre, Duck Egg Blue, Louis Blue, Coco, and Old White

• Sturdy cardboard boxes

• Annie Sloan MixMat™

• Coarse-grade sandpaper

• Electric buffer

• Clear wax

• Large wax brush

• Clean, dry, lint-free cloths

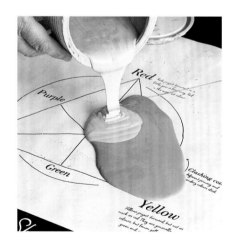

1 Paint the wall all over first with Old Ochre and allow to dry. Have a quantity of cardboard boxes cut up ready nearby. Pour more or less equal amounts of the mid-tone paints, Duck Egg Blue and Louis Blue, directly from the cans onto the MixMat™.

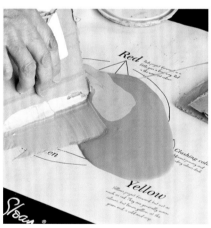

2 Take a piece of cardboard and scrape the two paints together, mixing the two blues roughly on the MixMat™ before applying the paint to the wall.

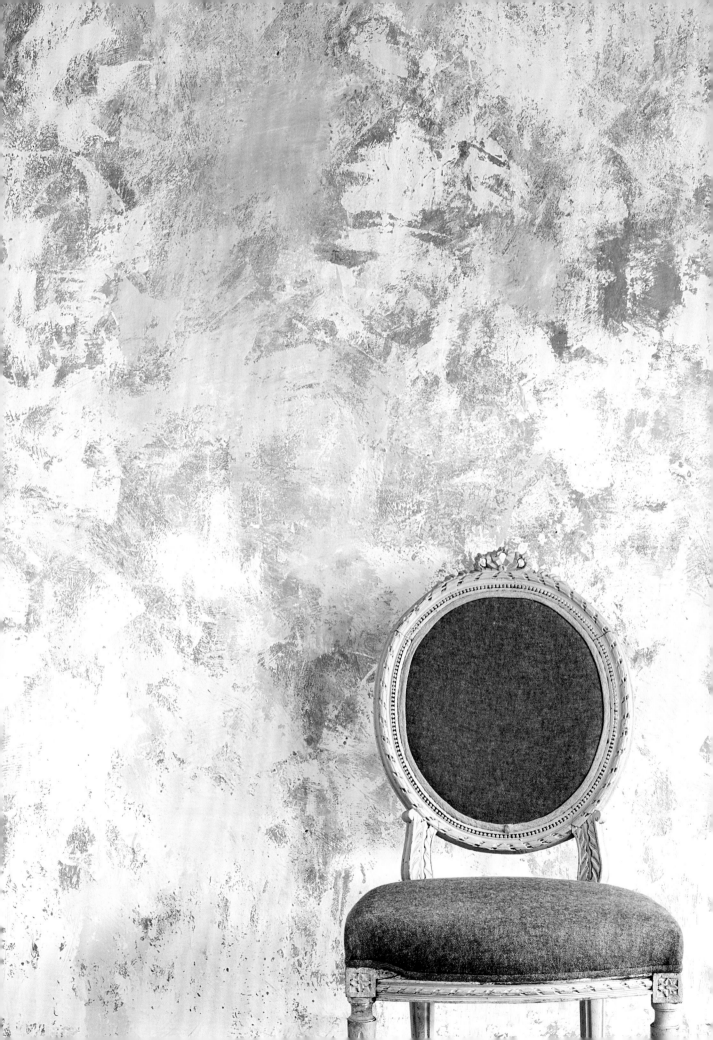

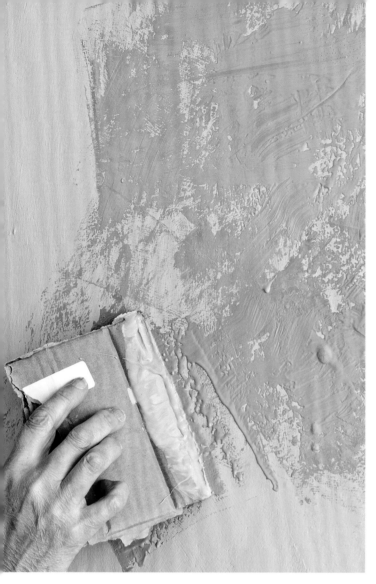

3 Softly scrape the paint along the wall, varying the pressure as you go. Apply the paint all over the wall, as this will be the main paint color with a paler blue over it.

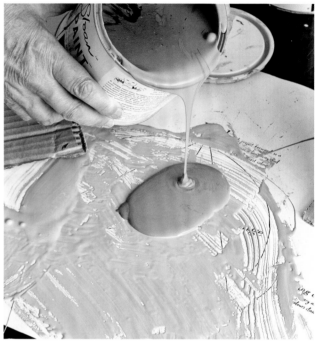

4 Pour some Coco onto the MixMat™. It doesn't matter that you still have remnants of the previous paint mix on the mat.

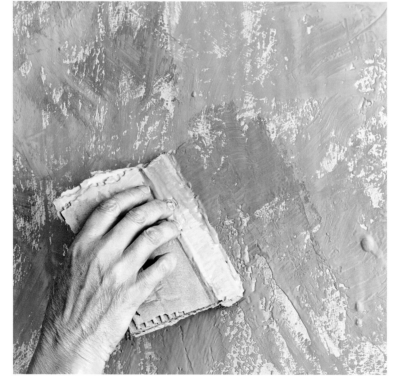

5 Apply the Coco to the wall in the same way as the previous color, although at lower quantities because this is a dark color and will have more impact.

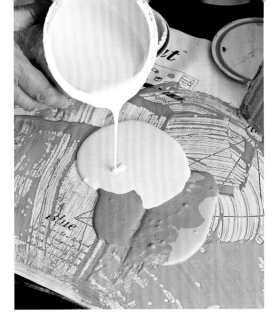

6 Pour the Old White onto the MixMat™ next and combine this with the blues and any leftover Coco to make a pale blue-grey color.

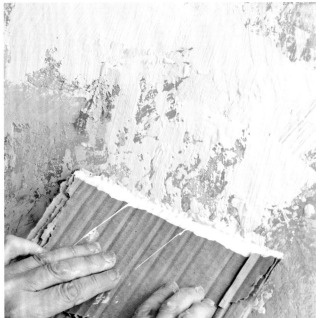

7 Apply a layer of this paint to the wall in the same way as before. Finally, apply Old White over the wall in places and allow to dry thoroughly.

8 Smooth with the sandpaper to remove any very uneven paint. Use an electric buffer to make the wall shine. You can finish the wall with clear wax applied with a wax brush to seal it. Remove excess wax with a clean cloth.

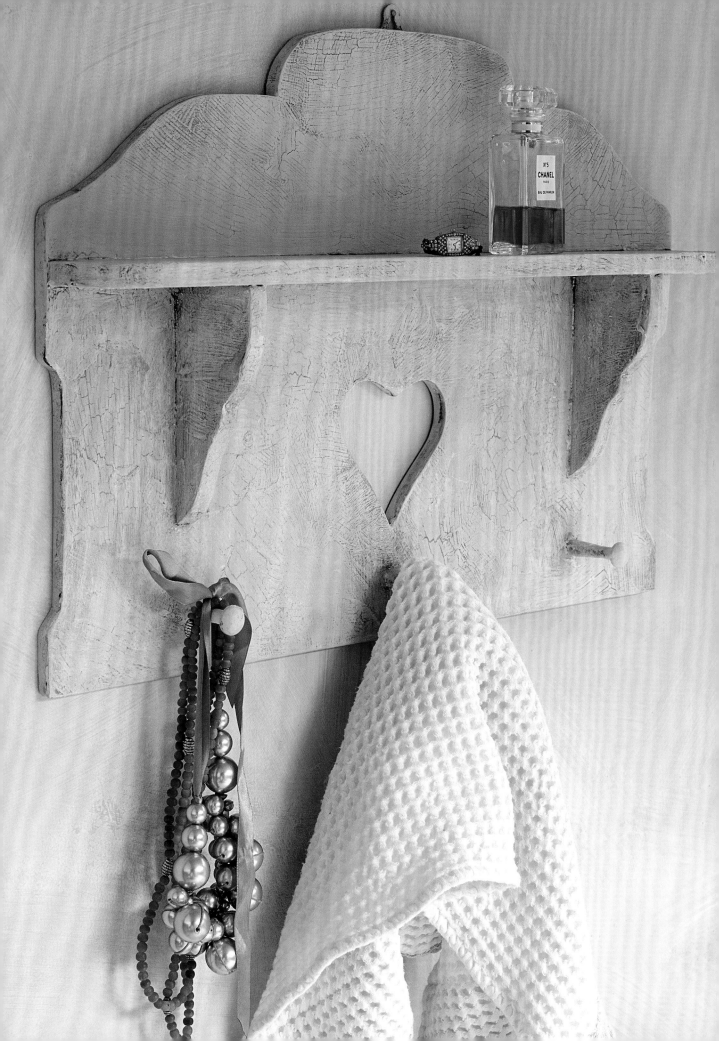

crackle-painted hooks

For me, the problem with MDF is that it lacks character and never develops with age in the way wood does. It is just too perfect so I like to find a way to give it some imperfections. This technique creates cracks in the paint and is a great way to lose the smoothness of the MDF finish. Chalk paint on its own applied thickly and then heated with a hair dryer cracks naturally. With a little practice you will be able to control the process, but don't try to aim for evenly sized cracks all over because this won't look natural. I chose a soft pink to go with the heart shape.

you will need

- Chalk Paint in Antoinette
- 2in (5cm) paintbrush for applying paint
- Hair dryer
- Tin of clear wax
- 1in (2.5cm) paintbrush for applying wax
- Tin of dark wax
- Small bristle brush for applying dark wax
- Cloths for removing excess wax

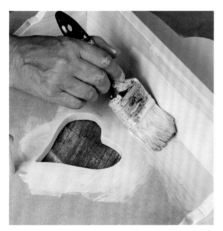

1 Paint all over the shelf in Antoinette. This will act as a base for the second coat as MDF is very absorbent.

2 Once the first coat is dry, apply a second coat. This has to be done in a different way to the application of a normal coat of paint. Charge the brush well with paint then hold it nearly horizontal on top of the shelf and gently "lay" the paint on the surface. Work one small area at a time, applying the paint in a few different directions—but don't make it too busy. Add the paint more thickly on some areas than others.

3 Quickly use a hair dryer on the highest setting to blow hot air on the freshly wet paint. After a few seconds the paint should start to crack. If the paint goes into ripples instead then you are too near the surface or the layer of paint is too thick. It can be difficult to see what is going on so move your head around to see the surface in different lights. When you have finished one area move onto the next, until the whole piece is covered with smaller or larger cracks.

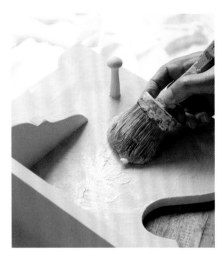

4 The paint is thicker than usual so make sure it is completely dry before applying the clear wax with a brush. Wipe off the excess with a cloth so there is a thin layer of wax.

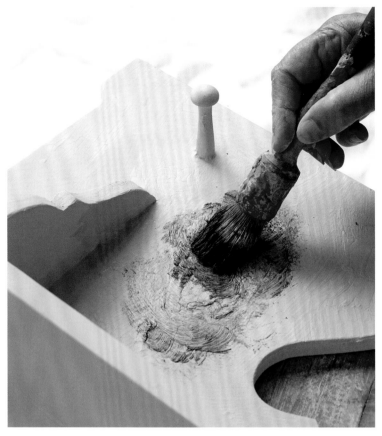

5 Next apply the dark wax. This should be done with a small bristle brush, pushing the wax into the cracks by working the hairs in different directions.

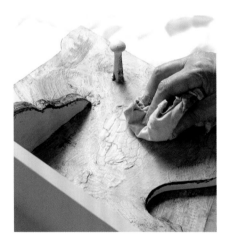

tip Do not confuse this crackle effect with "crackle varnish," a transparent varnish used over paint that cracks like the varnish on an old master painting. In the technique on these pages, the cracks are in the paint. There is a proprietary brand called Crackle Medium that can be used to achieve this look, but I prefer to use the hair dryer on the chalk paint.

6 Wipe off the excess dark wax with the cloth. You will find the dark wax is now in the cracks and will have changed the color of the paint too.

7 Take some clear wax and wipe it over the piece with a cloth to remove the dark wax from the surface, taking care not to remove any from the cracks. If any area is too cracked or busy then use the clear wax to remove some of the dark wax.

crackled lamp base

For this wooden lamp base, I was inspired by *raku*, a type of Japanese pottery that's characterized by a fabulously crackled effect. This centuries-old technique was introduced to the West at the start of the 20th century and then became very popular in the 1950s and '60s. Whether ancient or modern, *raku* has a timeless quality. I love *raku* pieces in pale colors, such as natural creams and whites, as well as all the celadon, jade, and turquoise colors, which are usually cracked with dark black cracks.

Here I created a paintwork and crackle-varnish technique, but I reversed the tones and used Graphite with the cracks picked out in white wax. The technique involves applying two layers of paint, which are then sanded smooth and treated with crackle varnish. Although I did not slavishly copy a *raku* piece, I tried to recreate the chance way the pottery glaze dribbles down the side of a pot. *Raku* can be a springboard for many pieces, including pale colors with black wax to bring out the crackled effect.

you will need

- Chalk Paint in Florence, Château Grey, Duck Egg Blue, and Graphite
- Small oval bristle brush
- Medium-grade sandpaper
- Annie Sloan Craqueleur Steps 1 and 2
- Small flat brush
- Hairdryer (optional)
- White wax
- 2 small wax brushes
- Clean, dry, lint-free cloths
- Clear wax

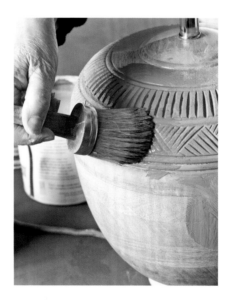

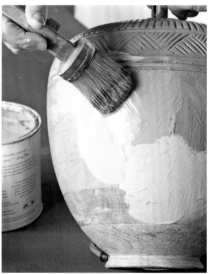

1 Use the oval bristle brush to paint irregularly shaped patches of Florence, Château Grey, and Duck Egg Blue over the base of the lamp. Dab and paint until the paint on the brush is more or less used up and then move on to the next color, using the same brush so that the colors blend well together.

2 Paint some areas more thickly and raised than others, even allowing drips to form, as these will show up later and are important at this stage. Allow to dry thoroughly.

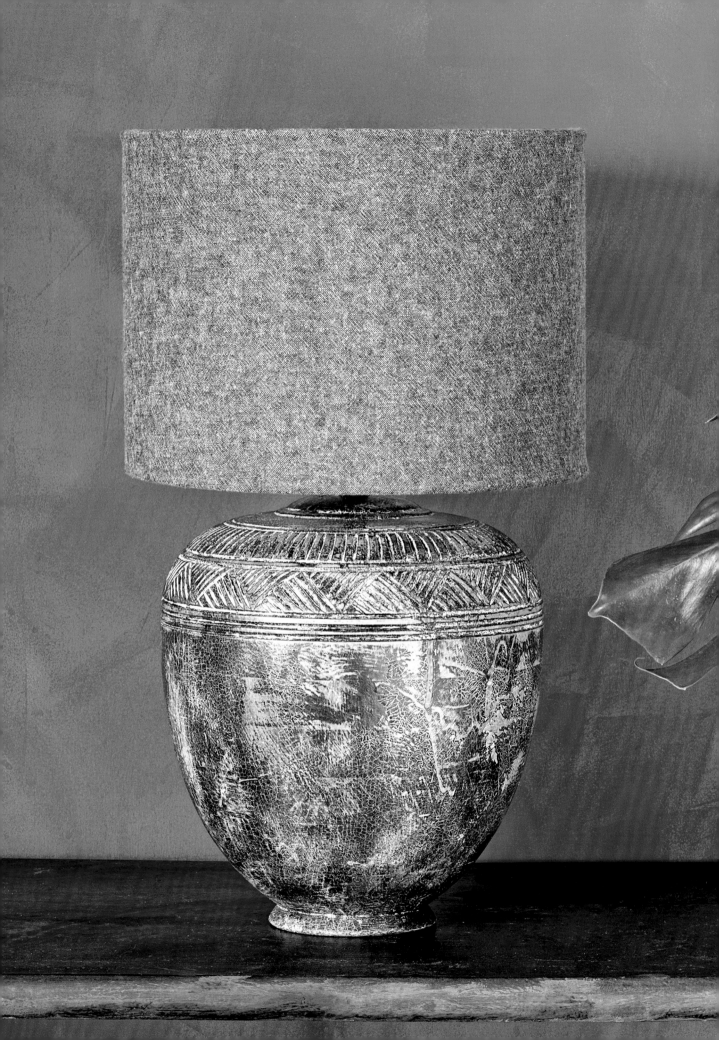

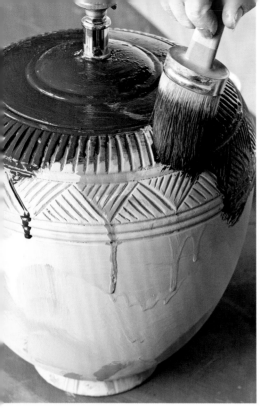

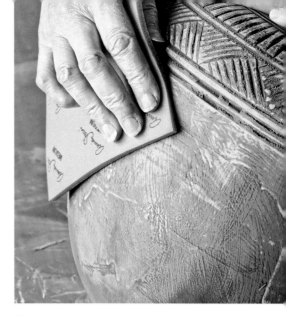

3 Apply a thin coat of Graphite all over the base, making sure the first coat of paint is fully covered. Allow to dry.

4 Gently sand the Graphite with the sandpaper, taking off some of the Graphite to reveal the colors underneath. Flatten off any areas of uneven paint to make them smooth.

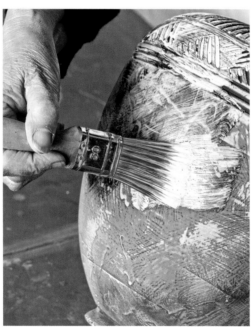

5 Apply Step 1 of the craqueleur with the flat brush, making certain you apply it all over, as any missed areas will not crackle. It will look white when first applied, but then dry completely clear. Dry with a hairdryer if you want to speed up the process, as it takes approximately 20 minutes to dry.

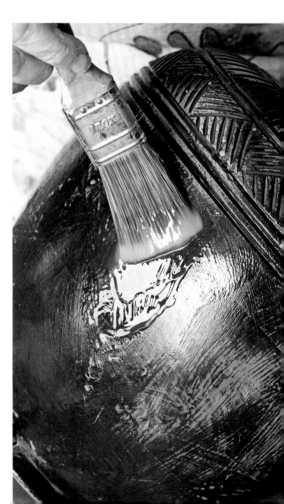

6 Apply Step 2 of the craqueleur, which is quite sticky and thick in consistency, and make sure you cover the whole area—you need to be very systematic in your application because it can be hard to see where you have been. Apply the craqueleur more thickly in some areas to create larger cracks. Either allow the base to dry naturally, in a warm, sunny environment, or use a hairdryer (make sure you do not hold this too close to the surface). This should take no longer than 5 minutes. The heat will make cracks appear.

7 Use one of the wax brushes to apply white wax quite generously all over the base, making certain that you apply it in all the cracks by brushing in all directions. Leave the wax on until it hardens slightly.

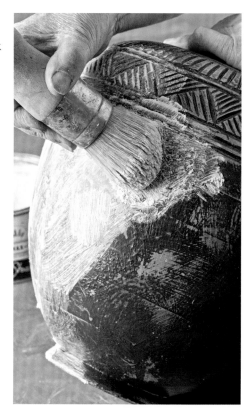

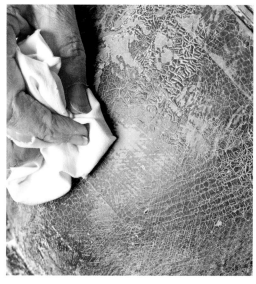

8 Wipe off the excess white wax with a cloth, taking off as much as you can while leaving the wax in the cracks.

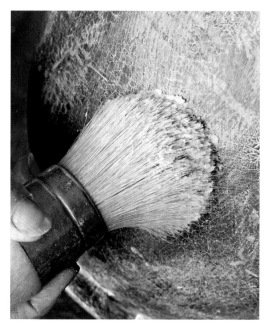

9 To get a very clean look, use the other wax brush to apply clear wax to erase any undesired white wax from the surface, but leave the white wax in the cracks. Carefully remove excess wax with a clean cloth.

gilded and painted 1920s glass-fronted cabinet

Glass-fronted cabinets were very popular in the 1920s for displaying your best china. They have largely gone out of fashion now, but as pieces of furniture they look great with a little overhaul. Try using one in a bathroom for perfumes, creams, and soaps or, as I have done here, in the living room with a collection of glass cake stands and a jug also from the twenties. Black, glass, and silver is a color combination from the thirties that also has a contemporary feel, so I used a black ticking fabric for the inside, gilded the top edge with aluminum leaf, and covered the edgings with a black ribbon.

you will need

- Chalk Paint in Graphite
- 2in (5cm) paintbrush for applying paint
- Paper
- Sticky tape
- Water-based gold size glue
- 2 small soft bristle artists' brushes
- Book of aluminum leaf
- Small dry brush for applying leaf
- Tin of dark wax
- 1in (2.5cm) paintbrush for applying wax
- Cloth for removing excess wax

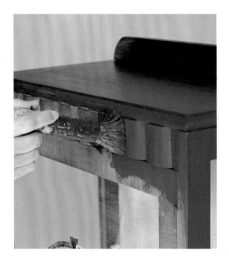 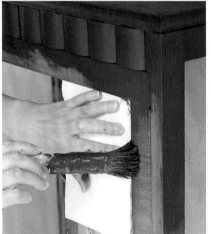

tip A little silver goes a long way so don't get too enthusiastic with it. I had contemplated doing the ball feet of this cabinet but in the end decided that less is more.

1 Apply a coat of Graphite to the cupboard with a brush, but leave the edges that are next to the glass.

2 Cover the glass on the cabinet with paper, fixing it in place with tape, and paint the frame around the glass. Take care not to get too much Graphite on the paper and the glass. Change the paper when it gets too wet.

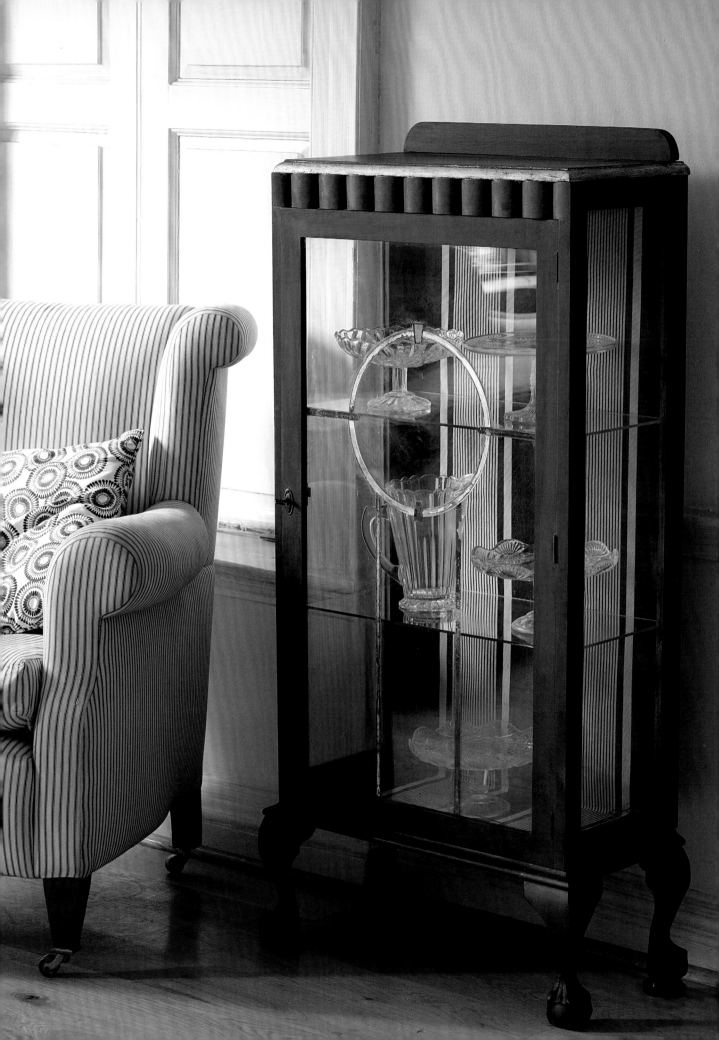

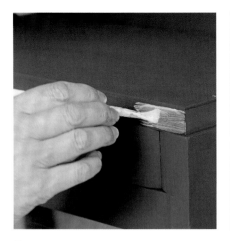

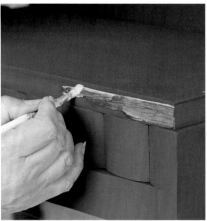

3 When the paint is dry, paint a thin layer of the gold size glue to the top edges of the cabinet. Take your time and avoid getting any glue on the top of the cabinet. Don't worry about the gold size drying out, it remains sticky for hours.

4 Leave the gold size to become transparent; this should take about five to ten minutes depending on the surface you are painting on.

5 Apply the aluminum leaf by letting the leaf fall on to the gold sized surface. Use a small, dry brush to guide it and to flatten it onto the wood. Dab rather than wipe the brush to stop the leaf from breaking up. When the leaf is sufficiently stuck down, tear off the excess. It will not show where there is a join in the wood.

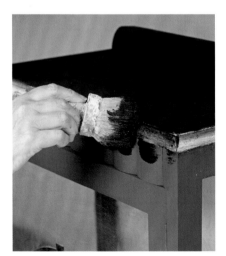

6 Using a brush, apply a layer of dark wax all over the top of the cabinet. This makes the previously dark gray paint turn a beautiful black. The aluminum turns from silver white to a lovely, slightly tarnished silver after the dark wax has been added.

7 While the wax is still wet wipe off the excess, working it into the paint. Take extra care along the edges so you don't damage the metal-leafed areas.

gilded mirror

This huge mirror was originally the door of an armoire—you can still see the keyhole. I have painted it in the timeless, classical look of the Palace of Versailles, where the wooden paneling is painted white with gilded moldings and carvings. The Napoleon III Apartments in the Louvre in Paris have similar paneling with chandeliers, and the rooms glitter with light and sparkle. This is a very inspiring look, but a little goes a long way in my mud-walled farmhouse room in France!

My Old White paint was inspired by the white of these historic rooms. Matte, neutral, and slightly cool in color, it works perfectly with gilding, which is reflective and warm. Traditionally, gilding is applied over a reddish-brown, ocher-red earth color called bole, and this is the color of my Primer Red paint. I have used brass leaf, which is an economical method of achieving a gilded look—you can use real gold but this would be in the form of transfer leaf and is, of course, more costly. Unlike gold, brass needs to be sealed with wax because it will tarnish as it oxidizes.

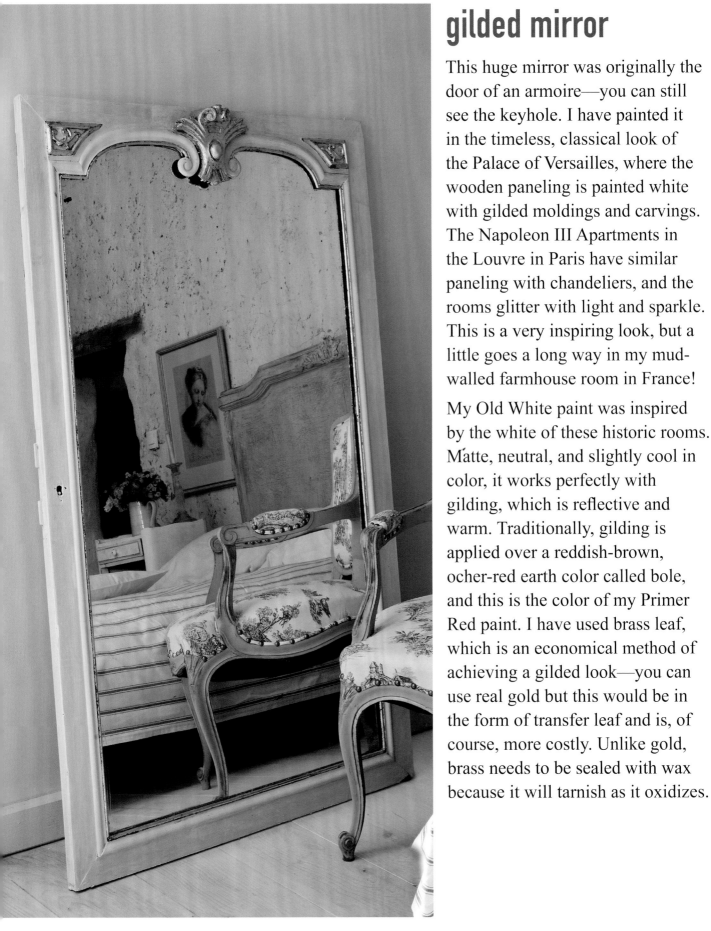

you will need

- Chalk Paint in Old White and Primer Red
- 2in (5cm) synthetic flat brush
- Clear shellac (optional)
- Plenty of clean, dry, lint-free cloths
- Small (No. 6) artist's brush
- Gold size
- Loose brass leaf
- Dry, firm but soft-haired brush, to push down the brass leaf
- Clear wax

1 Paint the wood with Old White using a flat brush, working with the grain of the wood so there are few brush marks. You may need to add a little water to the paint to achieve this.

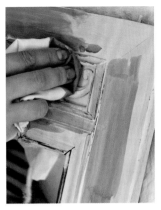

2 If any yellowish-brown stain comes through the paint from the wood, apply a coat of clear shellac with a cloth. I used dark shellac for this photograph so it could be clearly seen.

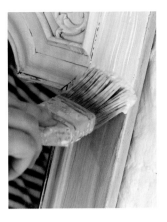

3 Paint over the shellac with Old White and let it dry.

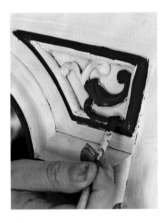

4 Using the small artist's brush, paint the molded areas in Primer Red. The molding between the mirror and the frame is most important, as this gives the feeling of reflected light. Allow to dry.

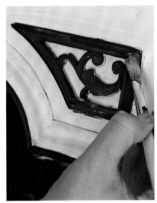

5 Apply gold size over the Primer Red using the (cleaned) small artist's brush.

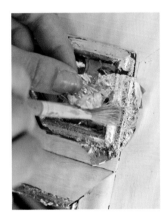

6 Apply the brass leaf over the gold size, using the soft-haired brush to push and guide the leaf into the moldings and awkward sections. Tear off small pieces of leaf to cover the whole area. If you want a very solid gold color, paint on a second coat of size and add more brass leaf.

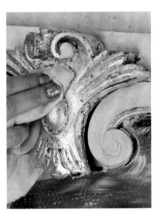

7 Using a clean, dry cloth, apply clear wax over the brass leaf and the paintwork. If you want your paintwork to remain completely matte, avoid buffing or restrict the wax to the brass leaf.

gilded trumeau mirror

This is a modern reproduction trumeau, a French style of mirror that traditionally has a painted or carved panel above or below the glass. Before starting, choose where you want your gilding to be. I have chosen to paint the frame in Duck Egg Blue in keeping with the style of mirror, but another color could work equally as well—perhaps white or gray, or a mixture of both.

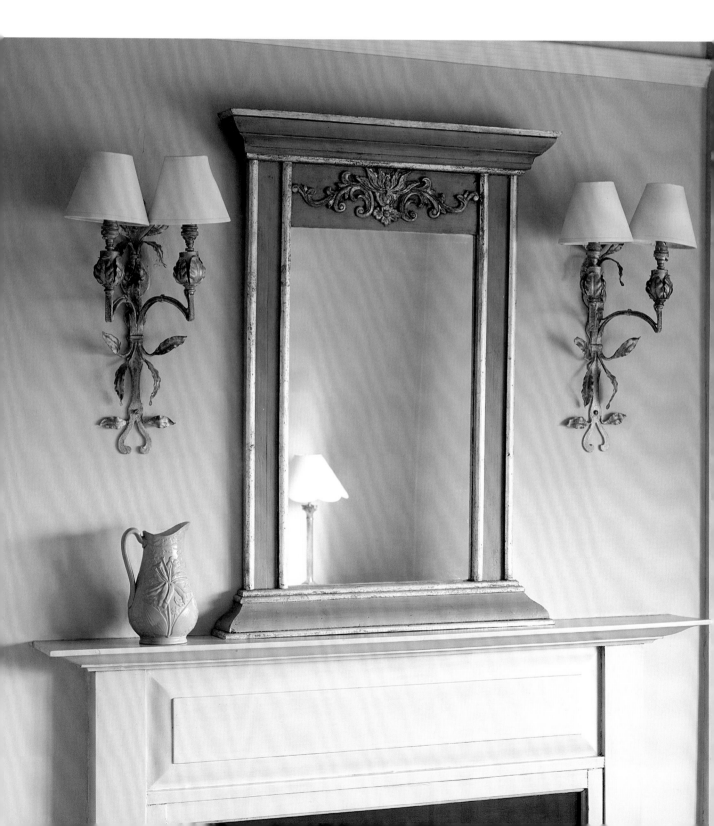

you will need

- Chalk Paint in Duck Egg Blue
- 2in (5cm) paintbrush for applying paint
- Water-based gold size glue
- Small artists' brush for applying glue
- Talcum powder (optional)
- Book of brass leaf
- 1in (2.5cm) paintbrush
- Small soft bristle artists' brush
- Tin of clear wax
- 1in (2.5cm) soft bristle brush for applying wax
- Cloth for removing excess wax
- Tin of dark wax
- 1in (2.5cm) paintbrush for applying dark wax

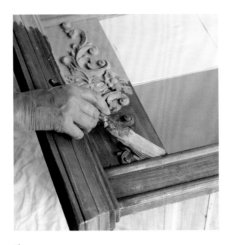

1 Paint all over the wood in Duck Egg Blue, taking care not to get paint on the mirror. Use a stabbing motion on the carved areas to ensure all the detailing is covered. You may have to apply a second coat to make certain the whole of the mirror is covered.

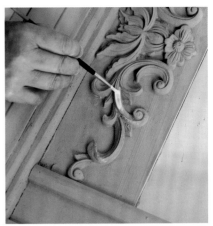

2 When the paint is dry take a small brush and paint the gold size glue onto all the areas where you want to apply the brass leaf. Be certain to cover everything completely and take care not to apply the gold size too thickly, or with drips and bumps. At first the gold size is white; leave it a few minutes and once it becomes clear it is ready to use.

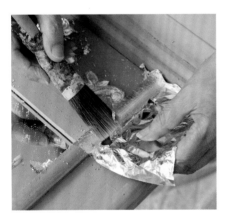

3 Before using the leaf it is a good idea to dust your hands lightly with talcum powder to make them very dry, because the leaf will stick to your hands if they are slightly damp or sticky. Take a sheet of the brass leaf from the book—it doesn't matter which side faces up—and with one hand lay it on the area with the gold size. With the other hand press the leaf in place with a brush.

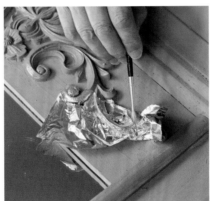

4 Use a small artists' brush to guide the leaf and lay it down as flat as you can, making it sure it has adhered well to the gold size.

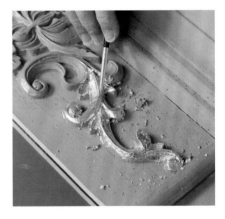

5 Use the brush to push the leaf into the crevices, making certain it sticks really well to the surface so it won't come off at the next stage. Sweep away all the excess leaf you don't want with the brush.

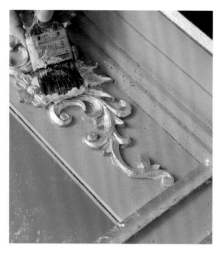

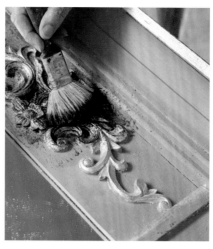

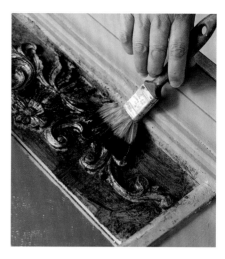

6 Take a soft brush and wipe the gilded areas with a thin layer of clear wax, pushing the wax into the carving. Cover the rest of the mirror with the clear wax then wipe off any excess with a cloth. A clean soft brush will remove any excess in the carving, too.

7 Apply dark wax to the carved areas of the mirror using a brush.

8 Be gentle but try to push the wax into the corners of the carving so it looks as if it was age and dirt.

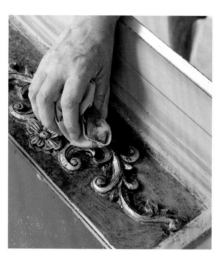

tip I have used brass leaf in this project as it is very inexpensive. Real gold leaf could be used but it is much more expensive. If you choose to use real gold you do not have to wax it because it does not tarnish like brass, but you will have to use the sheets in transfer form (see page 171).

9 Use a cloth and/or a brush to wipe and spread the excess wax on the carving. This is best done using some clear wax because it acts as a kind of "eraser," taking away the dark wax and softly wearing away the "gold." The harder you rub the more leaf will be removed—it is up to you how much of the dark wax and gold you leave.

10 Using a dry brush stipple the area to take away any pockets of dark wax and make the finish more even.

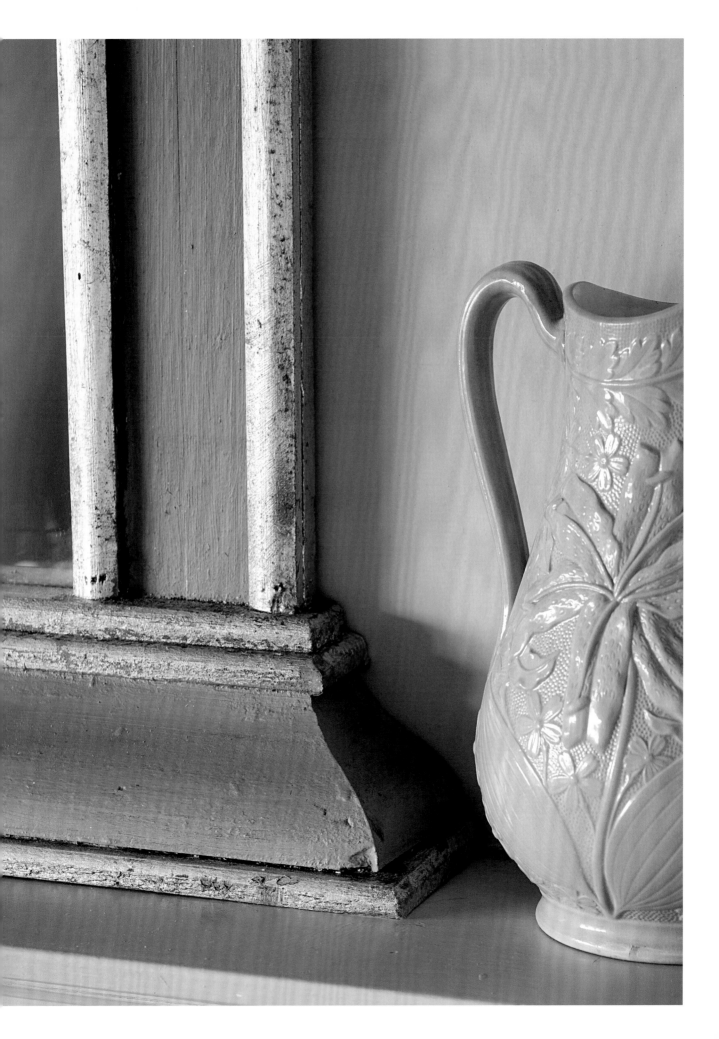

real gold gilded tray

This tray presented a perfect opportunity to use real gold leaf rather than brass leaf. Gold is, of course, more expensive than brass—but it's not out of the question to use it every once in a while, especially on a small project like this. Gold is unlike brass in that it doesn't tarnish if left exposed to air and will continue to look bright and lustrous; its shine is mellower and deeper, too. I love the matte simple dry look of this tray and the gold is reminiscent of Swedish painted furniture.

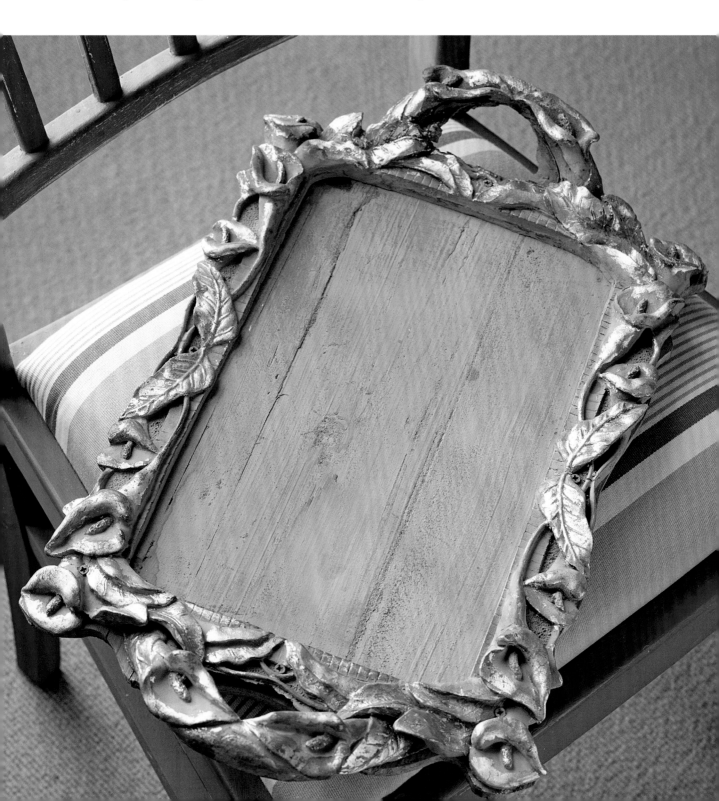

you will need

- Water-based gold size glue
- Small artists' brush for glue
- Gold transfer leaf (not loose leaf)
- 1in (2.5cm) brush for applying leaf
- Pot of shellac or button polish (optional)
- Cotton cloth to apply shellac

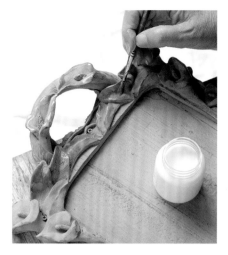

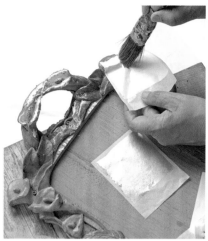

1 Apply the gold size to the areas that you want to gild. When the size is first applied it will be white before becoming clear, at which point it is ready to be used. I have applied the size along edges and centers of the plant design rather than solidly over all the detailing.

2 Take a sheet of transfer leaf and place it gold side down on the gold size. Use one hand to hold the tissue and in the other use a dry brush to press the tissue and stick the leaf to the size. The carving is textured, which means the coverage of the leaf will not be completely even unless you are prepared to go over the same area many times.

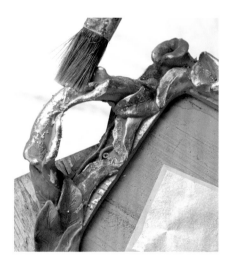

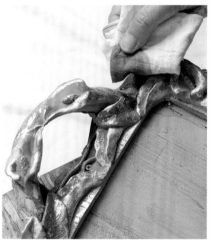

tip One of the many attractions of real gold is that it comes in many colors, from very pale yellow to coppery red. Brass leaf comes in just one color. To work with gold you need to use it in the form of transfer leaf because loose leaf is too fragile to use without specialist equipment. Transfer leaf is a very thin sheet of gold very lightly "stuck" to a square of tissue. Gold does not tarnish so does not have to be sealed, but you may want to put a coat of shellac on it to protect it.

3 With the dry brush, wipe away all the small pieces of leaf that are have not stuck to reveal the result of your work. At this point you can decide whether to leave it as it is if you want an old distressed look, or apply more size and leaf for a more solid gold effect.

4 This next step is not absolutely necessary, but I used a dab of shellac (sometimes called button polish) on the gold to help make it slightly darker and protect the work. This dries extremely quickly so put a little onto a cotton cloth, dab, and wipe once before moving to the next part.

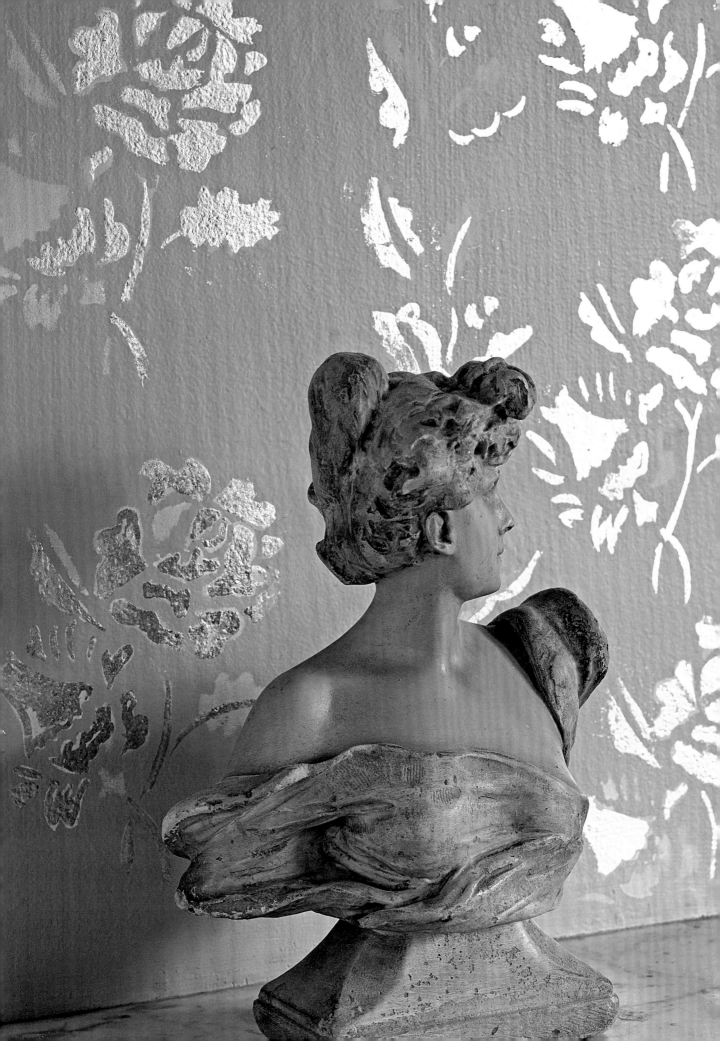

gilded wall stencils

Due to its position in the room this wall deserved special attention. I felt it would merit using a stencil design and real gold to attract the eye. The sheen and life in real gold is incredibly beautiful and without comparison to other forms of leaf. In keeping with my speedy approach to projects, I do not measure out the stencil to make it completely regular, even though here is a pattern that is repeated. I feel that if you want a uniform print then use wallpaper instead—any slight irregularity makes the wall lively and interesting. Apply the paint by eye and fill in any gaps with part of the stencil.

you will need

- Flower and leaf stencil
- Chalk Paint in Old White
- Roller and paint tray
- Water-based gold size glue
- Small artists' brush for glue
- Gold transfer leaf
- Small artists' brush for applying leaf

1 Place the stencil on the wall after working out roughly where you want the design to go. Using a roller and a small amount of paint lighter than the wall color—I chose Old White—mark out the stencil over the whole area you are working on.

tip Real gold comes in many colors (see page 171) so you can choose a gold that works with your background. For my background I have used taupe, a gray brown that works well with the mid-tone and shade of gold I have picked.

2 Using a small brush apply the gold size to the areas you want to be gold. Once the size becomes clear it is ready for the leaf to be applied.

3 Use a dry brush to apply the leaf to the wall. Have a piece of tissue paper behind the leaf and press against it. This helps the leaf to stick to the size and not to the brush or your hands.

4 Wipe away any excess leaf with a soft but firm brush and then check your work for any areas you may have missed.

copper leaf bath

This little corner of my Normandy bedroom is a boho-chic country haven. I had hankered after a freestanding copper bath for years—they are so sumptuous yet earthy-looking. One way of acquiring one was to cover the outside of my enamel roll-top bath in copper leaf.

Copper is a very warm and rich, gingery red color and, as it's a shiny metal, emits light. To soften its appearance, something cool and deep was needed underneath it, to show through. Florence—a coppery green paint, similar to the color of verdigris—was perfect. I could have used a bright blue instead, such as Greek Blue or Aubusson Blue or a mix of the two, but decided against it because the room was predominantly blue and I didn't want everything the same.

The bath has been mounted on black slate, and around the edge of it I put a wooden border, painted in a coat of thinned-out Graphite. I then covered it with clear wax so the wood shows through a little, to work with the wash on the floor. The planks of rough wood on the wall behind the bath have been colorwashed in a mix of Duck Egg Blue and Florence, using a damp sponge. The wonderful contrast of the shiny copper next to the matte of the wood and the floors is very soothing and pleasing. Napoleon, in an old print on the wall, surveys the scene.

you will need

- Chalk Paint in Florence
- Medium oval brush
- Water-based gold size
- Flat synthetic brush, to apply the gold size
- Sheets of copper leaf
- Talcum powder (optional)
- Dry, firm but soft-haired brush, to push down the copper leaf
- Clear wax
- Soft, clean, dry, lint-free cloth, to apply the wax

1 Paint the outside of the bath in Florence with the medium oval brush. When it is dry, paint over it with gold size, using the flat synthetic brush.

2 While the size is becoming clear, take a sheet of copper leaf and lightly crumple it in your hands. If you find the leaf sticks to your hands, put a light covering of talcum powder on them. Gently flatten out the leaf.

Size starts out as white, quickly turns to a rather luminescent ultraviolet color for a minute or so, then becomes clear. At this point, it is ready to be used, although it will actually remain sticky for several weeks or more. I normally apply the size all at once to the area I am working on. When choosing colors, bear in mind that the size makes the paint darken.

3 Lay the flattened sheet of leaf on the sticky size—don't do this until the size is completely clear with no white areas. I like to lay the leaf on with one hand and hold the firm brush in the other and use it to position the leaf.

4 Brush the leaf all over firmly. The folds in the leaf will make small cracks and gaps so the green paint underneath will show through. The finish will probably look quite messy at this point. Repeat steps 2–4 with the remaining sheets of copper leaf.

5 Once you have applied the copper leaf all over the side of the bath, use a soft cloth to coat it with clear wax. This will remove any excess gold leaf and flatten everything out, giving a smooth finish. If you want to see more of the green underneath, rub a little harder so that some of the copper leaf is removed.

tip You might consider leaving the copper leaf to darken and tarnish slightly before applying the wax. Once the wax is applied, the air can't get to the leaf anymore, so the tarnishing process is arrested.

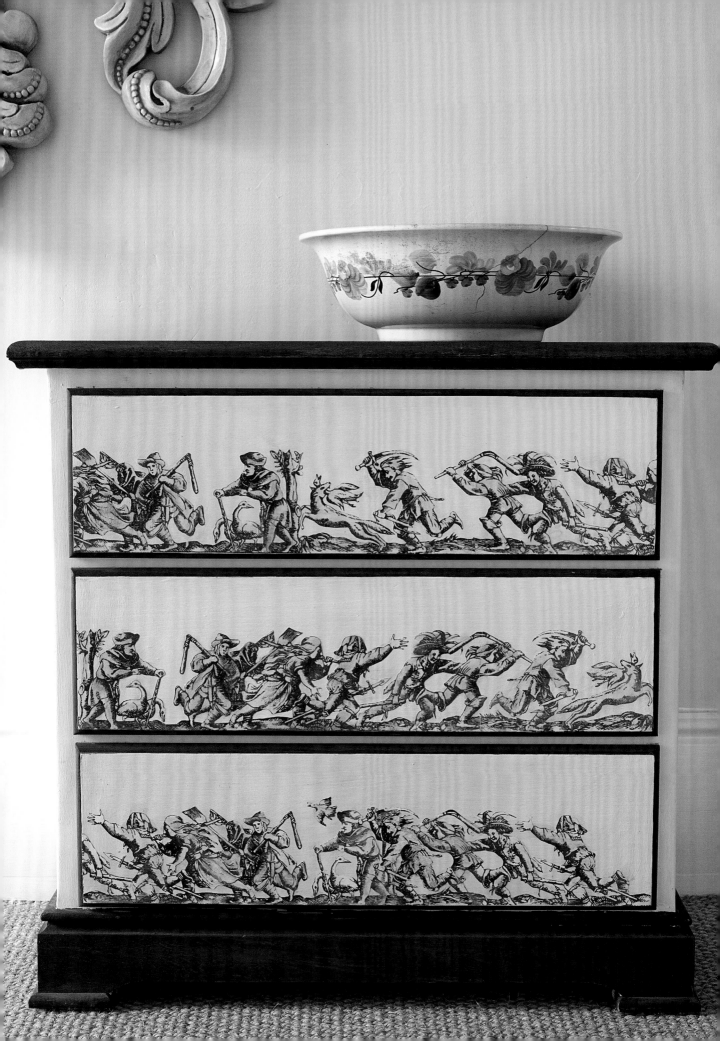

decoupage chest of drawers

There are decoupage motif books, but you could also find a good image in a magazine or online. The picture can then be adjusted, scanned, and printed using a computer. The paper design is then cut out and stuck down onto a surface and varnished several times. I have chosen a design of people running to go along each drawer.

you will need

- Design from a print book or other source
- Computer, scanner, and printer
- Scissors
- Water-based matte decoupage medium
- 1in (2.5cm) paintbrush for applying medium

- Chalk Paint in Barcelona Orange, Giverny, and Olive paint
- Water
- Small artists' brush
- Tin of clear wax
- 1in (2.5cm) paintbrush for applying wax

1 I have chosen a design of a hilarious medieval chase with skirts flying and arms waving that I saw in a book of decoupage prints. After measuring the height of the drawers I scanned and enlarged the design to the required size. The initial printout was a little dark for my taste so I changed the color to a brownish black and printed it out again. I also reversed the design on the computer so that the people will be running the opposite way on the middle drawer. If you struggle with computers, take your chosen design to a local copy shop; they will be able to help you scan and print it out.

2 Cut out the figures with a sharp pair of scissors, getting as close to the edge of the design as possible. It's best if you cut everything out before you start glueing so you can plan roughly where you are going to position each figure. Next, paint the whole area of one drawer front with the decoupage medium.

 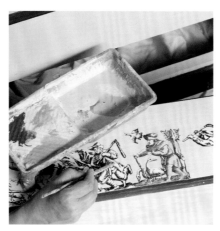 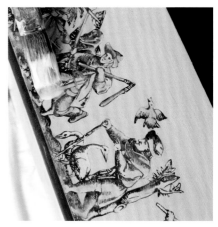

3 With the decoupage medium still wet, place a cut-out figure at one end of the drawer. At the same time brush over the design with the medium, which will now act as a varnish. Try to avoid the paper bubbling up by brushing from one end to the other. If a bubble does come up try to press it down and out the side, but do this quickly before the varnish begins to dry. Repeat the process until the whole drawer front is filled with images. Varnish the drawer twice more, allowing each layer to dry thoroughly.

4 For the painting of the pictures choose one main color and two or three others to partner it. I selected watered down Barcelona Orange as my main color with some Giverny and Olive Green—one hot and two cool colors. I applied the colors to the "clothes," sometimes deliberately missing the area a little so it looks more like a painting. Use the paint like watercolor and make the color uneven in parts. If you make a mistake take the paint off with water.

5 When you've finished coloring, complete the drawers with two layers of varnish. Either wax the whole piece, including the drawer fronts, with a brush or continue with varnish—I prefer wax.

6 I painted my main color Barcelona Orange inside the drawers, which is in deliberate and strong contrast to the coolness of the outside decoration.

tip Try to avoid having a single small image in the middle of a drawer as it can look a little corny. If you have one good image perhaps try using it enlarged so it fills up the area.

decoupage sideboard

This sideboard, or buffet, as it is known in France, was given to me by my neighbor in Normandy, Marie Gaillard. (I have also used her monogrammed linen for the Dyeing Fabric with Paint project on pages 218–221.) I painted and decorated the sideboard many years ago for the house, and since then, I have had a bit more fun with it. I used some amusing and rather brightly colored wrapping paper with vintage luggage labels on it to decorate it. For the two central panels, I folded the paper in half and cut out a shape resembling a plant in a pot. The inspiration for this project came from traditional Eastern European paper cutting, which is very intricate; making paper dolly chains, which I did as a child; and also patchwork.

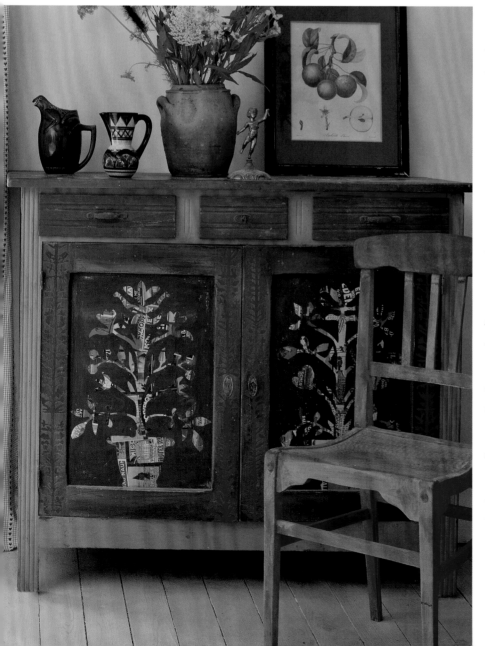

I originally painted the entire sideboard with Aubusson Blue over Barcelona Orange, sanding a little before finally varnishing. The decoupage flowerpots were cut out from wrapping paper depicting vintage luggage labels, while the four red strips are done in plain red paper. Since then, I have added more Barcelona Orange, which brings out the colors of the central panels and painted the drawers in Olive over Barcelona Orange. I varnished the papered areas with the Annie Sloan Image Medium decoupage glue and varnish, before lightly rubbing with coarse sandpaper for a delicate, worn effect. I then covered the decoupage with a coat of clear wax, to soften the look.

you will need

- Large sheet of plain paper or wrapping paper, to fit the sideboard panel
- Sharp scissors
- Pencil
- Annie Sloan Image Medium decoupage glue and varnish
- 1in (2.5cm) flat brush
- Coarse sandpaper
- Clear wax
- 1in (2.5cm) brush, to apply the wax
- Clean, dry, lint-free cloth

1 Cut the paper so that it fits into the panel. Fold the paper in half.

2 Draw one half of the plant pot at the folded edge of the paper, and the central stalk of the plant, with branches and a few big leaves coming off it. Make sure the stalk and the branches are not too thin, and that there are no gaps within the design.

4 Apply the decoupage medium fairly generously over the entire panel, so that it stays wet.

5 Take the paper and, starting at the top, very carefully position it on the panel, making certain that it goes on straight. Brush over the paper as you go with more decoupage medium to make certain the paper is sticking well and also to protect it.

3 Carefully cut out the design in one connected piece.

6 When the decoupage medium is dry, rub over the paper lightly with coarse sandpaper, to give a slightly worn effect. Use the wax brush to apply a coat of clear wax over the entire panel, removing any excess with a clean, dry cloth.

tip If using a wrapping paper for your decoupage, choose a densely patterned design or an extremely plain one, to contrast with the color of the furniture underneath.

typographical chest of drawers

There is a huge interest in typography today, although it's really not surprising, as billboards, signs, and notices are to be seen everywhere. Many people are very knowledgeable about fonts and appreciate the beauty of old advertisements with their old-fashioned typefaces. These are now being used to decorate a lot of furniture. Inspired by several such pieces that I'd seen on social-media sites, I decided to create my own.

I'd had this eccentric, probably handmade piece of furniture in my studio for many years. It had obviously once been used in a garage, as it was covered in oil, and hammer and saw marks. After sealing and painting it, I used it to store my brushes and drawing materials. For a long time, though, I had my eye on it as possible storage for important papers, keys, and souvenirs in the main part of the house.

The eight drawers of different depths suggested to me lines of text, so I chose to decorate them with the first lines of James Joyce's *Ulysses*. I love the unusual combination of words and the different shapes I make with my mouth when I speak them. The chest now stands at the top of the stairs, as the writing on the fourth drawer suggests.

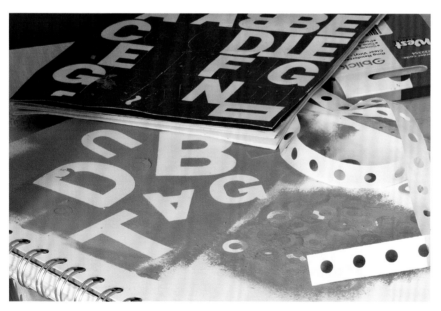

you will need

- Chalk Paint in Old White and French Linen
- Soft flat brush
- Pencil and paper
- Sticky letters for making signs (I used three different heights: 3in/75mm, 1¾in/47mm, and 1½in/35mm)
- Oval bristle brush
- Clear wax
- Brush, to apply the wax
- Clean, dry, lint-free cloths
- Coarse sandpaper

My drawer letters are created out of sticky plastic letters used to make signs, and are available in a range of different sizes. I have actually used the letters as a resist to the paint, and peeled them off when the paint is dry. I chose a combination of French Linen and Old White because I like the sepia look they create together.

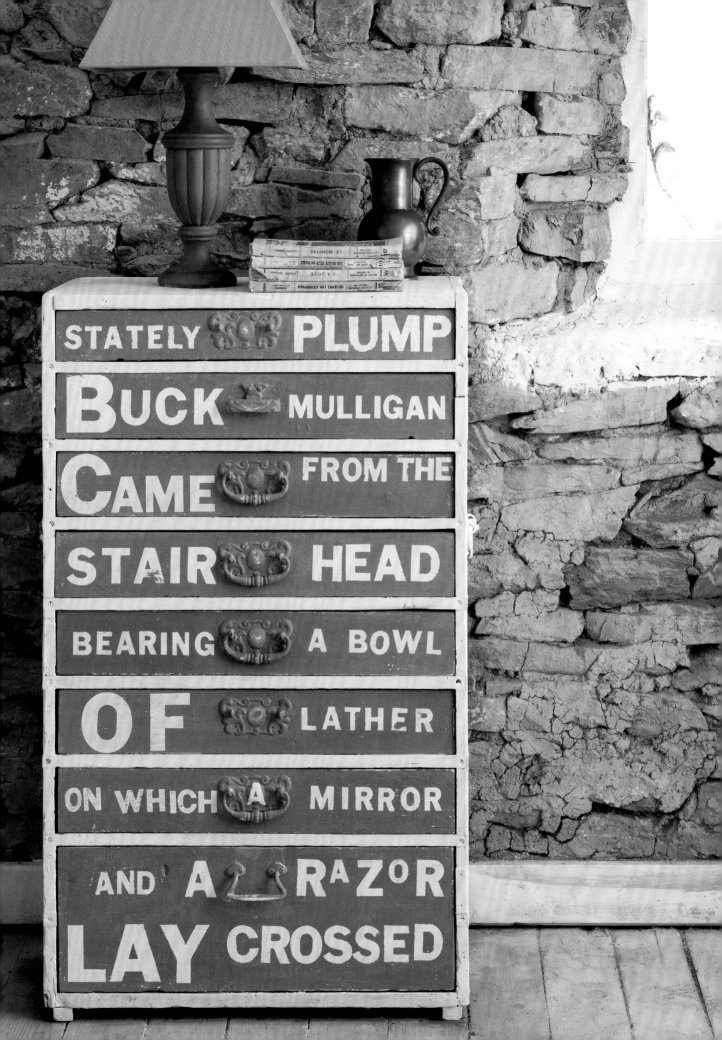

1 Remove the drawers and paint them and the carcass of the chest in Old White—this will be the color of the letters. Apply the paint smoothly with the soft, flat brush, so you don't create a lot of texture and the letters will stick down well. Cover the handles with paint, too. Let the paint dry.

2 Write down your chosen words on paper, and work out which ones you want for each drawer and the size of the letters. Write the final version on the drawers. For me, this involved a certain amount of trial and error, as the words, the letter size, and the drawers were all different sizes. When happy with their position, stick the letters in place—it is easy to stick and remove them a few times before the glue becomes less effective.

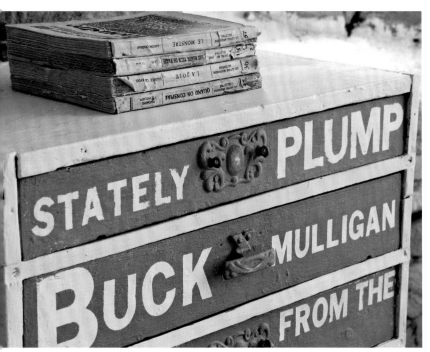

The letters are not perfectly straight, or even perfectly aligned and centered, but they are balanced enough and convey just the right amount of idiosyncrasy. When I waxed the drawers, I used a brush that had a little bit of red paint on it. This gave a blush to a few of the words, adding to the interest. The mismatching metal handles also contribute to the uniqueness of the piece. I painted directly over them and sanded them lightly, so that some of the original metal shows through.

3 Once the letters are in place and firmly stuck down, paint the drawers in French Linen with the oval bristle brush, stippling the letters with fairly dry paint. If the paint is wet and you use the normal brushing technique, paint can go under the letters and spoil them. If this happens, just repaint and try again. Leave the paint to dry.

4 Once the paint is dry, carefully peel off each letter. If any French Linen has seeped under a letter, touch it up with some Old White.

5 Use the brush to apply clear wax all over the drawers and carcass, wiping off any excess with a clean, dry cloth as you go.

6 As this was a very old and roughly made piece of furniture, a little sanding seemed appropriate. Rub coarse sandpaper lightly over the surface, including the handles, to soften the look.

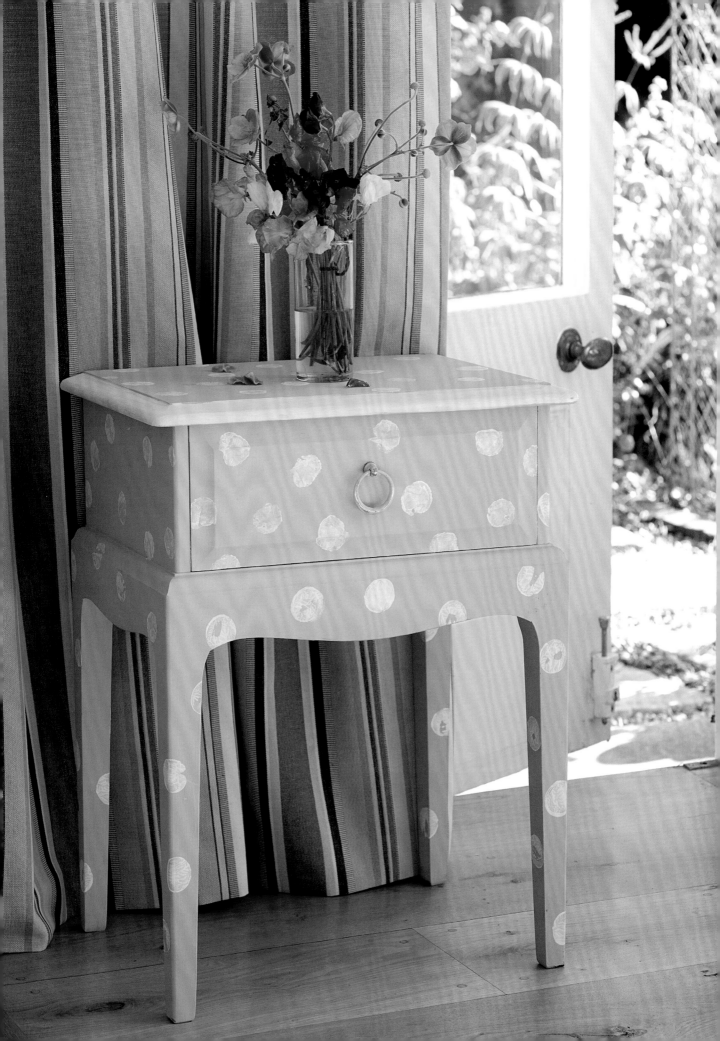

potato-print side table

For this side table I wanted to do something with spots and one of the easiest ways to do this is with potato printing. A polka dot design can look very childlike, but by choosing a smart gray with white spots the finished result is charming and sophisticated. For the drawer interiors I chose a splash of a strong green, but you could try a softer color that will work well with your interior instead.

you will need

- Chalk Paint in Paris Grey and Antibes Green
- 1in (2.5cm) paintbrushes for applying paint
- Potato
- Non-serrated knife
- Felt-tip pen
- Cloth
- Old White paint
- Scrap paper
- Tin of clear wax
- 2in (5cm) paintbrush for applying wax
- Fine-grade sand paper

1 Paint the outside with the Paris Grey, including the uppermost edges of the drawer and the metal drawer pull. Next, paint the interior of the drawer with one coat of Antibes Green.

2 Cut a potato in half with a non-serrated knife. Draw a circle on the cut side with a felt-tip pen either freehand or using a coin as a template. Some potatoes can be very wet inside so dab the cut end with a cloth to absorb the moisture before you start drawing.

 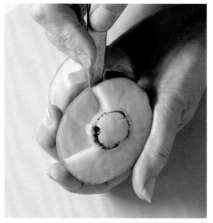 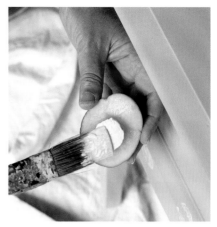

3 Using the pen line as a guide, push the knife about ½in (1.5cm) down into the potato and cut around the sides of the circle.

4 Next, cut into the side of the potato until you reach the point where you cut down into the circle in the previous step. Slice away bits from the side of the potato to form a raised circle that will be used as a spot stamp. Alternatively, rather than cutting a shape into a potato you could use a smaller round potato cut in half, or maybe even try a carrot!

5 Test your stamp by dabbing some white paint onto the potato circle with a brush and pressing it on some scrap paper. The spots formed may be a little uneven the first few times, so it is best to practice until you work out the correct amount of paint and pressure needed.

6 When you are happy with your practice spots, start printing them on the table. I have applied mine randomly, starting where I knew I wanted one and then leaving a comfortable gap between that and the next one.

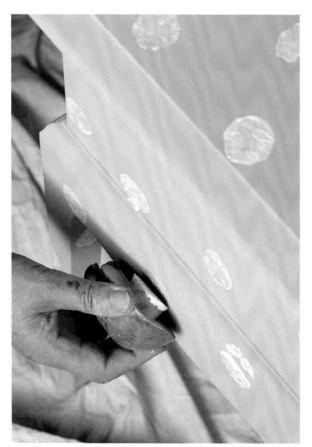

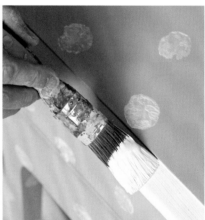

7 Once I had finished with the potato I painted the molding around the top Old White to give the piece a neat edging. This helps to offset the randomness of the spots.

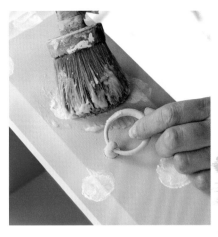

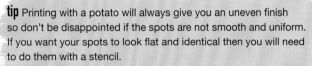

tip Printing with a potato will always give you an uneven finish so don't be disappointed if the spots are not smooth and uniform. If you want your spots to look flat and identical then you will need to do them with a stencil.

8 Using a big brush, apply a thin layer of clear wax all over the table including the drawer handle.

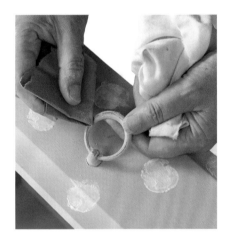

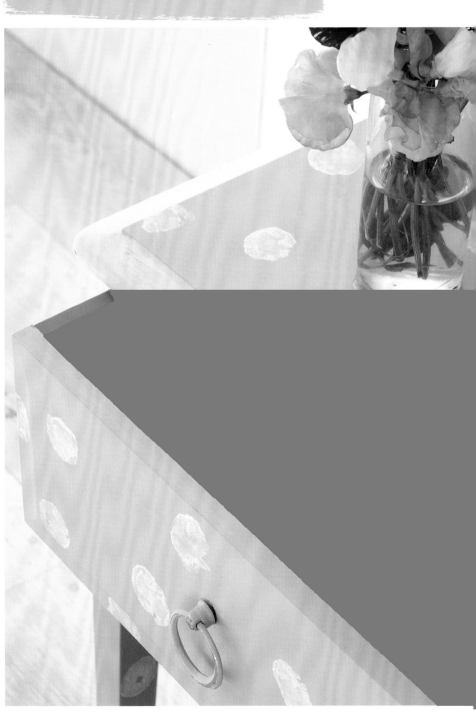

9 Rub the handle lightly with the sandpaper so that just a little of the metal shows through.

tile-effect stencil table

I am interested in the idea of fusing different styles together and this is what I have done here; as is the case in most homes, there is always a certain amount of compromise. Here the three design elements—the table, the chairs, and the stencil pattern—are all quite different, but they result in a contemporary look when combined. The table is a standard one from the 1970s, which was initially inspired by a now very collectible Danish designer. However, the central slat is much higher in this table than in the original design.

The chairs are modern interpretations of Windsor-style farmhouse chairs, while the stencil I used was inspired by Eastern European folk-art, especially the embroidery pieces in which quite a lot of color would be used. So, three very different styles—how to make them work! I decided to put all the color into the chairs and to keep the table and stencil light and subtle. In fact, in certain lights the stencil is hardly visible. To give the stenciling a gentle subtlety, I varied the gray as I stenciled, adding a little more Paris Grey in places.

you will need

- Chalk Paint in Pure and Paris Grey
- Annie Sloan MixMat™
- Large flat brush
- 1 yardstick (meter ruler) and string, to find the center of the table
- Poster tack
- Folk-art stencil
- Pencil
- Small stencil roller
- Rag cloth, for removing paint
- Clear wax
- Small wax brush
- Clean, dry, lint-free cloths

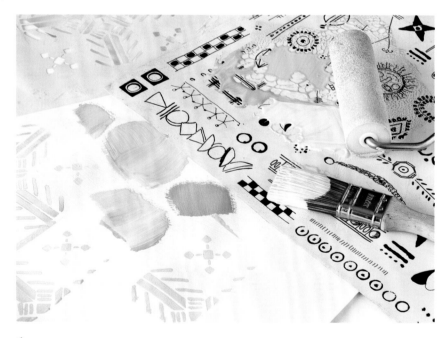

1 Paint the table very smoothly with Pure paint. I wanted to achieve with the stenciling was an almost white on white. Working with the paints on the MixMat™, it took many tries to get the color exactly right. Starting with Pure, add a little Paris Grey to change the color very slightly and then use the flat brush to test out the color on paper first to ensure the tones are right.

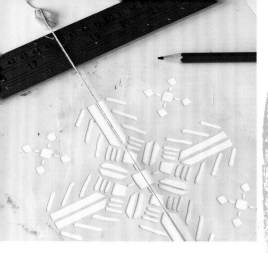

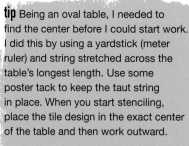

tip Being an oval table, I needed to find the center before I could start work. I did this by using a yardstick (meter ruler) and string stretched across the table's longest length. Use some poster tack to keep the taut string in place. When you start stenciling, place the tile design in the exact center of the table and then work outward.

2 Find the center of the table (see Tip, right). Line up the stencil, ensuring it's in the exact center of the table; you can use a pencil to mark the table gently, but don't leave an obvious mark.

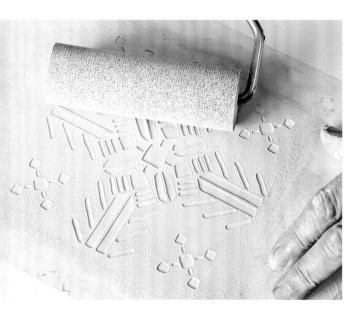

3 Load the paint onto the roller and hold the stencil in position. Go over the stencil two to three times, making sure you cover the stencil completely.

4 Use the rag cloth to wipe the paint off the stencil, so that you can line up the next stencil print. Use the ruler to align and position the stencil correctly again.

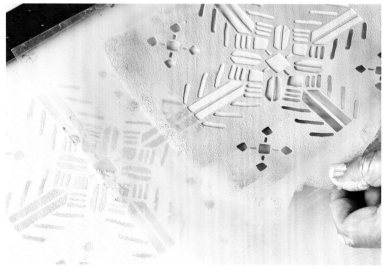

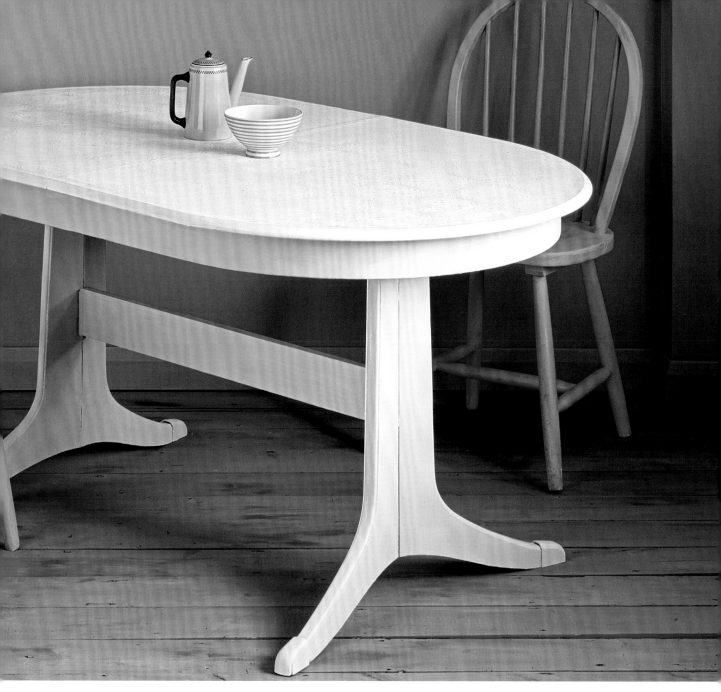

5 To create the illusion of light, shadow, and depth, add a tiny bit more Paris Grey to the paint mix as you stencil. Once you have applied the stenciling to the whole table and it is completely dry, apply clear wax with the wax brush. Remove excess wax with a clean cloth.

printed pillow

I have several beautiful wooden printing blocks: some abstract-looking, rectangular, French ones, as well as several Indian blocks with an image of a tree or leaf, or a Paisley design. The aged patina of the wood makes them an interesting decoration for my home. Wooden blocks are a very old form of printing and can be found all over the world in various cultures. A piece of fine-grained wood is used, with the design being drawn on and then carved out of the wood. To ensure the wood doesn't warp, the block is quite thick, so it is pleasingly chunky. This printing method is still used in India and you can buy the blocks from craft fairs and specialist stores.

I have printed a pillow here, but the method could, of course, also be used to decorate some drapes (curtains), or perhaps a lampshade, table runner, or bed cover. Imagine a fine sheer drape printed with a delicate color! You will need a fabric that's not too coarse for your design. Really fine block designs have to be printed on a delicate fabric. More robust designs require a bit of texture in the fabric. Look at the smallest parts of the carving and compare them to the fabric weave. If the weave is bigger, the design won't show up clearly. I also advise printing onto a color, rather than onto white, so that the color and design of the print have something to connect to.

you will need

• Chalk Paint in Aubusson Blue, Florence, and Old White

• Batting (wadding)—i.e. the type often used for quilting—or something equally soft, as the blocks are hard on the table and need something soft to press into

• Table protector (such as an oilcloth), to stop paint going onto and sticking to the table

• Medium-weave linen (enough to make the pillow, plus some extra to try out the design)

• Wooden printing blocks from India

• Small sponge roller

• Annie Sloan MixMat™

• Iron and ironing board

• Pillow pad, to fit the size of pillow

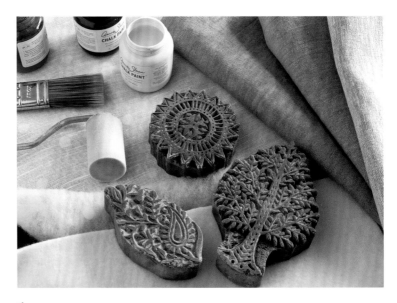

1 Cover the table with the batting (wadding) and table protector, ensuring the surface is soft, but firm. Put the fabric on the table. For this pillow, the fabric was dyed beforehand with Aubusson Blue (see pages 216–217 for advice on dyeing fabric). To make the pillow more interesting, I dyed the fabric for the reverse side in Florence and then printed the design in Old White.

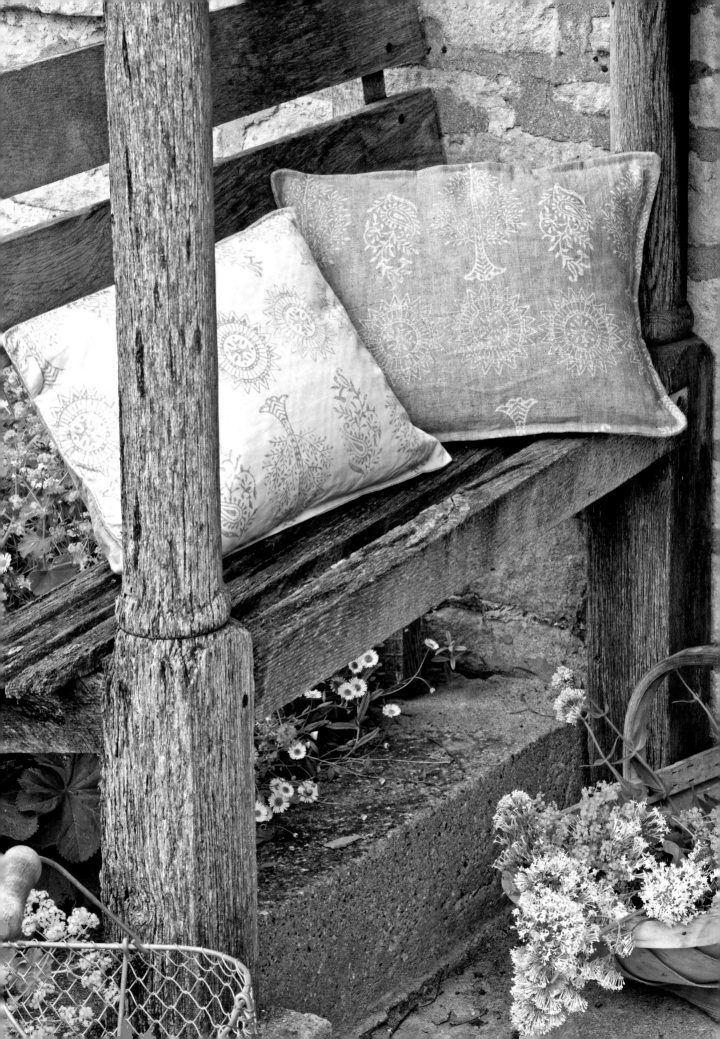

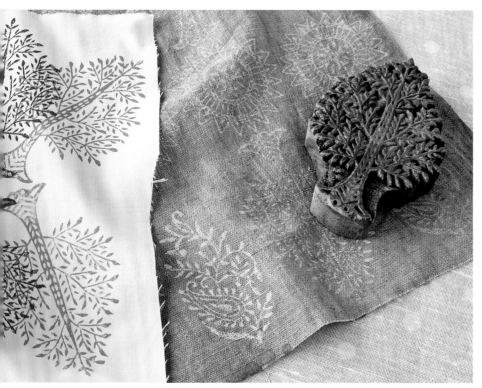

2 Experiment on a spare piece of fabric, making sure you know exactly how much pressure to apply and how much paint to use. The first one or two designs won't print as well until the paint has wet the wooden block sufficiently. Depending on the type of block, try printing the design in different ways, such as upside down or centrally, or perhaps alternate the design with a second block or print it in lines, etc. Be aware that printing on fabric is not going to give a perfectly even and consistent look, but this is part of its charm. Don't be discouraged if some of the pattern does not fully print when you start.

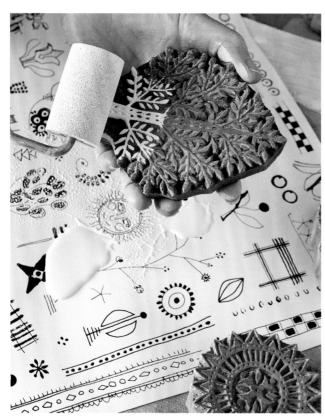

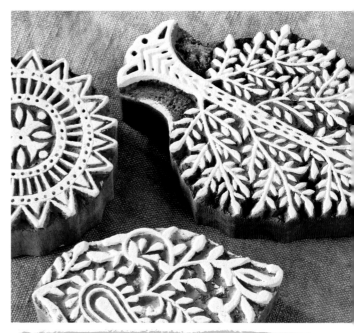

tip Make sure you wash the wooden blocks thoroughly after use. Use a strong bristle brush such as a small flat brush to remove all the paint after printing and so prevent a build-up of paint.

3 Apply the Old White paint to the printing block with the sponge roller, being careful not to get too much paint on the block. Work the roller on the MixMat™ to test beforehand.

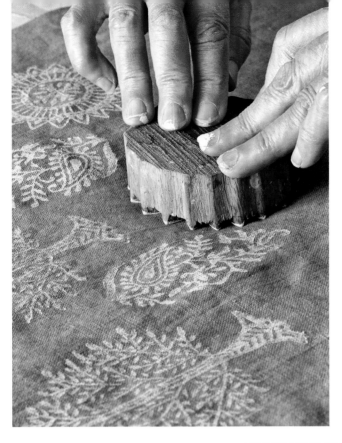

4 Place the printing block on the fabric, checking that it is positioned correctly. Apply an even amount of pressure on the block so that the design prints consistently.

5 Iron the fabric on a warm setting to set the color. The fabric can be washed on a light wash, although you might lose a little of the strength of the color. I washed the dyed linen before printing on this piece of fabric, but haven't tried washing it after printing with the design.

6 Make up the pillow and insert the pillow pad before sewing up the last side. I left the Florence-dyed linen on the back of the pillow plain, but you can print the designs in Old White on this side too if you wish.

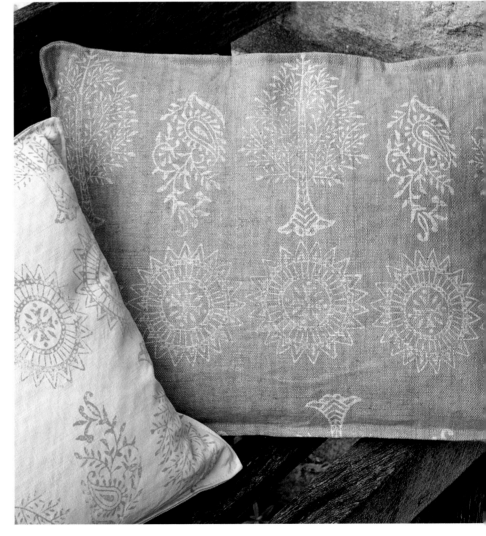

Note: For instructions on making up the pillow, visit www.anniesloan.com/techniques.

printed table runner

This is probably one of the easiest projects in the book! It is simply a piece of fringed fabric printed with a little paint using objects from my toolbox. What could be easier? However, the skill lies in finding a good piece of fabric of the right weight and keeping the design simple and uncomplicated. For this piece I used my Annie Sloan Coloured Linen in Old White and Old Violet. This has a tumbled look and a pronounced texture that matches the slightly unpredictable nature of the printing. The little dots and circles are quite delicate and restrained in contrast. The color chosen is also important, so the contrast is not too great.

I had fun raiding my toolbox for objects to make circular shapes, including a piece from a drape (curtain) pole, a rawl plug, and an assortment of nails and screws—all perfect for making dots, rings, and spots. So, choose to make rectangles, lines, squares, or triangles, and find suitable things for printing. I made a series of printed lines along the width of the runner, marking them randomly and irregularly. One of the joys of hand-printing is the way you can make an apparently repeated pattern look quite irregular! So some of the lines are made from many dots and others from just a few larger circles. If you are new to printing, then keep the design simple and use just one or maybe two colors.

you will need

- Chalk Paint in Emperor's Silk
- Annie Sloan Coloured Linen in Old White & Old Violet
- Small flat brush
- Annie Sloan MixMat™
- Selection of circular objects, such as rawl plugs, nails, screws, bolts, and pencils, for printing
- Batting (wadding)—i.e. the type often used for quilting—or something similarly soft to press into
- Table protector (such as an oilcloth), to stop paint going onto and sticking to the table
- Iron and ironing board

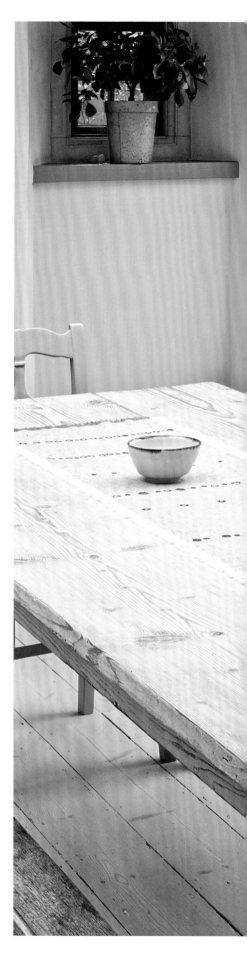

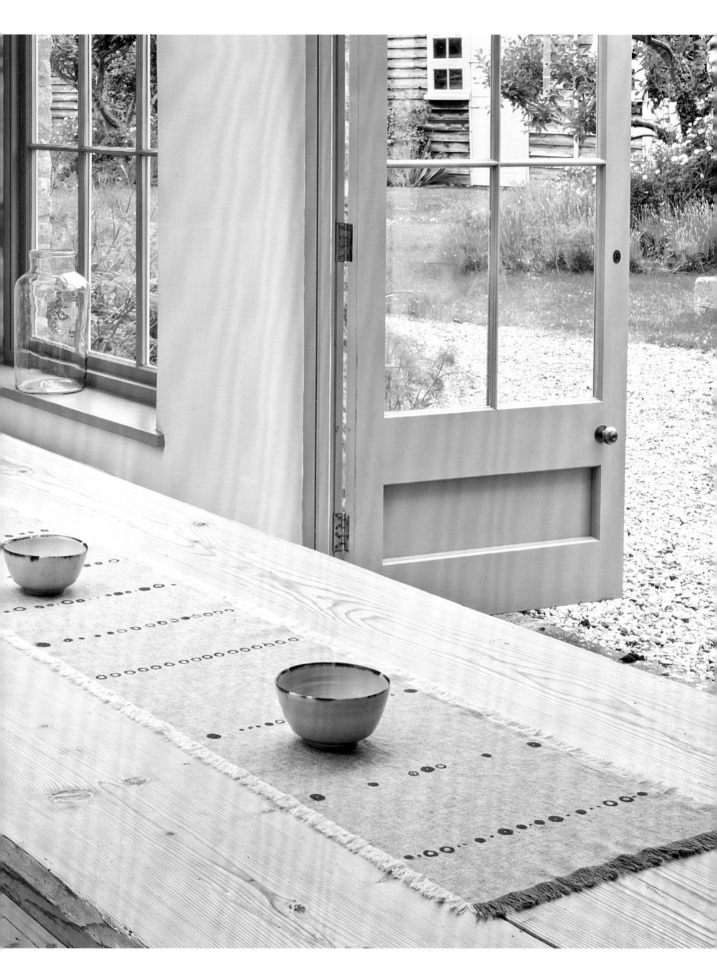

1 I am not a lover of measuring things, but it's important to find the approximate center of the runner so that you can keep the design well balanced and the lines straight. My simple method involves folding the runner in half and then in half again. Continue folding in this way until you have the desired number of sections. Press firmly to make a fold mark in the fabric—this will give you guidelines for your design.

2 Brush a small amount of Emperor's Silk onto the MixMat™. The mat allows you to mix paints and can then be easily washed and used again.

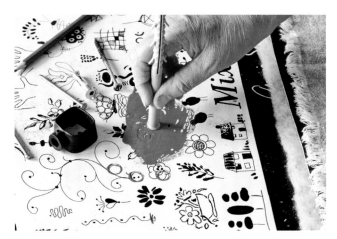

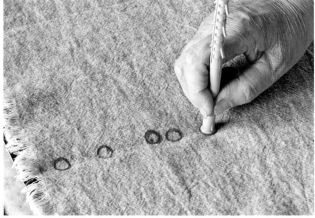

3 Take your printing objects—I started with a fairly bold rawl plug, since it was not the biggest nor smallest of the pieces. Test the piece by dipping it in the paint and printing a couple of times on the MixMat™ to check that it has enough paint on it and is leaving a complete print.

4 Print the circular shapes on the fabric. Using the soft batting (wadding) and table protector beneath the fabric helps enormously to get a good print, as you need something soft for the fabric to sink into as the hard metal prints.

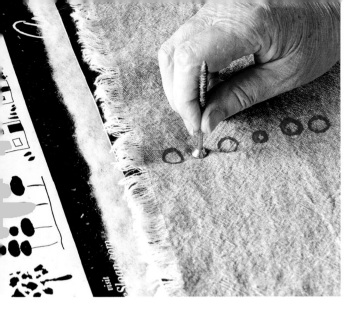

5 I then chose the end of a screw because it was the next size down, printing onto the fabric and using the fold as a guideline to keep the line of printed dots straight. I worked along the crease.

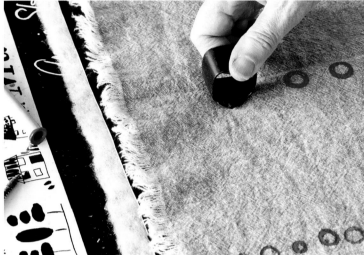

6 I then used the largest of the circle-making devices to ensure that the design was balanced, and continued making the lines.

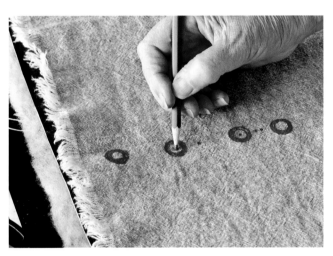

7 Dip the pencil into the paint and place small dots in the center of some of the circles to give some variety to the repeated dots. Once dry, iron the fabric to set the paint. Wash as necessary on a low temperature.

Note: For instructions on making up the table runner, visit www.anniesloan.com/techniques.

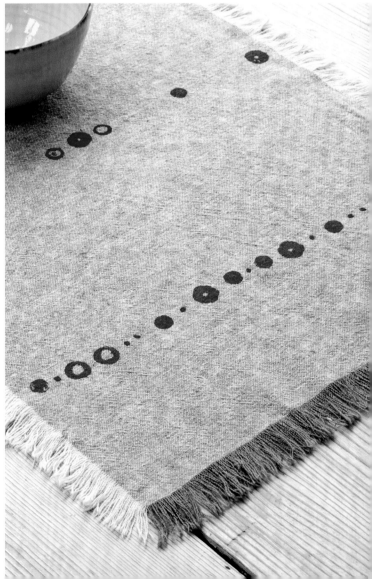

stenciled rug

I have made several burlap (hessian) rugs and love the way they remain very soft and pliable even when covered with paint. I made this piece of burlap into a rug by taking two layers of fabric and then folding over and sewing the edges to make a wide border. This not only gave the rug strength, but also meant the border could be used for the black design.

I experimented with different designs using several stencils on spare bits of burlap. I "measured" everything by eye, and then filled in any areas that looked a little bare. I am inspired by traditional Persian carpets, where colors are changed and some parts of the design missed out—these imperfections give a rug life.

you will need

- Chalk Paint in Graphite
- Burlap (hessian) fabric
- Small flat brush
- Annie Sloan MixMat™
- Small sponge roller
- Flower, "V" shape, bird, leaves, and sand dollar shaped stencils
- Iron and ironing board

1 Transfer some Graphite to the MixMat™ using the flat brush. Load the dry roller with paint, making sure it is not too full by testing it on a spare piece of burlap (hessian). If the roller is too wet, the paint will spill out under the stencil. You'll also need to try out the roller a few times on some spare fabric to get it sufficiently immersed in paint to work successfully—that is, not too wet and not too dry. A small amount of paint goes a long way. Position the flowers stencil on the burlap and apply the paint lightly at first, then with more pressure. For the second print, line up the last flower with the previous print by eye to ensure the gaps are the same.

2 Position the "V" shaped stencil next to the flower. Start in the center of the rug, and continue stenciling. These stencil designs might not match perfectly in length, so don't worry if you see the "V" shaped stencil meeting the flowers in different places as you move along.

Note: For instructions on making up the burlap rug, visit www.anniesloan.com/techniques.

3 Position the bird stencil and calculate visually how many birds will fit along the length of your rug. There were a few gaps at the ends and corners of my rug, so I filled these by stenciling in the little branches from the bird stencil. I finished by stenciling another line of flowers on the inside of the rug and filled the outermost corners with the sand dollar stencil. Once dry, I ironed the rug with a hot iron to seal the paint, but I did not varnish or protect it in any other way.

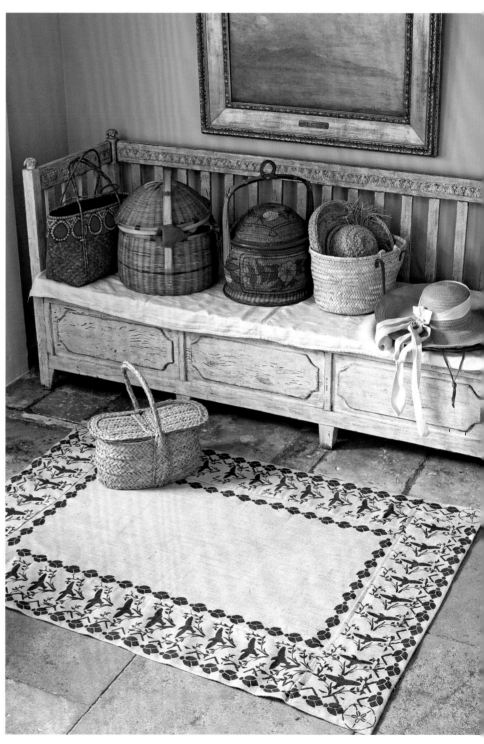

Swedish painted blind

I was inspired to make this blind after staying in a friend's traditional Swedish barn. I drew a picture of it so I could make similar blinds for my house and studio. My friend's windows were lower, smaller, and shorter than mine, so it was easy to reach up and release the fabric from the hooks. My blinds probably won't get much use, because they are too high to be unhooked easily, but I like the way the blind looks at the top of the window. My blinds are also wider, so there is a soft dip in the fabric that was less apparent in the Swedish ones.

you will need

- Chalk Paint in Aubusson Blue
- Annie Sloan Coloured Linen in English Yellow & Antibes Green
- Large table, for painting the stripes
- Tape measure
- Masking tape
- Small flat brush
- Iron and ironing board

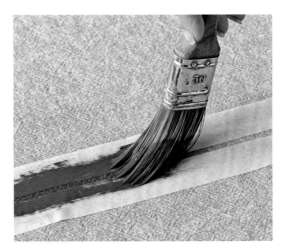

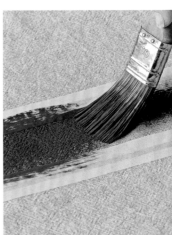

1 Measure the blind to find out where you want the stripes to be. Apply masking tape to the fabric to mark out the two thin side stripes. Press the tape firmly onto the fabric to ensure that no paint will seep under the tape. It's really important to test the paint's characteristics on a piece of scrap fabric between some strips of tape before starting. The paint must be a little dry, with only a small amount of paint on the brush. Do not load your brush with lots of wet paint or, again, it will seep under the tape. Paint all the thin stripes on the blind and then remove the strips of tape, starting with the first ones, which should now be dry.

2 Apply the tape in the same way to make the wider stripes on the fabric, making sure you achieve the same paint quality as before.

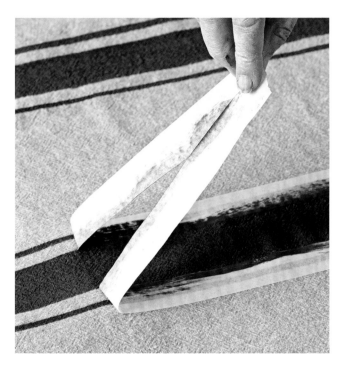

3 The paint will dry very quickly, so pull off the strips of tape as soon as it is dry. Then iron the fabric to seal it. I washed the fabric gently by hand, but this could also be done in a washing machine on a cool, gentle wash. Washing the fabric takes away any paint hardness and softens the whole look.

Note: For instructions on making up the blind, visit www.anniesloan.com/techniques.

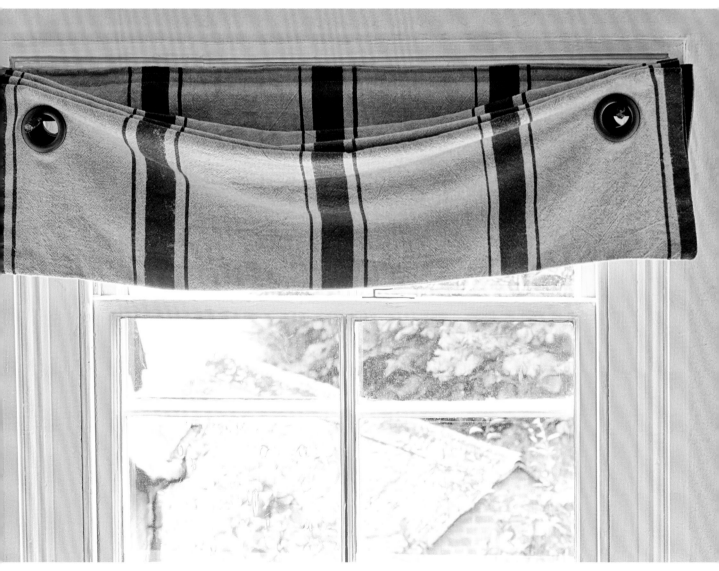

alphabet transfer banner

Sometimes, you see old blinds in secondhand stores or when you move into a new home, and wonder what you can do with them, because they never fit anywhere apart from the place they were intended for. This is a brilliant solution. The blind shown here was made into a banner with a simple transfer design. My son Felix had made an alphabet banner for his daughter, so we came up with a method to make something similar.

For an alphabet, you will need space for 26 letters in seven rows, with four letters in five of the rows and two lines with three letters. If you find measuring stressful, either get someone to help you—as I did—or do a more irregular placing of the letters. I found an alphabet free of copyright that I could print out. You will need to print the letters reversed (as a mirror image), so that they are not backwards once transferred.

It is important to take your time to do this project well. Allow the paint and the paper cutouts to dry thoroughly for several hours, or overnight. If you don't, then the paint can rub off too easily and the printed ink can smudge and run.

you will need

- Chalk Paint in Provence, English Yellow, Antoinette, and Greek Blue
- Old blind
- Scissors
- Pencil
- Yardstick (meter ruler)
- Medium oval bristle brush
- Small flat brush
- Reversed alphabet letters (see Introduction above), printed on ordinary computer printer paper
- Annie Sloan Image Medium decoupage glue and varnish
- Clean, dry, lint-free cloths
- Clear wax
- Small wax brush

1 Cut the top and bottom off the blind so that you have one piece of fabric. Place the blind on your work surface with the fabric side facing uppermost.

2 Draw lines lightly in pencil on the blind, measuring carefully with the yardstick (meter ruler) so that you have a line going though the center of each letter. I marked a spot on the line where each circle of color would be.

3 I chose four colors and then used the oval bristle brush to paint each one with a swirling twist to give a bit of movement to the shape.

4 Roughly cut out the letters in whatever way you want, bearing in mind that the more paper you leave on the pieces, the more you will have to remove later.

5 With the print side facing upward, use the flat brush to coat the first letter transfer with decoupage glue.

6 Stick the transfer immediately on its painted spot. Let dry thoroughly for several hours at least. Repeat for each of the letters.

Note: For instructions on making up the banner, visit www.anniesloan.com/techniques.

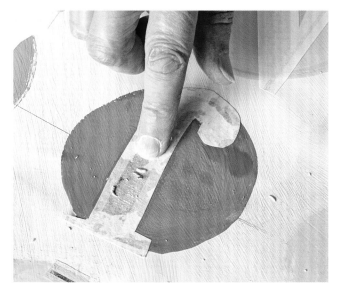

7 Soak the transfers with some water using your finger, rubbing at the same time to remove the paper. Use a cloth to help you remove the paper and allow to dry. You may need to take off more paper because, as it dries, you will find that the paper is still very white in places and less so in others. If the paper is still white and solid, then remove this by adding more water. Some parts might break and split. Bear in mind that some of the paper will disappear when you wax the finished banner. Apply clear wax with the wax brush and remove excess wax with a clean cloth.

shibori lampshade

Shibori is the ancient Japanese art of dyeing fabric to make patterns. There are many ways to do this, from simply folding and dipping (as I have here) to more complicated methods. There is always a random element to the result, but you will learn to control your design to an extent. Once you start, you won't want to stop, as results are easily achieved. Use cotton sheet fabric to practice, but use good-quality fabrics such as fine linens and cottons with a good texture for finished pieces. Silk is also a possibility, since it's the traditional fabric often used in Japan. The fabric should not be too thick, as this will make it difficult to fold and it won't absorb the dye well. It will also be more difficult to make the lampshade because this involves folding the fabric tightly. Most of my paint colors work well, although I have found Napoleonic Blue and Aubusson Blue to be especially good. This may be because they're similar to the traditional color used in Japan. Off-white fabrics work well with the blue.

you will need

- 4 oz. (120ml) pot of Chalk Paint in Napoleonic Blue
- A generous piece of vintage linen
- Large glass bowl
- Pitcher of water
- Mixing stick
- Iron and ironing board

1 Put approximately one tablespoon of Napoleonic Blue into the glass bowl.

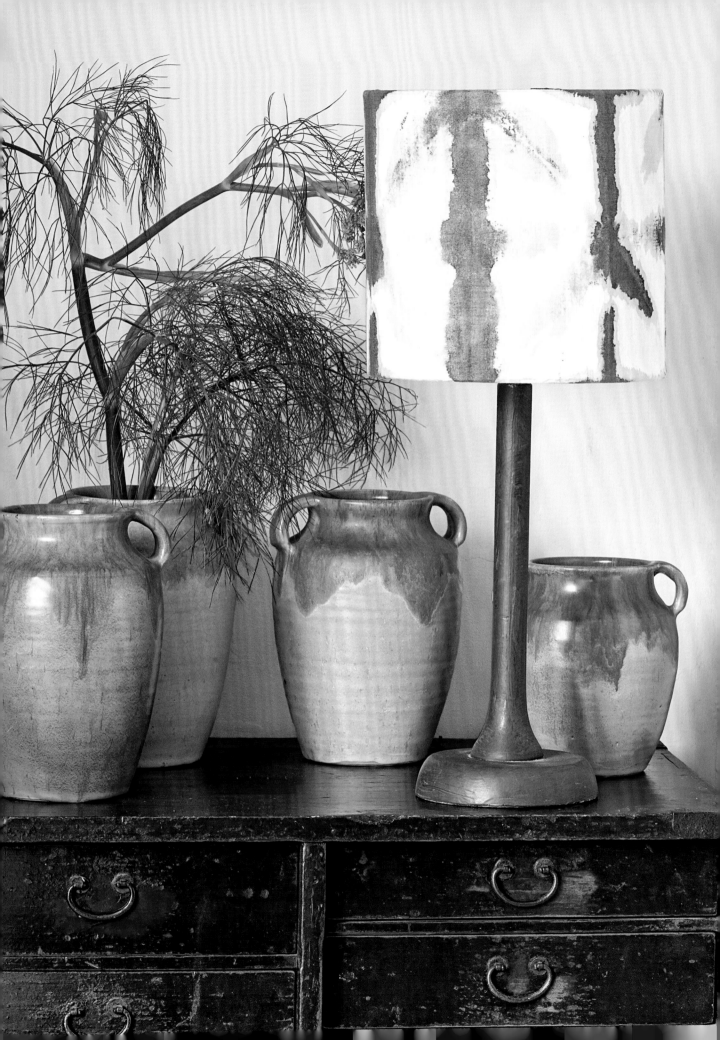

2 Pour in the water and use the mixing stick to stir well, making sure the paint isn't sitting at the bottom of the bowl. Do a test patch on some spare fabric to check the color and add more paint if you need to make it stronger.

3 Concertina the fabric by folding one way, turning the fabric over, then folding the fabric back on itself. The bigger the fold, the bolder the pattern will be.

4 Concertina-fold the fabric again, but this time into triangles.

5 Fold and then turn the fabric over and fold on the other side. Repeat until you have a complete triangle and tuck in any loose edges.

6 Before you dip the fabric, make sure the paint has not settled at the bottom of the bowl. If it has, then stir again to mix. Dip the first edge of the folded fabric in the dye and hold for a second until the dye seeps into the fabric. You need to keep the center of the fabric white. Note that the paint mix will continue to absorb a little after you take out the fabric.

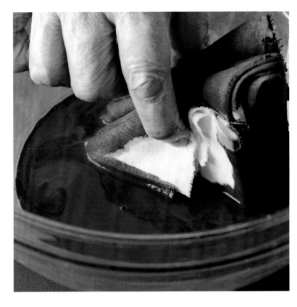

7 Repeat this step for the other two sides of the triangle. Make sure there is still some undyed fabric left in the center, otherwise there will be little or no pattern.

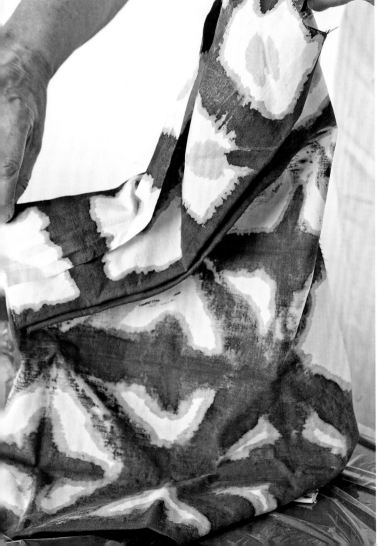

8 Open up the fabric immediately to see the pattern and hang it up to dry. You can keep the piece of fabric folded, but it will take much longer to dry like this. Once dry, iron the fabric on a warm setting to set the color.

Note: For instructions on making up the lampshade, visit www.anniesloan.com/techniques.

dyed lace sheer curtain

I found this single panel of quite intricate, machine-made, cotton lace in a box of old sheer curtains in a house clearance store. This one caught my eye as a good target for dyeing because it had a beautiful pattern, but it was very grubby and had several stain marks.

You will need a container such as a basin, old pail (bucket), or bath tub that can hold enough water to cover the piece of fabric you are dyeing. The fabric also needs space to move around in the water. If the container is too small, there is a risk that the dyeing will be patchy and uneven.

This is such a simple technique, but take care when choosing the color for the dye and also consider the fabric and original color of the piece you're using. I've found most synthetic sheer fabrics dye well, although some have a finish that stops them absorbing color completely. To be sure, test a small piece of the fabric first before embarking on dyeing the whole piece.

This fabric was already a muted, toned-down, "dirty" white. If I'd wanted to dye it a bright color, I wouldn't have been successful, as I would have needed a really white fabric to start with. Also, if I had chosen a brightly colored fabric at the outset, the end result would have been muted. So, I chose a dark paint which created a charcoal color that obliterated the stains and gave the fabric a wonderful silhouette against the light of the window.

you will need

- Chalk Paint in Graphite
- Old pail (bucket) or bath tub
- Water
- Tablespoon
- Mixing stick
- Old lace sheer curtain (net curtain)
- Iron and ironing board (optional)

Note: For instructions on making up the sheer curtain, visit www.anniesloan.com/techniques.

1 Fill the pail (bucket) or bath tub with enough water to cover the fabric well, and then add a spoonful of the Graphite paint. I added a tablespoon of paint, but paint colors are not all the same strength, and you should consider the weight of your fabric, too, so I suggest using a smaller amount of paint to begin with, then adding more as needed to achieve the desired strength. Use the mixing stick to mix in the paint, making sure that it is completely dissolved. I like to use my hands to do this, so that I can search for any clumps of paint.

2 Dunk a little of the sheer curtain into the dye to test the strength of the color. If you're happy with the color, immerse the curtain fully and soak it for a few minutes, making sure that all the fabric is covered with the dye. Again, I like to use my hands to work the dye through the fabric to ensure the whole piece is covered.

3 Remove the curtain from the dye and allow it to drip dry. Heat the curtain to seal in the color, either by putting it in a tumble dryer, ironing it, or hanging it in hot sun.

tip If the color is too strong or too weak, you can either re-dye the piece or wash it in a washing machine to take out some of the color.

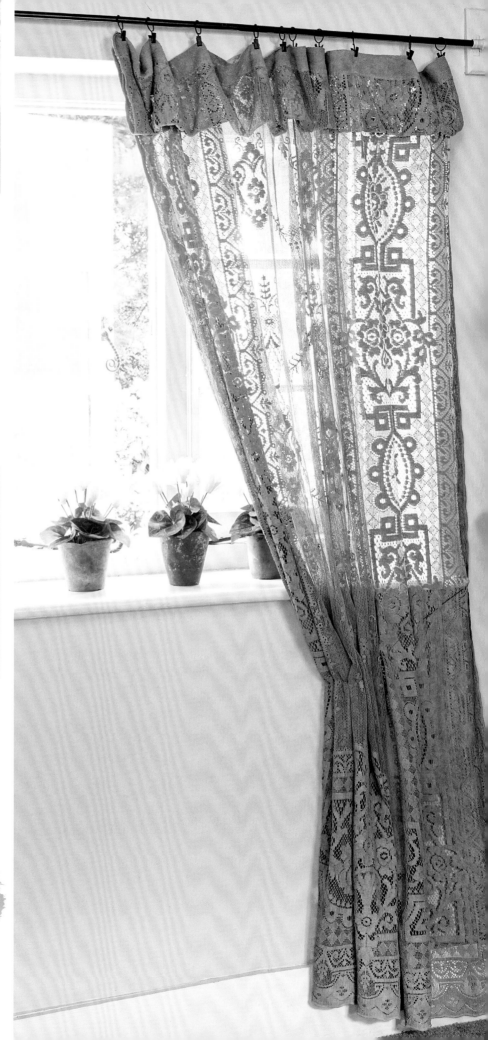

dyeing fabric with paint

My elderly neighbor in Normandy, Marie Gaillard, moved to a retirement home and no longer wanted her old linen. Luckily for me, none of her family did either, so I very gladly bought it. I now have a huge pile of gorgeous linen, all of it white and much of it monogrammed, including one very pretty piece that belonged to Marie's mother.

I have used this linen on beds and upholstery, and also for curtains. Not wishing to have white everywhere, I decided to dye the linen for these curtains with Aubusson Blue paint. I left them unlined so that the light would filter through, which emphasized the texture of the fabric and the slight unevenness of the "dye." According to tradition, when Marie was married, all the sheets in her trousseau were embroidered with her initials, "MG." This simple monogram takes pride of place in the center of the pelmet.

The intensity of the final color depends on the ratio of paint to water, the shade of paint, the type of fabric, and the amount of it being dyed. Old French linen sheets are often particularly large, so work well as curtains. My linen sheet measured 10 x 7¼ft (3 x 2.2m). To dye it, I used about one-third of a liter can of paint and approximately 7.5 liters (15½ pints) of water. Any material that is coated or contains polyester will not take the dye so well.

you will need
- Chalk Paint in Aubusson Blue
- Water
- White linen sheet
- Large, old metal tub
- Wooden stick, for stirring
- Rubber gloves (optional)

1 Pour the paint carefully into the tub—I did this in the yard where it didn't matter if the "dye" was spilled. Gently mix in the water (in a ratio of roughly 1 part paint to 20 parts water, but you can adjust this ratio depending how light or dark you wish the "dye" to be) with the stick. Leave the sheet to soak for about 30 minutes.

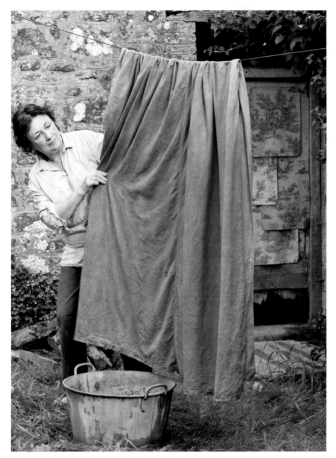

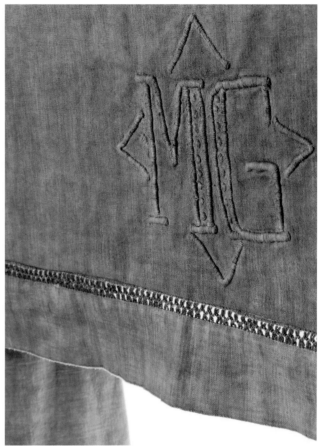

2 Remove the sheet from the tub and hang it outdoors to drip dry. You can then wash it in a machine or leave it as it is.

3 Once the sheet is dry, make up the curtains according to the size of your window. If the sheet is monogrammed, you can cut off the embroidered end of the sheet and turn it into a pelmet.

After making up the curtains, I experimented with washing a remnant of the dyed blue fabric with other pieces of linen. The result was a delightful and delicately washed-out blue. I also dyed one of the sheets using Scandinavian Pink, which gave this wonderful dusty pink color.

Summer daisies and sweet-smelling honeysuckle grow wild in the hedgerows in Normandy. Arranged in an earthenware pitcher (jug), they are offset beautifully by these vintage a linen curtains dyed in Aubusson Blue.

index

useful addresses

Chalk Paint is available throughout the UK, Europe, US, southern Africa, Middle East, Far East, Canada, Japan, Australia, and New Zealand. For a complete list of stockists where you can buy Chalk Paint and my other products, please go to www.anniesloan.com.

Follow me on:
Blog: anniesloanpaintandcolour.blogspot.co.uk
Facebook: facebook.com/AnnieSloanHome
Twitter: twitter.com/AnnieSloanHome
Instagram: instagram.com/AnnieSloanHome
Pinterest: pinterest.com/AnnieSloanHome
YouTube: youtube.com/AnnieSloanOfficial